MESSENGER OF BEAUTY

THE LIFE AND VISIONARY ART OF NICHOLAS ROERICH

"In Beauty we are united,
through Beauty we pray,
with Beauty we conquer."

N. Roerich.

MESSENGER
OF BEAUTY

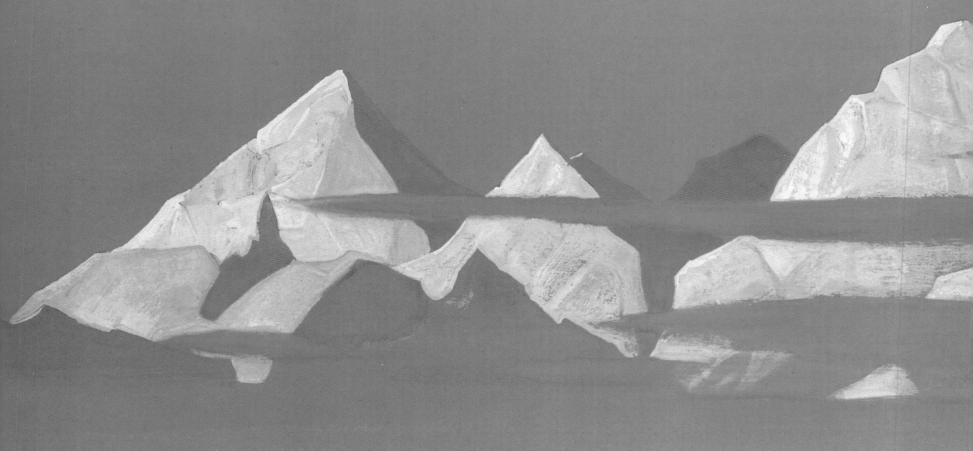

Park Street Press
Rochester, Vermont

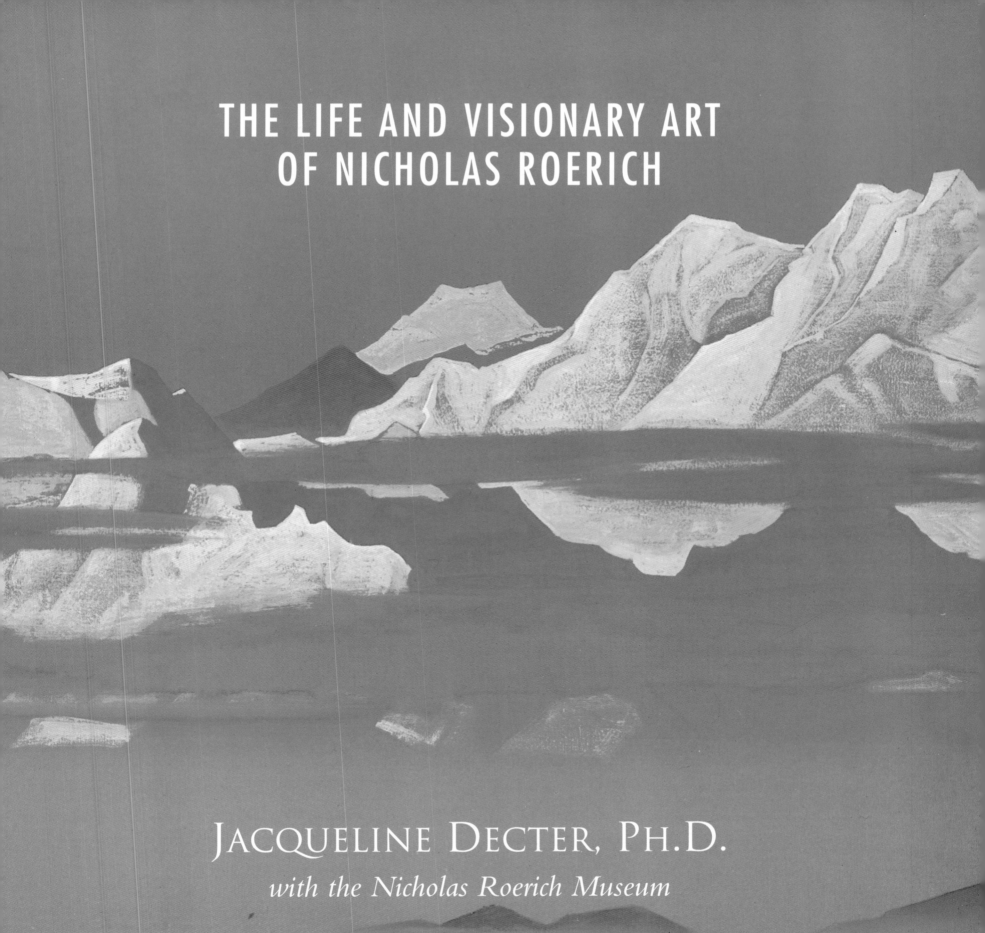

THE LIFE AND VISIONARY ART
OF NICHOLAS ROERICH

JACQUELINE DECTER, PH.D.

with the Nicholas Roerich Museum

Park Street Press
One Park Street
Rochester, Vermont 05767

Originally published in hardcover under the title *Nicholas Roerich; the Life and Art of a Russian Master* by Park Street Press in 1989

Library of Congress Cataloging-in-Publication Data
 Decter, Jacqueline.
 Messenger of beauty ; the life and visionary art of Nicholas Roerich / Jacqueline Decter
 with the Nicholas Roerich Museum.
 p. cm.
 Includes bibliographical references and index.
 ISBN 0-89281-493-4 (paper)
 1. Rerikh, Nikolai Konstantinovich, 1874–1947—Criticism and interpretation.
 I. Nicholas Roerich Museum (New York, N.Y.)
 II. Title.
 ND699.R6D42 1997
 759.7—dc20 93-14093
 CIP

Printed in Hong Kong

10 9 8 7 6 5 4 3 2 1

Text design by Virginia L. Scott

This book was set in Bembo with Baker Signet as the display typeface

Park Street Press is a division of Inner Traditions International

Distributed to the book trade in Canada by Publishers Group West (PGW), Toronto, Ontario
Distributed to the book trade in the United Kingdom by Deep Books, London
Distributed to the book trade in Australia by Millennium Books, Newtown, N.S.W.
Distributed to the book trade in New Zealand by Tandem Press, Auckland
Distributed to the book trade in South Africa by Alternative Books, Ferndale

Cover image: *Star of the Hero,* 1932. Tempera on canvas, 53 × 41 in. Nicholas Roerich Museum, New York.
Title page image: *Pink Mountains,* 1933. Tempera on canvas, 31 × 48 in. Nicholas Roerich Museum, New York.

CONTENTS

In memory of my father, William E. Decter

ACKNOWLEDGMENTS

I am greatly indebted to Daniel Entin, director of the Roerich Museum, for giving so selflessly of his knowledge and time, and for offering me unlimited access to the museum's library and archive. To Edgar Lansbury, president of the museum, I am thankful for guiding me toward a deeper understanding of Roerich's philosophical and spiritual beliefs. I would also like to thank Carl Ruppert for his invaluable help in researching the specifications of the paintings reproduced in this book.

I am grateful to Ehud Sperling, president of Inner Traditions, for having the vision to undertake this project, and to his entire staff, especially Leslie Colket, for their constant encouragement and support.

To my family and friends, who stoically put up with me throughout and never stopped believing in me, my gratitude is unbounded. To Larry Levitsky, who served as the catalyst, I owe special thanks. And to my husband, Vadim Strukov, who introduced me to Roerich in the first place, and who is my best teacher and most demanding critic, mere words of thanks are not enough.

PREFACE

From his earliest years, Nicholas Roerich exhibited a marked affinity with nature, a great thirst for knowledge, and a deep appreciation of beauty in all its forms. These innate qualities found expression in a prodigious and multifaceted career, the fruits of which included more than 7,000 paintings and set designs. His archeological findings contributed significantly to the understanding of the origins of man in his native Russia and in Central Asia. His humanitarian undertakings earned him a nomination for the Nobel Peace Prize. His artwork was praised by many of the key artistic and literary figures of his time, including Leo Tolstoy, Sergei Diaghilev, art patron Pavel Tretyakov, and scholar Vladimir Stasov. Yet, at the time of his death in 1947, and until quite recently, Roerich's name was little known in the West, except to a relatively small number of people who value him as a painter of extraordinary Himalayan landscapes—and as a man who made the pursuit of beauty and culture his religion.

With dexterity and insight, Jacqueline Decter has provided the most comprehensive treatment of Roerich's life and work ever published in the English language. Each phase of his varied career is included in her narrative, from his university years and involvement in Russia's tumultuous turn-of-the-century art world to his studies in Paris; his marriage to Helena Shaposhnikova; his career in stage design; his travels in Europe, the United States, Central Asia, and the Far East; and his establishment of art schools, international cultural organizations, and scientific institutes on three continents. The growing number of his admirers who find their way to the doors of the Nicholas Roerich Museum will welcome the appearance of a book so rich in biographical detail and so amply endowed with reproductions of Roerich's artwork.

Nicholas Roerich's wide diversity of talents would have made him a unique individual in any era. Trained not only as an artist but also as a lawyer, he wrote extensively on legal matters, the arts, ethics, and their links to a more general law of the universe. He was convinced that the evolution of culture depended on a synthesis of knowledge from all fields of human endeavor. His belief in the fundamental unity of all cultures and civilizations led him to a profound study of Eastern culture and philosophy. He and his lifelong partner, Helena Roerich, wrote prolifically on this subject and eventually settled in northern India's Kulu Valley. There, in the foothills of the Himalayas, Roerich painted some of his most inspired canvases.

In the course of his life Roerich became a friend and adviser to scientists, heads of state, spiritual leaders, artists, writers, and poets. Jawaharlal Nehru referred to him as a "creative genius." The Indian poet Rabindranath Tagore considered him a voice for "what every sensitive mind feels about the greatest of all arts, the Art of Living." As this century draws to a close and we attempt to address the uncertainties of the next, Roerich emerges as an effective link between the cultural heritage of humankind and the vast creative potential of a new era.

Edgar Lansbury
President, Nicholas Roerich Museum

MESSENGER OF BEAUTY

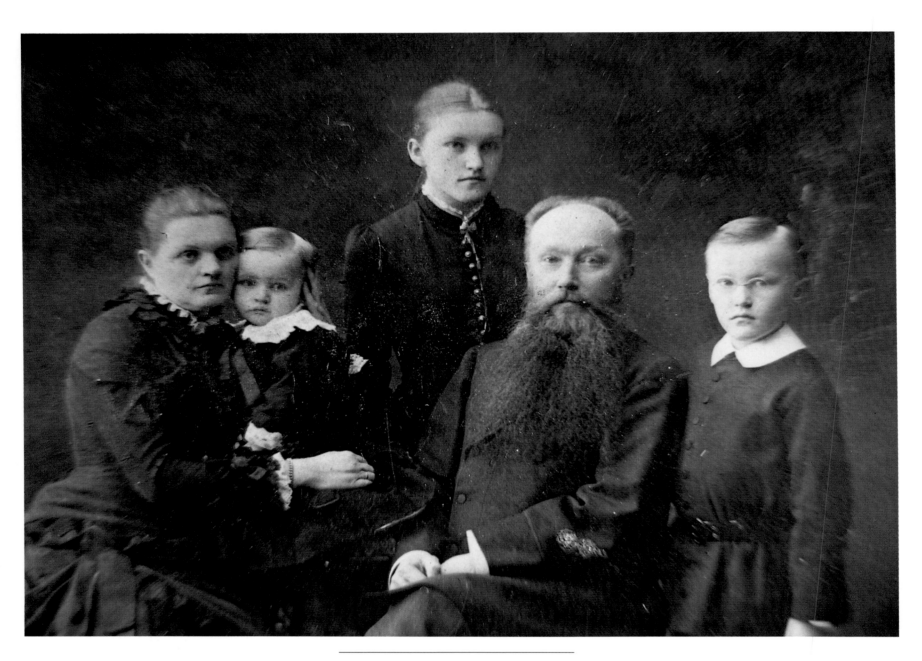

The Roerich family, early 1880s.
Left to right: Maria Vasilievna, Boris, Lidia,
Konstantin Fyodorovich, and Nicholas.

EARLY YEARS

Roerich. Scandinavian in origin, the name means "Rich in Glory." According to family legend, it dates back to the time of the Vikings. One of the early Roerichs was head of the Knights Templar in the thirteenth century. Others served as politicians and military leaders, including a Swedish officer who fought in the Russo-Swedish campaign against Peter the Great. His descendants, retaining their Lutheran faith, settled in northwestern Russia.

One of these descendants, Konstantin Fyodorovich Roerich, was born in a town on the Baltic Sea in what is now Latvia. In 1860 he married Maria Vasilievna Kalashnikova, whose Russian lineage can be traced back to tenth-century Pskov, and took his bride to live in St. Petersburg. A lawyer by training and a notary by profession, Konstantin Roerich set up his office on the *bel étage* of their home, a fine residence on the Nikolaevsky (now University) Embankment overlooking the Neva River.

His practice flourished, attracting affluent clients who entrusted him with drawing up their wills, distributing their inheritances, and other important legal matters. In 1872 this prosperous and respected gentleman became notary of the St. Petersburg circuit court.

At the end of the long working day, Konstantin Roerich would retire to the spacious family living quarters on the second floor of the house on the bank of the Neva. There

Maria Roerich had created a warm, inviting atmosphere and presided as competently over domestic affairs as did her husband over business matters. Often, in the evenings, guests were ushered to comfortable armchairs and, bathed in soft lamplight, engaged in unhurried conversation with their hosts. The topics of discussion might well have included Tsar Alexander II's abolition of serfdom in 1861; the Law Reforms of 1864, which established independent courts in Russia; and the latest studies of the Free Economic Society★—all causes that the liberal minded Konstantin Roerich ardently supported. His interests were not limited to the law and politics, however, as the diverse array of scientists, scholars, and artists who visited the Roerich home attests. Among the frequent guests were the eminent chemist Dmitry Mendeleyev; the noted historian and folklorist Nikolai Kostomarov; the orientalists Golstunsky and Pozdneyev, perhaps just back from one of their trips to Mongolia or the Himalayas; and the painter and sculptor Mikhail Mikeshin.

On October 9 (September 27, old style), 1874, Konstantin Roerich received congratulations on the birth of his first son. The boy was baptized in the Russian Orthodox

★ The Free Economic Society, founded in 1765 by Catherine the Great, had as its aim the study and improvement of economic and agricultural conditions in Russia.

Church, his mother's religion. The priest plunged the infant into the font, placed a gold cross around his neck, and gave him the name Nikolai (Nicholas), which means "one who overcomes." Thus, even in his name, the ancient Nordic heritage belonging to his father and the pure Russian ancestry of his mother were united in Nicholas Roerich.

Nicholas; his younger brothers, Boris and Vladimir; and their older sister, Lidia, grew up in the large, cozy apartment on the University Embankment. From its windows they could see ships from all over the world sailing along the Neva on their way to and from the nearby Gulf of Finland, and the bronze statue of Admiral Kruzenstern, the first Russian to circumnavigate the globe. Their paternal grandfather, Fyodor Ivanovich Roerich, lived with the family until his death at 105. His grandsons were fascinated by his collection of mysterious Masonic symbols, which he allowed them to look at but never to touch. Even in old age, Fyodor Roerich had no need for eyeglasses, and he smoked so much they called him "a walking tobacco factory."

The children often visited their maternal grandmother's home in Ostrov, an old fortress city near Pskov, where they played brigands (a Russian version of cops and robbers) and feasted on raspberries from the large overgrown garden. Dressed in a suit of gold-colored cardboard armor, a present from his uncle, and wielding a wooden sword painted copper, Nicholas would imagine that he was a bold Viking or a brave Russian warrior valiantly fighting off dragons.

Summers and winter holidays were spent at the Roerichs' country estate, Isvara, about fifty-five miles southwest of St. Petersburg near the village of Volosovo. "Everything special, everything pleasant and memorable is connected with the summer months at Isvara," Nicholas Roerich would later recall.[1] Konstantin Roerich had acquired the estate in 1872. Its original owner, Count Semyon Vorontsov, who was Russian minister at the courts of London and Vienna during the reigns of Catherine the Great and Tsar Paul I, had named his estate Isvara after

traveling through India. The word in Sanskrit means "Lord" or "divine spirit." In the living room of the manor house at Isvara, rising high above copies of paintings by the Dutch "little masters," was a picture of a magnificent snow-covered mountain lit by the setting sun. Only many years later did Nicholas Roerich discover that the mountain in that painting was none other than the sacred Himalayan peak Kanchenjunga (pages 6–7).

Isvara was large—about 3,000 acres—and profitable. In addition to the two-story white stone manor house, it had a granary, a stable of thirty horses, a cow barn, a poultry barn, a distillery, and a smithy, and on the river a watermill, a windmill, a dairy barn, and a hatchery for trout.

While Konstantin Roerich was busy overseeing his large and often cantankerous staff of peasants, his children played in the garden and roamed the estate. The environs of Isvara—the mossy hills, the fields dotted with boulders and ancient tumuli, the immense dark forest on the horizon, the meandering rivers and cool lakes, and the fantastic, seemingly animate cloud formations in the vast, transparent sky—instilled in young Nicholas a deep, life-long love for nature and especially for the northern Russian landscape.

Nicholas's love of history was also kindled at Isvara. In the estate's library there was a series of children's books about the history of Russia, and as soon as he learned to read, Nicholas became fascinated by the tales of wise princes, bold warriors, saintly martyrs, and stunning battles against infidel invaders from the East.

Some of Nicholas Roerich's happiest childhood memories were of music. In his memoirs, *Diary Leaves,* he recalls that a blind old piano tuner used to tune the grand piano in the Roerichs' living room. He was an excellent musician and would always play a piece or two after tuning the instrument. How impatiently Nicholas waited for the man to start playing, and how amazed he was that a blind man could play the piano![2]

The Roerichs had season tickets to the opera, and even at a young age their eldest son's taste in music tended toward the East. He preferred Glinka's A *Life for the Tsar*

THE MANOR HOUSE AT ISVARA.

and *Ruslan and Lyudmila* to Verdi's *Rigoletto* and *La Traviata* or Donizetti's *Lucia di Lammermoor,* which he found somehow alien in spirit. Verdi's *Aida* was more to his liking, as was Meyerbeer's *L'Africaine,* with its chorus of Africans singing of the Indian gods Brahma and Vishnu.[3]

As was customary for the children of upper-middle-class Russian families in the nineteenth century, Nicholas Roerich was educated by private tutors at home until he was nine years old, in preparation for entry into the gymnasium (a combined elementary school and high school). St. Petersburg had many gymnasiums: private and public, expensive and inexpensive, some touted throughout Russia for their academic excellence and some for their strict, almost military discipline. Konstantin Roerich decided to enroll his children in one of the best, most expensive private schools in the city, the gymnasium of Karl von May. In 1883 Nicholas passed the entrance exams with ease—so well, in fact, that von May himself exclaimed, "Well, here we have a future professor!"[4]

Every school morning the "future professor" would awake before dawn, eat his breakfast by the light of a kerosene lamp, and walk the short distance to the gymnasium, a book satchel on his back and his blond head shielded from the cold, damp St. Petersburg climate by a *bashlyk,* a hood with long ends wrapped snugly around his neck. Inside the building, at the top of the staircase leading

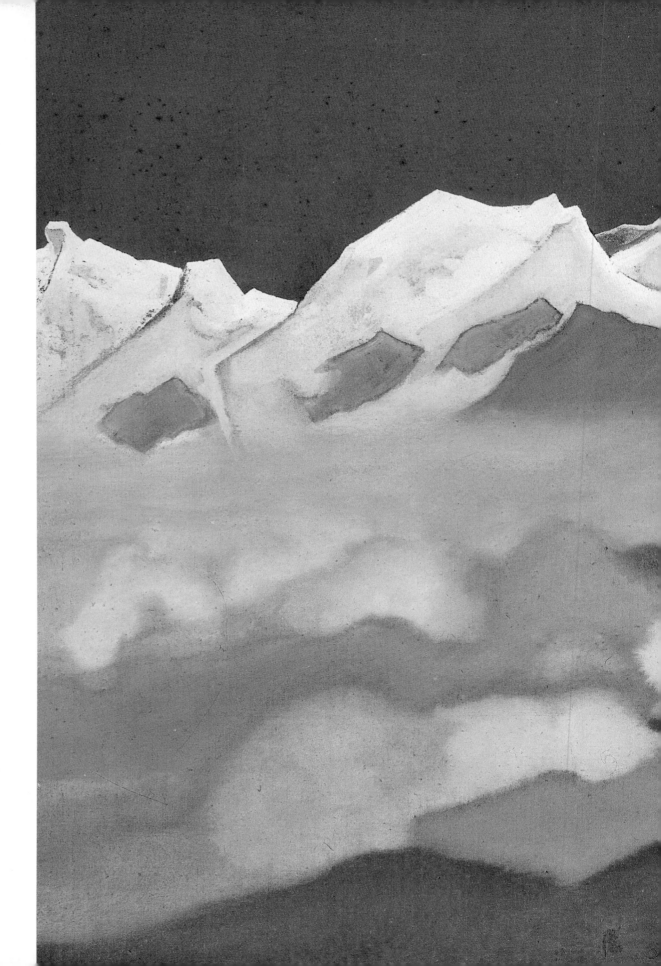

Kanchenjunga, 1924.
TEMPERA ON CANVAS, 27½ x 42½ IN.
NICHOLAS ROERICH MUSEUM, NEW YORK.
ONE OF ROERICH'S MANY PAINTINGS
OF THE HIMALAYAN MOUNTAIN
HE FIRST SAW DEPICTED AT ISVARA.

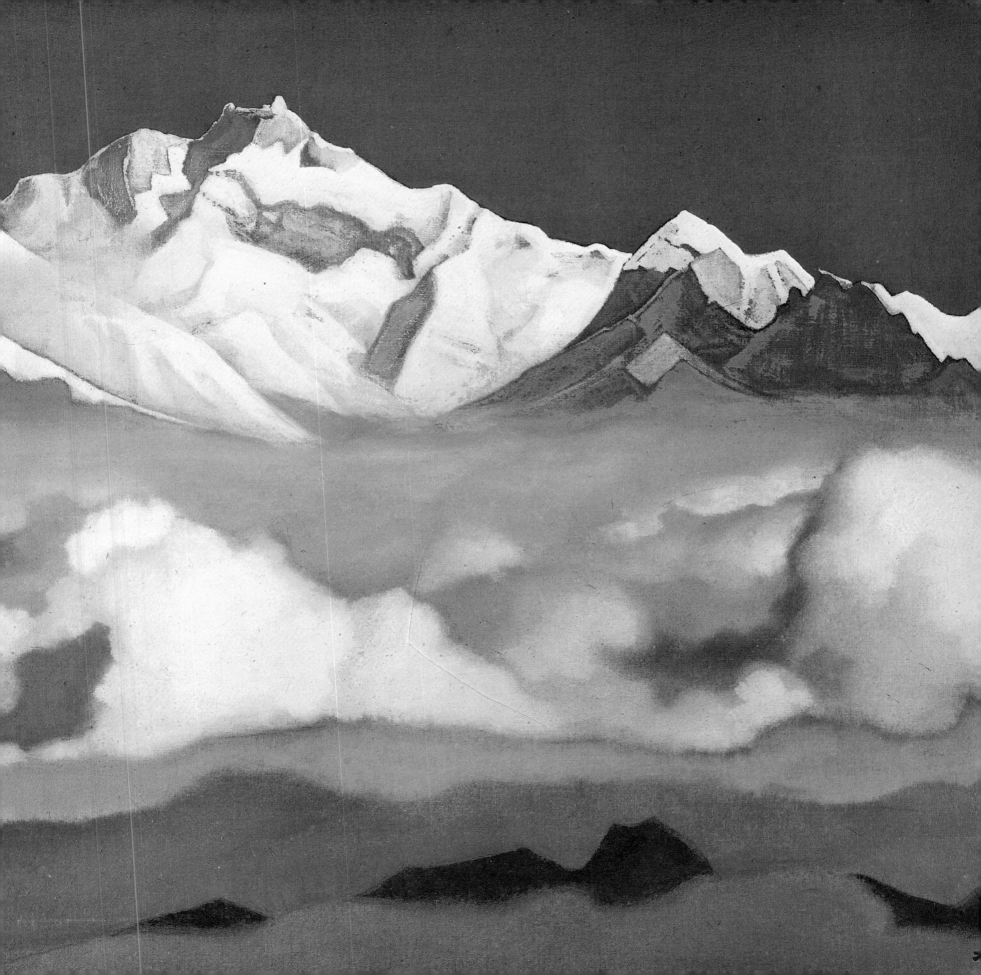

to the classrooms, stood a tiny, bearded, old man in gold-rimmed spectacles and a long black frock coat with a red and yellow handkerchief poking jauntily out of the breast pocket. He would greet each pupil with a handshake. This was Karl von May, and the personal welcome he gave to every pupil was indicative of the way he ran his school, with "obvious respect for the individuality of each pupil," as one graduate, the artist and art historian Alexander Benois, later wrote.[5]

The curriculum was rigorous. Most of the subjects were taught in German, and the pupils, "May bugs" as everyone called them, also studied Latin, Greek, English, and French. Nicholas Roerich was a serious, diligent student and excelled in all his subjects, from algebra to religion, but his favorite was geography, which was taught by von May himself. The professor had his pupils draw and color large maps of countries and continents and sculpt mountain ranges out of multicolored plasticene. The creation of the world's mountains, rivers, plains, and deserts with his own hands fired Nicholas's imagination about faraway, exotic lands. This interest was reinforced and enriched at home; he would listen with rapt attention to the stories told by his parents' guests, the orientalists Golstunsky and Pozdneyev. They spoke of the ancient caravans that used to cross the mountains and deserts of Central Asia, of the rich culture of the nomadic Asian tribes, and of the legendary Asian hero Gesar Khan, a prophet of the future and a defender of his people.

Another family acquaintance who exerted a strong influence on Nicholas was the archeologist L. K. Ivanovsky. Not long after the boy started going to the gymnasium, Ivanovsky came to Isvara. He was conducting excavations of the burial mounds in the Volosovo region and invited Nicholas to come along. The experience of unearthing rusted swords and axes, bronze bracelets, clay shards, and other artifacts that might have once belonged to the ancient heroes of his childhood history books brought the past to life for him and made it a vivid reality. "My very first burial-mound finds," he wrote many years later, "coincided not only with my beloved history lessons, but in my memory lie close to geography and to Gogol's fantastical historical fiction as well."[6] Roerich the boy instinctively sensed the interrelatedness of fields as disparate as archeology and literature—or, more generally, the synthesis of science and art—that would become key to the philosophy of Roerich the man.

The initial thrill of coming into direct physical contact with the earth and with objects of the ancient past developed into a lifetime avocation. While still a "May bug," Roerich asked for and received permission from the Imperial Archeological Society to conduct his own research into archeological sites around Isvara. He went about his work quite professionally, keeping meticulous records of the name, location, and dimensions of each site, and describing his finds in minute detail. He found it helpful to sketch the burial mounds and the objects he discovered in them. With a few strokes of his pencil he could depict accurately the cross-section of a tumulus, the position of a skeleton in it, the shape of a bead, the design of an ornament.

Roerich did not confine himself to collecting and cataloguing archeological artifacts. He also compiled collections of plants and minerals, and even did a study of birds in the St. Petersburg region, cataloguing them by subclass, order, and family. In April 1892 the St. Petersburg Forestry Department authorized him to collect bird eggs for scientific purposes throughout the year in the state-owned forests of the St. Petersburg region.

Even with all these activities, Roerich somehow found time for his favorite sports, horseback riding and hunting. He had begun to hunt on doctor's orders. Every fall, as soon as the Roerichs returned from Isvara to the "St. Petersburg swamps,"* Nicholas would invariably become ill with bronchitis. Finally, after his third year at the gymnasium, the family doctor prescribed a radical cure—to spend time outdoors in the winter—and suggested that he take up hunting. Accompanied by the steward of Isvara, "a bearlike man both in appearance and in his love

* Peter the Great had ordered the construction of the city that bore his name on swampland near the Bay of Finland.

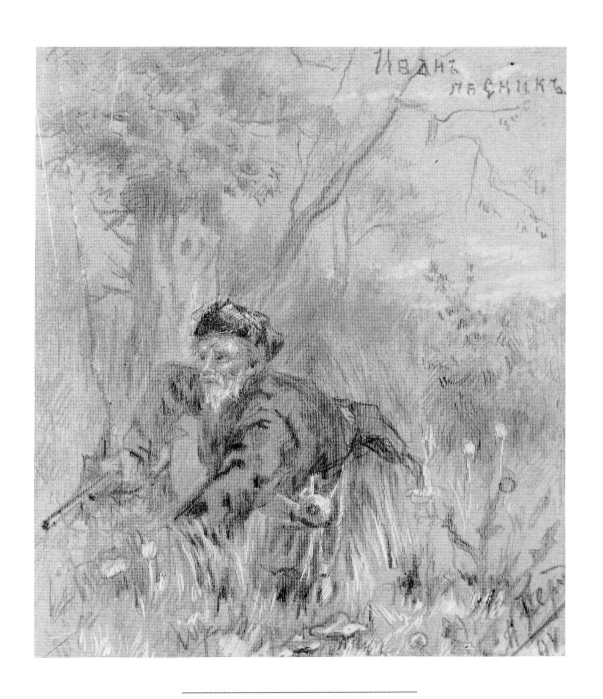

Ivan the Woodsman, 1894.
DRAWING, 4½ X 3¾ IN.

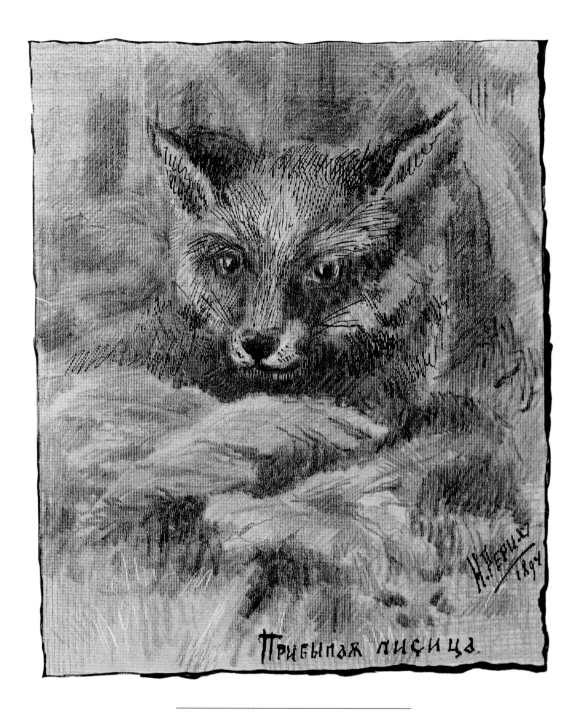

Прибылая лисица.

Young Fox, 1894.
DRAWING, 4½ X 3½ IN.

for hunting and the forest," Nicholas raced after fox on skis, trailed lynx, and sent the estate's foresters in search of bears' dens.[7]

His love of hunting inspired him to write sketches and stories describing the wonders of nature seen by the hunter at all hours and seasons. Unlike the classic Russian work of this genre, Turgenev's *Sportsman's Sketches,* Roerich's youthful essays do not contrast the harmony of nature with the dissonance of human society, but celebrate man's unity and communion with nature. These early literary attempts reveal an unusual sensitivity to visual imagery—the play of light and shadow on trees, for instance, or the precise color of the winter sky.

Some of Roerich's pieces about hunting were published in the magazines *Russian Hunter* and *Nature and Hunting.* One of them was a scathing review of a book about buzzards and crows. With complete command of the subject, and not without a good dose of one-upmanship, the "future professor" cited and corrected every erroneous statement the author had made.

Roerich filled notebook after notebook with his own compositions. In addition to hunting stories, he wrote poems, stories, and plays on such historical Russian themes as Igor's campaign and Olga's revenge for Igor's death.

Nicholas's parents did not discourage him from any of his many interests. They knew that once absorbed in a new endeavor, whether archeology, mineral collecting, or hunting, he would neither abandon it halfway nor let his schoolwork slide. This capacity to find time for a multitude of activities without sacrificing thoroughness or quality in any of them was a trait that remained with Roerich all his life.

Since their eldest son showed promise in such a diversity of areas, Konstantin and Maria Roerich placed no special significance on his artistic talent. The young Nicholas made many drawings: horses and landscapes at Isvara, portraits of friends and of Karl von May, set designs for school performances, sketches of burial mounds and archeological finds, and of course the inventive maps for his favorite geography class. It was yet another friend of Konstantin Roerich, the artist Mikhail Mikeshin, who first recognized Nicholas's gift and encouraged it.★

When Mikeshin discovered that Nicholas had never had formal instruction in drawing, he offered to give him lessons and thus became his first art teacher. Mikeshin also had to intercede on Nicholas's behalf when Roerich announced to his parents that upon graduation from the gymnasium he wished to attend the Imperial Academy of Arts and pursue a career in art. Konstantin Roerich was not pleased by the news and tried to discourage his son from taking such an impractical direction. He had always dreamed that Nicholas would attend the law faculty of the Imperial University and eventually take over his thriving notary office. But with Mikeshin's backing, Nicholas won a compromise: his father would permit him to attend the Academy of Arts on the condition that he simultaneously enroll in the law faculty.

In 1893, at age 18, Nicholas Roerich graduated from Karl von May's gymnasium and passed the required exams for entry into both the Academy of Arts and the law faculty of the famed Imperial University on the embankment overlooking the Neva.

★Mikeshin is best known for the sculptures built according to his designs that are still found all over Russia. He was also a painter, a book illustrator, and the publisher of a journal.

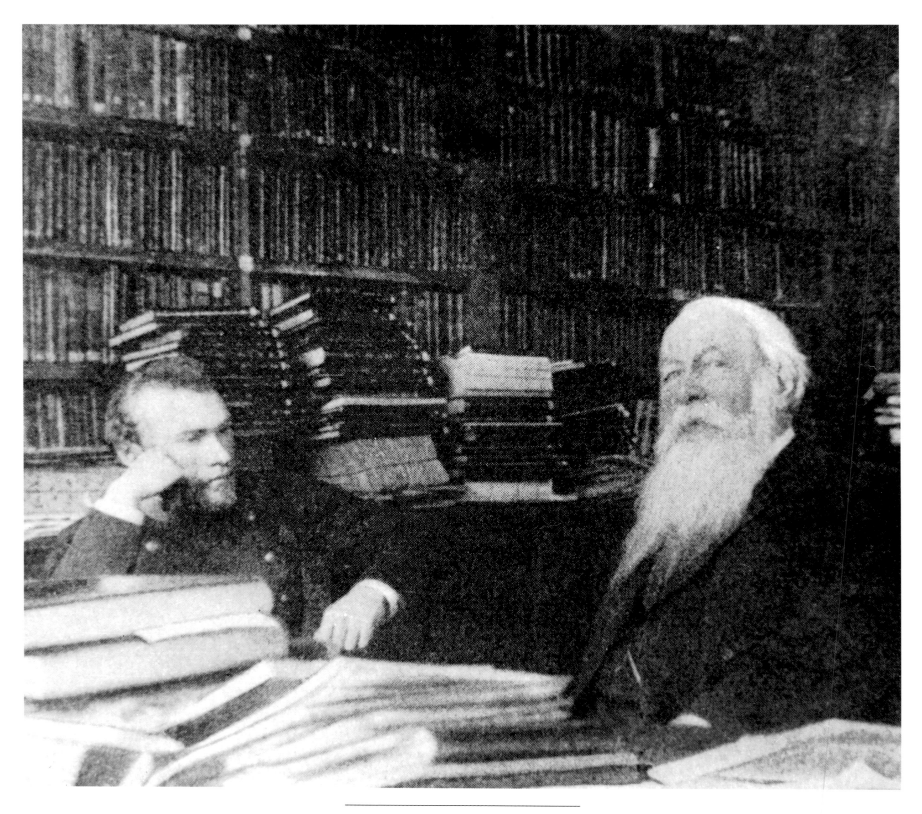

ROERICH WITH VLADIMIR STASOV IN THE SCHOLAR'S OFFICE IN
THE IMPERIAL PUBLIC LIBRARY, ST. PETERSBURG, LATE 1890S.

UNIVERSITY YEARS

When Nicholas Roerich entered the Imperial Academy of Arts in 1893, it was undergoing radical reform, reflecting the general ferment in the arts during the 1890s. In Russian literature, for instance, a new generation of poets led by Valery Bryusov had rejected realism with its strong social message and embraced the aesthetics of European *fin-de-siècle* poetry. Labeled "decadents" by their opponents, but calling themselves symbolists, these young poets espoused art for art's sake and a neo-romantic individualism. They were concerned with refining poetic form, creating verbal music, and achieving a synthesis of beauty and religious truth. An interest in distant times and places is characteristic of many of the Russian symbolists, as is a metaphysical, mystical bent.

"Decadence" was soon to make its mark on the art world as well, with the formation in 1898 of Mir Iskusstva (The World of Art), a group of young artists headed by the art critic and future impresario Sergei Diaghilev. But in 1893 Diaghilev and many of the artists who would rally around him were still students, and the reforms that shook the foundations of the Academy of Art were not the result of student protest but the culmination of a thirty-year battle between the academy's administration and the so-called Peredvizhniki (Wanderers), the leading art movement of the 1870s and 1880s in Russia. The struggle centered on artistic freedom. It began in 1863, when fourteen graduating students staged a rebellion and refused to paint the conventional academic subject that was assigned as their graduation project. They proclaimed as their artistic goal the true-to-life representation of contemporary life. Lacking official recognition by the academy, they organized traveling, or "wandering," exhibitions of their works.

These exhibitions—with their urban genre paintings expressing compassion for the poor and condemning the rich, their scenes of wretched peasant life, their portraits so accurately capturing the sitter's essence, and their landscapes of Russian fields and copses—became so popular that works of the Peredvizhniki gradually began to be shown at exhibitions in the Academy of Arts itself, next to traditional paintings of biblical and classical subjects. Ironically, only in the 1890s, when the popularity of the Peredvizhniki was waning, did the academy administration finally yield to their original demands. The system of assigning one subject to all graduating students was abolished. Each student was now free to choose his own subject for his final project and had more time for independent work. Several of the prominent Peredvizhniki, including Ilya Repin and Arkhip Kuinji, were invited to teach upper-class students in their own studios, and the students themselves chose the professors with whom they wanted to study.

These changes promised to transform the academy from a training school into a much more flexible and creative institution, in which the development of each student's individual talent was encouraged. The inscription over the portico of the magnificent palace that housed the Academy of Arts—DEDICATED TO THE FREE ARTS—had never rung more true.

Little did Nicholas Roerich know, as he rushed from his law classes to his art classes, that the academy reforms would have a profound effect on his own art. He first had to complete the required courses in figure drawing, working from plaster casts of famous ancient sculptures and from live models. He studied figure drawing with Pavel Chistyakov, who was a mediocre artist but unsurpassed as a teacher. Generations of students benefited from his tutelage, including such major artists as Repin, Vasily Surikov, Valentin Serov, and Mikhail Vrubel. In his vivid, folksy idiom he was able to communicate the most perceptive of artistic suggestions. Once he stopped in front of Roerich's easel and said, "Good, only terribly cumbersome (literally, trunk-like)."[1] The point was well made; Roerich tried hard to follow Chistyakov's advice, but his greatest weakness at the outset was his drawing technique.

At the university, in addition to his law and history courses, Roerich became involved with a literary journal, not as a writer but as an illustrator. He also placed illustrations in literary and art journals such as *Zvezda* (The Star) and *Vsemirnaya Illyustratsiya* (World Illustration). He welcomed this work for the money as well as for the experience. Although he was being supported by his father, he did not want to take money from him for art supplies because Konstantin Roerich was as opposed as ever to his son's art studies. Besides illustrating, Nicholas found other ways to earn extra money. He took commissions from several churches to paint icons and wrote articles about art exhibitions for various newspapers.

As in his gymnasium days, Nicholas managed to juggle his time to accommodate all his classes, lectures, and jobs. But in a moment of exasperation he had to admit, "I suppose I'm fated to hurry all my life. I wonder if I'll find time to die."[2] In his intensity and seriousness he differed from most of his classmates at the academy and the university. One of them once said to him, "You know, you're not at all like us academy students. [We] sit around at home before class, drinking tea and gabbing with one another, but you always seem to be working, thinking somehow."[3]

Although Roerich did form several close friendships during his university years, his personality was an enigma to many of his acquaintances. He had an affable, gentle manner, but was very reserved. Some interpreted this reserve as arrogance, others as coldness. The artist Stepan Yaremich, who later knew Roerich well, perhaps made the best analysis of his character:

> He's too reserved by nature. But not reserved in the sense of secretive; Roerich's reserve comes close to solitariness and is expressed in his unusual tactfulness and sensitivity toward people and human relationships.
>
> Once, in conversation, the artist . . . compared himself to a flower that cannot tolerate being touched. The slightest touch and it closes. This is a very accurate analogy. Though he is as trusting and tolerant of people as a child, he will hide in his shell if approached by anyone in the least indelicate way. And that is the end of his sincere openness. What remains is an ordinary relationship, simple and courteous, but at the same time cold and profoundly indifferent. This type of alienation stems in part from an instinctive sense of self-preservation and a fear of losing one's emotional balance, but primarily from mature judgment and an unwillingness to profane one's holy of holies. Personalities like Roerich's are rare and striking for the unity and wholeness of their *Weltanschauung*, which is usually formed at a very early age.[4]

By the time Roerich completed the life drawing course, the academy reforms had gone into effect and the moment had come for him to choose a professor in whose studio he would continue his studies until he graduated. The studio of historical painting was to be led by Repin,

that of landscape painting by Kuinji. Since Roerich was so interested in history and archeology, he was naturally drawn to the genre of historical painting and decided to apply to Repin's studio. He brought some samples of his work to show the great artist. To his delight, Repin said he would be flattered to accept Roerich into his studio, but to his great disappointment, the master informed him that his class was already filled.

A simple class quota problem, therefore, led Nicholas Roerich to the studio of Arkhip Ivanovich Kuinji. Much later Roerich summed up the influence that this renowned painter of hauntingly beautiful, contemplative landscapes came to have on him: "Arkhip Ivanovich became my teacher not only of painting but of all life."[5] He regarded his relationship with Kuinji as similar to the sacred one between master and student, or *guru* and *chela,* as it is known in the East.

Kuinji was born into a poor family of Greek origin and was orphaned early in life. He taught himself to draw, spent most of his meager earnings as a photo retoucher on paints, and tried but failed to pass the entrance exams into the Academy of Art. In 1868, however, one of his paintings was exhibited at the academy and he was given the title of artist. He began to show his paintings at exhibitions of the Peredvizhniki. There was such a demand for his works that he became wealthy. Though he could have lived lavishly, he preferred to give his money away to needy art students, paying for their schooling anonymously so that they did not know where the help was coming from.

His kindness extended to animals and birds as well. In his home he set up an infirmary for birds and cats. Every day at noon he could be found on his roof. As soon as the cannon in the Peter-Paul Fortress boomed, signaling the hour, a cloud of birds would descend upon the roof to feast on the cut-up meat, bread, and grain he provided for them.

This man who had persevered against all odds demanded no less from his students. He was harsh in his criticism but did not impose his own taste on others. After criticizing a student's work, he would customarily soften the blow with a mild comment: "However, everyone is entitled to his own opinion. Otherwise there would be no growth in art."[6]

Kuinji's students were all inspired by his artistic vision and his sense of the unity of land and sea, sun and sky. Wanderlust entered their souls, and in summer they were off to all parts of the earth—Greece, the Crimea, the Baltic Sea, the Arctic Circle—trying to capture on canvas the beauty of its steppes, its sunsets, its northern and southern seas.

Roerich felt a deep resonance with Kuinji's approach to art. "There must be inwardness in a painting," the professor would say. "Composition and technique must be subordinate to this inwardness. Nothing should distract the viewer from the main idea. Do not fill in empty spaces on the canvas with details that have no relation to the subject."[7] These precepts remained central to Roerich's art throughout his career.

Even though Roerich had enrolled in Kuinji's landscape class, his primary interest remained historical painting. In this genre he was most influenced by Viktor Vasnetsov. Whereas Surikov and Repin concentrated on depicting historical events of sixteenth- and seventeenth-century Russia or later, Vasnetsov's subject matter was not merely Old Russia but ancient Russia, "that time when the *bogatyrs* [heroes] of the *byliny* [folk epics] stood guard at the farthest outposts of Kievan Rus, when the air whistled with feathered arrows, not bullets."[8] His aim was not to resurrect the everyday life of the period but rather to pictorialize its legends and fairy tales. Like the other historical painters of his generation, Vasnetsov was painstakingly precise in his attention to detail, down to the brocades of the dresses worn by the princesses of the underground kingdom and the design on the *bogatyrs'* quivers.

The early paintings done by Roerich were highly imitative of Vasnetsov's in theme and in the meticulous rendering of realistic detail. The first painting to bring him recognition was *The Varangian in Tsargrad* (1895), which depicted a long-whiskered Viking warrior in a suit of chain-mail armor leaning on a pole axe. It was praised in

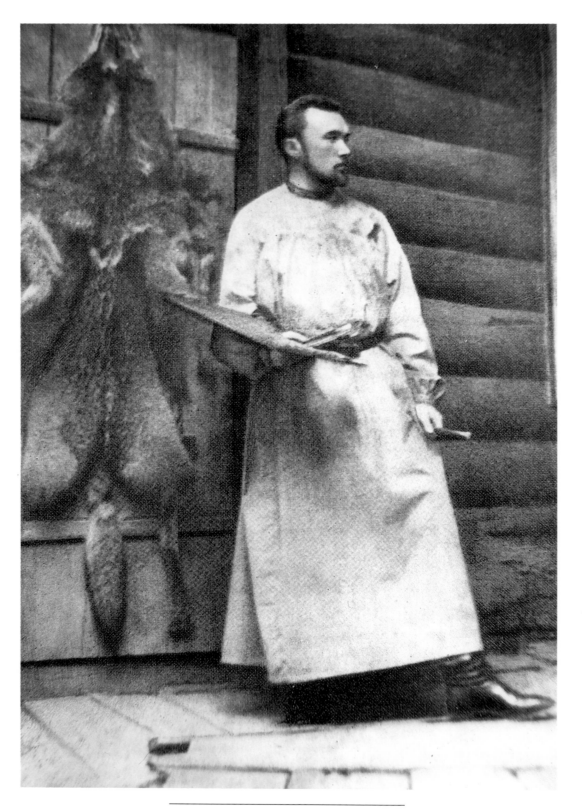

ROERICH PAINTING AT ISVARA, 1897.

the press, and to Roerich's surprise, when it was shown at a student exhibition at the academy an art collector wanted to purchase it. The curator of the academy museum asked Roerich the price. The young artist timidly suggested eighty rubles, whereupon the curator smiled and said, "Consider it sold."

Roerich's research of his favorite historical subjects took him to the Imperial Public Library. There he would spend hours poring over the *Letopis* (the ancient Russian historical chronicle) and the lives of the saints. There too, in 1895, he came to know Vladimir Vasilievich Stasov, an eminent historian and critic of art, music, and literature, who exerted a powerful influence on the artistic life of St. Petersburg for several decades. As head of the library's art department, Stasov welcomed the visits of young artists, composers, and writers to his large office.

The young Roerich, dressed in his student uniform, came to see Stasov for the first time carrying an essay he had written on the meaning of art in contemporary life. Eager to have the scholar's opinion of it, Roerich introduced himself and politely asked Stasov if he would read the manuscript. Stasov glanced through the text and engaged Roerich in conversation. When Nicholas was about to leave the office, Stasov asked if he could hold on to the manuscript and invited him to stop by again soon.

This was the beginning of a long and mutually rewarding, if at times difficult, relationship. Roerich visited Stasov frequently to discuss ethnographic details of his paintings or simply to share his creative ideas. Stasov supported his young friend's interest in ancient Russian history and was impressed by his accomplishments in archeology: while still at the university, Roerich became a member of the Russian Archeological Society and lectured there from time to time on the results of his excavations.

Roerich was captivated by Stasov's theory of the strong ties between ancient Russian culture and that of the East. In 1868 Stasov had published an article, "The Origin of Russian Byliny," in which he maintained that there was an unquestionable similarity between the story lines and images of the Russian folk epics, the Persian epic *Shahnameh,* and the Indian epic *Mahabharata.*

Writing to Stasov on February 26, 1897, Roerich spelled out his plans to do a series of paintings devoted to the founding of the Russian nation and listed twelve titles, each corresponding to an event in the *Letopis.* Had it been completed, the series would have depicted a two-year period in history that had great personal significance for Roerich. In 860 A.D. fighting erupted among the Slavic tribes. In order to restore peace, they decided to seek a prince to rule over them. They went overseas to one of the Nordic nations, the Varangian Rus, and invited the leader of the Rus, Prince Rurik, to become their ruler. The Varangians set sail for the Slavic lands in their great Viking ships and arrived in their new homeland, from then on called Rus, or Russia, in 862. This peaceful union of the Slavs and the Nordic Varangians closely paralleled Roerich's own heritage.

But Roerich finished only one of the paintings in this ambitious series: *The Messenger: Tribe Has Risen Against Tribe* (page 18). It depicts an old messenger sitting in a wooden boat. His stooped back and lowered arms convey sadness and concern; he is bearing news to a neighboring settlement that the tribes are at war. It is night and all is quiet. The young moon illuminates the white shirts of the messenger and the oarsman, who is standing as he rows up the river. In the distance the outline of a Slavic settlement nestled in the hills is barely visible in the darkness.

The Messenger was the work Roerich submitted as his graduation project at the academy. He worked on it with his usual thoroughness and discipline, checking every minute detail with Stasov. Nevertheless, it is not the archeological accuracy or the historical atmosphere that rivets the viewer, but the mood of anxiety and mysteriousness that suffuses the painting.

The Messenger is unlike Vasnetsov's idealized, fairy tale-like rendering of ancient Russia, and it does not resemble the action-packed, photographically realistic genre scenes of the Peredvizhniki. Although it belongs to the genre of historical painting, its technique, its somber dark palette, and its spiritual "inwardness" give it the stamp of Roerich's adherence to Kuinji's studio. In this work, then, Roerich achieved a new synthesis of historical and landscape painting.

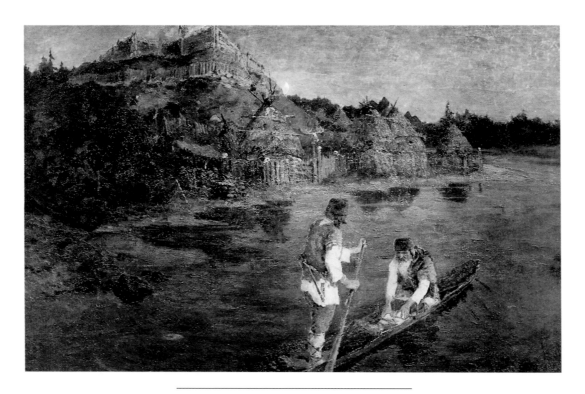

The Messenger: Tribe Has Risen Against Tribe, 1897.
OIL ON CANVAS, 49 X 72½ IN.
TRETYAKOV GALLERY, MOSCOW.

In 1897, while Roerich was busily developing the plan for his "Slavic Symphony" series, tension was growing between the academy students and the staff. The conflict began when the rector of the academy, a powerful, abrasive man, spoke to one of the students so rudely that a meeting of the entire academy was called and the students demanded that the rector apologize to the student. The teachers adamantly opposed this demand. The students then declared a strike and began boycotting their classes. At one of the striking students' gatherings Kuinji appeared and urged them to end the strike and go back to their classes.

The administration, enraged to learn that Kuinji had attended a student meeting, removed him from his teaching position and suggested that he submit his resignation. His friends were indignant and advised him not to give in, but Kuinji left the academy, as did his students, including Roerich.

The renegade "Kuinjists" were nevertheless included in the graduation ceremonies later that year, and their paintings were shown at the exhibition of graduating students' works in the academy museum. The long-awaited day finally arrived: November 4, 1897, the anniversary of the founding of the academy. The conference secretary, in full-dress coat complete with sword, stood and gave an account of the academy for the year. Then he read off the names of the students who had been awarded the title of artist. Roerich's name was among them. As the graduates were receiving their diplomas, Arkhip Kuinji entered the hall. His appearance was greeted with a deafening ovation. Everyone who had seen the exhibition had to admit that its best paintings were the work of Kuinji's students. *The*

Messenger was singled out for particular recognition by students, critics, and art collectors alike.

Sergei Diaghilev, in his review of the exhibition for the newspaper *Novosti,* called it one of the most interesting works in the exhibition and noted a legend-like quality that distinguished it from the other historical paintings. It was one of only three paintings in the exhibition chosen by the prominent collector Pavel Tretyakov for his renowned gallery in Moscow.

Stasov was enraptured by the painting and told his protégé, "You must visit Tolstoy. What do I care about all your diplomas and honors. Let the great writer of the Russian land himself promote you to the rank of artist. Now that will be recognition. And no one will appreciate your *Messenger* as much as Tolstoy. He will grasp at once the news with which your 'messenger' hastens. There's no point in delaying it. In two days Rimsky-Korsakov and I are going to Moscow. Come with us!"[9]

Roerich went, bringing with him a large photograph of the painting. Tolstoy's reaction to it proved Stasov correct. The great man not only approved of the painting but saw in it a parable:

> Have you ever crossed a rapidly flowing river in a boat? It is always necessary to steer higher than the spot toward which you are headed, otherwise you will be taken downstream. So, too, in the sphere of moral demands it is always necessary to steer higher—life takes everything downstream. Let your messenger hold the helm high, then he'll reach his destination."[10]

The Messenger earned Nicholas Roerich more than the title of artist; it secured for him a place in the history of Russian art.

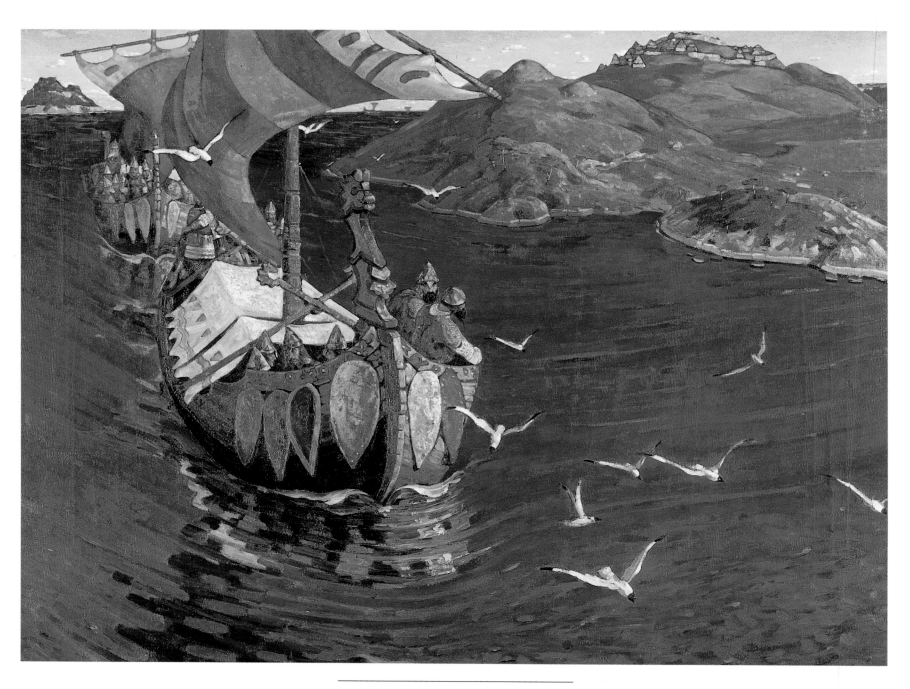

Overseas Guests: A Folk Painting, 1901.
OIL ON CANVAS, 33½ X 44¼ IN.
TRETYAKOV GALLERY, MOSCOW.

THE WORLD OF ART

The unanimous praise accorded Roerich's *Messenger* in 1897 belied the growing schism between the Peredvizhniki, whose most ardent spokesman was Stasov, and Mir Iskusstva, the group of young artists headed by Diaghilev. Like his contemporaries, the Russian symbolist poets, Diaghilev championed the aesthetics of *fin-de-siècle* Europe, from Impressionism and Post-Impressionism to art nouveau.

To introduce Russia to contemporary European art, Diaghilev organized an exhibition of German and English watercolorists at the beginning of 1897 and one of Scandinavian painters in the fall of that year. The following January he mounted an exhibition of Russian and Finnish artists, at which some of the founding members of Mir Iskusstva were represented, and in November 1898 he published the first issue of the journal *Mir Iskusstva*. Devoted to art, literature, and music, the journal became the forum for the views of the new generation. Their position was articulated in the first issues by Diaghilev; he advocated art for art's sake and rejected the socially directed art of the Peredvizhniki. Alexander Benois later recalled how alienated the Mir Iskusstva group had become from their predecessors: "We instinctively longed to leave behind the backwardness of Russian artistic life, to free ourselves from our provincialism, and to move toward the cultured West, toward the purely artistic quests of the foreign schools, as far as possible from the hackneyed tendentiousness of the Peredvizhniki, from the helpless dilettantism of pseudo-innovators from our worn-out Academism."[1]

Initially, *Mir Iskusstva* was subsidized by two patrons of the arts, the railroad magnate Savva Mamontov and Princess Maria Tenisheva, a collector of folk art and an artist in her own right. Mamontov was already renowned in the art world for the artists' colony he had established at Abramtsevo, his country estate near Moscow. Artists, musicians, and singers were invited to live and work there as well as in Mamontov's Moscow residence. He is credited with discovering Fyodor Chaliapin; the celebrated basso was featured in many of the operas produced in Mamontov's theater. Artists such as Vasnetsov, Vrubel, and Izaak Levitan were commissioned to design the sets for these productions.

Princess Tenisheva would soon transform her estate, Talashkino, into an artists' colony as well. Like Abramtsevo, Talashkino became a center for the revival of the applied arts, from furniture design and lace making to theater decor and icon painting.

In January 1899 Diaghilev and the other founders of Mir Iskusstva (the "Miriskusniki") organized their most ambitious exhibition to date, "The Mir Iskusstva International Exhibition of Painting." It presented works by contemporary French, English, German, Finnish, Norwegian,

Belgian, Italian, and Swiss artists, as well as a broad range of Russian painters, including not only the Miriskusniki but some of the foremost Peredvizhniki. The eclectic nature of the paintings demonstrated the organizers' interest in purely aesthetic issues rather than ideological content. Stasov, who was enraged by the strong anti-Peredvizhniki stance of the journal *Mir Iskusstva,* lashed out at the organizers of the exhibition in a series of newspaper articles. He labeled them "decadents" and criticized most of the paintings they had selected for the exhibition.

Roerich was caught in the middle of the battle between the Stasov group and the Diaghilev group. The founders of Mir Iskusstva were his contemporaries—Diaghilev had been two classes ahead of him at the law faculty; Alexander Benois, Konstantin Somov, and Dmitry Filosov (Diaghilev's cousin) were former classmates at the gymnasium—and he shared their love for the art of the past and their interest in the new trends in western European art. He had a great appreciation for the work of some of the young Russian artists, especially Vrubel, and like Diaghilev he was interested in exhibiting Russian art in western Europe. So, to Stasov's disappointment, Roerich did not join him in his fight against the "decadents." Yet, Nicholas did not abandon his mentor either. He became assistant to the editor-in-chief of Stasov's own journal, *Art and Artistic Industry,* and regularly contributed articles about the St. Petersburg art scene to it. To underscore the independence of his opinions and his lack of affiliation with any group, Roerich wrote these pieces under the pseudonym R. Izgoy.★

The reaction to Roerich's paintings of this period was symptomatic of the widely divergent artistic camps that were forming. When his *Meeting of the Elders* was shown in the annual spring exhibition at the Academy of Arts in 1899, it elicited both high praise and sharp criticism. Like *The Messenger,* this painting is set in ancient Russia. A group of elders has gathered around an idol in a forest clearing. The sky has just begun to turn light; the figures themselves are cloaked in semidarkness. Their faces are indistinct, but from their calm poses it is clear that they are involved in quiet, serious discussion of the important matter that has brought them to this holy spot. The painting is executed in broad, free brush strokes and imparts a strong sense of mystery through an economy of means: the unity of coloring, and the semidarkness concealing the outline of the figures.

The critic M. Dalkevich, who wrote reviews for *Art and Artistic Industry,* considered *Meeting of the Elders* the most significant work in the exhibition. Others who praised it included Vasnetsov, Surikov, Kuinji, and Repin—all of them Peredvizhniki. Benois, on the other hand, wrote that Roerich lacked the gift of historical insight, that he had not yet found his niche, and that if he thought he had depicted prehistoric Russia convincingly he was sadly mistaken, because in fact the painting was boring and strained.[2] Roerich himself agreed with Stasov, who found fault with the drawing technique. The young artist was dissatisfied with both the technique and the composition, but he did feel that if the work had any strength, it was historicity.[3]

Another painting that provoked a critical controversy was *The Campaign* (1899). In its attention to realistic, almost naturalistic detail, it comes closer to conventional historical painting than *The Messenger* or *Meeting of the Elders,* but there Roerich's nod in the direction of tradition ends. In *The Campaign* we see a contingent of Old Russian troops trudging dejectedly through dirty snow, their backs to us, their heads lowered, their fur coats worn and bedraggled, their heavy red shields seeming to weigh them down. Their path extends to the horizon, giving the impression that their trek is endless and perhaps futile.

Since the painting had a stylistic resemblance to the historical paintings of the Peredvizhniki, Stasov might have been expected to be delighted with it. But the scholar criticized it on ideological grounds, disapproving of its melancholy mood and the soldiers' lack of courage and enthusiasm. Kuinji also had reservations about it. Dalkevich, however, praised *The Campaign,* noting that "you cannot approach this painting with established 'measuring sticks,' which is especially disturbing to those connoisseurs accustomed to using them." The critic was particularly impressed with Roerich's ability "to convey

★ In Russian, *izgoy* means "social outcast" or "recluse."

22

NICHOLAS ROERICH AROUND THE TURN OF THE CENTURY.

voked conflicting reactions, but they both reflected Roerich's continuing passion for ancient Russian themes. Even his final thesis at the law faculty dealt with this subject. It was entitled "The Legal Position of Artists in Old Russia," and it won him his diploma in 1898. After he graduated, he not only took the editorial job at *Art and Artistic Industry* but, with Stasov's help, became the assistant director of the museum of the Society for the Encouragement of the Arts. As if that were not enough, the same year he gave a series of lectures at the Petersburg Archeological Institute, called "Artistic Technique Applied to Archeology." The lectures were much broader than this utilitarian title suggested. They dealt with the origin of art, the importance of archeological research for contemporary art, and the inseparability of science and art. He took issue with the view of orthodox historians that art in Russia began with Christianization; rather, he maintained, art had its beginnings in prehistoric times, and its origin was nature itself. He cited as examples of prehistoric art the artifacts uncovered by archeological research—remains of cities and dwellings; jewelry; toys; articles made of stone, metal, and bone; ceramic ornaments—all of which signified to him the harmoniously integrated life of the ancient tribes. He saw in these artifacts an inexhaustible source of motifs for contemporary art to draw on. Roerich not only taught these ideas; they were central to his life and art.

the spirit of an entire historical era in such a way that it has a distinct mood, something rarely encountered in multivolume historical novels and monographs."[4]

Diaghilev liked the painting well enough to reproduce it in one of the issues of *Mir Iskusstva*. He also invited Roerich to participate in the next Mir Iskusstva exhibition, but Roerich refused; he had already promised *The Campaign* to the organizers of the next spring exhibition at the academy. Diaghilev's invitation interested him nevertheless, and in his diary he mused about the consequences if he were to accept: "I can imagine what a scandal it would cause—Stasov would howl and many people wouldn't know what to think."[5]

Meeting of the Elders and *The Campaign* may have pro-

In St. Petersburg, as in most major European cities at the turn of the century, cultural life was booming. Musical, literary, and art salons thrived. The symbolists met regularly at Vyacheslav Ivanov's apartment, "The Tower," for poetry readings and philosophical discussions. A famous "watercolor" salon was held on Thursday evenings in the magnificent Italian Renaissance studio of the artist Ekaterina Zarudna-Cavos. Such luminaries of the art world as Repin, Kuinji, and Chistyakov, who was Zarudna-Cavos's teacher, often attended these "Thursdays." The guests would draw nude models or portraits. Not only professional models posed, but the artists' acquaintances as well. At the end of the evening the model was permitted to choose the portrait he or she liked best as a souvenir.

Roerich participated in these evenings from time to time. He also frequented the music salon of Mitrofan Belyaev. A passionate music lover all his life, Belyaev had made a fortune in the timber industry, finally giving up his business to move to St. Petersburg and devote himself entirely to music. He organized a small ensemble of musicians, in which he himself played the viola, and gave concerts in his home on Friday evenings. Everyone in St. Petersburg's musical world came to Belyaev's "evenings," including the composers Rimsky-Korsakov, Anatoly Liadov, and the young Alexander Glazunov.

In 1898 Wagner's operas were performed in St. Petersburg for the first time since the 1860s. Roerich did not miss a single performance. He felt a strong natural affinity for the composer's use of ancient Germanic and Nordic legends and was dismayed by the vehement criticism of the operas in the Russian press. He later wrote, "It is horrifying to recall that people who considered themselves cultured thundered against Wagner and considered his music cacophony. Evidently, every great accomplishment must go through the crucible of negation and mockery."[6]

Roerich's involvement in the salon life of St. Petersburg widened his circle of acquaintances considerably. Among his new friends were the Schneider sisters, Varvara and Alexandra. Stasov had introduced Nicholas to them because they too were artists and had a great interest in Russian folk art. Roerich would sometimes spend entire days in their living room, where other artists, scholars, and literary people would gather to exchange the latest news of the art world and discuss the most recently published books. The Schneider sisters encouraged their guests to fill out the questionnaire book that always lay on a table in their living room. Books of this kind were popular in the second half of the nineteenth century; theirs was published in London and was called *Confessions: The Album to Record Opinions, Thoughts, Feelings, Ideas, Peculiarities, Impressions, Characteristics of Friends*. Between 1885 and 1906, some eighty people recorded their answers to the curious series of questions, among them Nicholas Roerich. His entry is dated 31 May 1900; he was then twenty-five. The questions were given in English, his answers in Russian:

Your favorite virtue: indefatigability

Your favorite qualities in a man: talent, a defined goal

Your favorite qualities in a woman: femininity

Your favorite occupation: [my] work

Your chief characteristic: wanderer

Your idea of happiness: to find one's path

Your idea of misery: to be misunderstood

Your favorite colour and flower: violet (ultramarine, Krapplack [madder lake], Indian yellow)

If not yourself, who would you be? traveler-writer

Where would you like to live? in my native land

Your favorite poets: A[lexei] Tolstoy

Your favorite prose authors: L. Tolstoy, Gogol, Ruskin

Your favorite painters and composers: Beethoven, Wagner, Glinka, Borodin, Rimsky-Korsakov, V. Vasnetsov

Your favorite heroes in real life: Leonardo da Vinci, *skhimnik* [a monk under the most austere vow]

Your favorite heroines in real life: [left blank]

Your favorite heroes in fiction: Don Quixote

Your favorite heroines in fiction: [left blank]

Your favorite food and drink: *kvas* [a beer-like fermented beverage], very rare (alas) roast beef

Your favorite names: Elena, Tatyana, Nina, Ingegerda, Roman, Rostislav, Arseny

Your pet aversion: vulgarity and smugness

What characters in history do you most dislike? Peter the Great

For what fault have you most toleration? passion

Your favorite motto: "Forward, without looking back!"[7]

This self-evaluation reveals a young man who had a

clear idea of who he was and where he was headed. The future would bear out the remarkable self-understanding of Roerich's answers. He would indeed become a wanderer and a traveler-writer in addition to being an artist. He would continue to be indefatigable in all his pursuits. He would marry a woman of great femininity named Elena. He would combine the seemingly contradictory traits of a Renaissance man (Leonardo da Vinci) and a reclusive monk *(skhimnik)*. In his painting he would come to favor the pure, intense, symbolically rich colors he listed. He would find his path but would be misunderstood by many along the way. Only one of his ideals was not to be fulfilled: he was not destined to live out his life in his native land.

One of the first trips the traveler-writer took was a steamship journey in the summer of 1899 from St. Petersburg to Novgorod, following part of the great river route that the Varangians had taken in their Viking ships more than one thousand years before. In his mind's eye, Roerich could see these mighty vessels sailing along the Neva, the Volkhov, and the Dnieper, and across the Black Sea all the way to Tsargrad (Constantinople). His imagination was somewhat impeded, however, by the sight of tastelessly built modern towns and villages on the banks of the rivers and by the sorry state of repair in which he found so many of the ancient churches. The restoration he did observe appalled him; the restorers' artistry was far inferior to that of the masters who had painted the original icons and frescoes.

Roerich recorded his impressions of this trip in an essay, "On the Route from the Varangians to the Greeks" (1900). In it he voiced his outrage at the neglect of the ancient Russian churches and the lack of appreciation for them. The preservation of churches and other landmarks of Russia's—and the world's—rich cultural heritage became a cause to which he would devote much of his writing, many of his paintings, and a good part of his life.

Later that same summer the Russian Archeological Society sent Roerich to the Pskov, Novgorod, and Tversk regions to study ancient architecture. On the way he stopped off in Bologoye, at the country estate of Prince Putyatin, a well-known archeologist and expert on the Stone Age in Russia. While Roerich waited in the vestibule for a servant to announce his arrival, an attractive young woman with thick, beautifully braided hair appeared and warmly invited the visitor into the dining room. She was Elena (Helena) Ivanovna Shaposhnikova, Princess Putyatina's niece. Many years later she would recall her first meeting with Nicholas Roerich. She had gone to the bathhouse, as she did every Saturday, and upon her return had encountered a young man with a flaxen beard, whom she took for a surveyor. Only later, over tea, did she learn that he was an artist.[8] For both of them, the meeting was as pleasant as it was unexpected, and Roerich spent the next several days in Bologoye.

Helena and her mother, Ekaterina Vasilievna Shaposhnikova, lived in St. Petersburg but spent almost every summer at the Putyatin estate. Her father, the late Ivan Ivanovich Shaposhnikov, had been an architect. Helena was descended from a long line of Tatar princes. Her mother, née Golenishchev-Kutuzov, was the granddaughter of Mikhail Kutuzov, the great field marshal who had led the Russian army against Napoleon and was subsequently immortalized in Tolstoy's *War and Peace*. Modest Mussorgsky was another prominent relative.

Helena was a gifted pianist and had a lively interest in art. Roerich was instantly smitten by her charm and intelligence. His affection for her continued to grow throughout the fall of 1899. He visited the Shaposhnikov home, where he was always cordially received, and wrote to Helena often, sometimes several times a day. She was five years younger than he, and at the age when young women of her standing were introduced into society. Roerich had to contend with rival suitors. When he learned that a certain fellow named Molvo had been visiting the Shaposhnikovs "with intentions," he immediately wrote to Helena: "At our gymnasium there was someone named Molvo—I wonder if he's the one? That one was a scoundrel."[9]

By November he was deeply in love. As he wrote in his diary: "Today E. I. [Elena Ivanovna] was in the studio. I am afraid for myself—there are so many good things about her. Again I am beginning to want to see her as

often as possible, to be where she is."[10]

Early in 1900 Roerich proposed to Helena and she accepted. Their marriage plans had to be postponed, however, because Konstantin Roerich had become gravely ill with a heart ailment. By the summer his condition had worsened, and he was hospitalized at the end of June. Roerich's relationship with his father had been strained for a long time; nevertheless, he was deeply upset by his father's illness and visited him regularly in the hospital. Konstantin Roerich seemed to be recovering well until one morning he simply failed to wake up.

In *Diary Leaves,* Roerich writes briefly of his father's final illness. The passage portrays Konstantin Roerich as a rather bitter, lonely man and reveals much about Nicholas's ambivalent feelings toward him:

> My father didn't like to undergo medical treatment. For a long time his doctors had demanded that he take a rest. But he didn't know life without work. They asked him not to smoke or to cut down on his smoking, because he was in danger of nicotine poisoning, but he responded: "If you smoke, you die; and if you don't smoke, you die.". . . Much went unsaid. There were probably some disappointments. His friends died earlier than he and new ones did not appear. There were some ruined plans. His greatest dreams were not realized. Few people, perhaps no one, knew what his heart ailed from.[11]

After Konstantin Roerich's death, Maria Roerich sold Isvara. With his inheritance, Nicholas was enabled to fulfill a long-cherished dream—to study art in Paris. He wanted to combine work with pleasure and turn the trip into a honeymoon, but he could not afford a lengthy stay abroad with Helena, so the marriage was postponed once again.

Roerich left for Paris in September 1900, by way of Berlin, Dresden, and Munich. He rented a large, modestly appointed studio in Montmartre and set to work. He was not in the least attracted by the bustle of the Parisian boulevard scene or by the Impressionists who captured its fleeting charms. Instead, as he himself admitted, he lived in Paris as in a monastery. From 9:00 A.M. to 5:00 P.M. he did not step away from his easel. Certain hours were set aside for studying French and English and visiting the city's museums. He arrived in time to attend the landmark Universal Exhibition, which ushered in the twentieth century and at which his own *Meeting of the Elders* was shown.

The contemporary French artists whose works had the greatest impact on him were Gauguin, whose depiction of subject matter and use of color he found an affinity for; Degas; and especially the muralist Pierre Puvis de Chavannes (1824-98), a central figure in the Symbolist movement of the 1880s and 1890s. Roerich was particularly impressed by Puvis's murals depicting the history of St. Geneviève in the Panthéon. He found in them strong parallels to his own artistic ideals. "The more I examine his works," Roerich wrote in a letter at the time, "the more I hear about his method of working, his life, and his habits, the more I am amazed by the great similarity with much of what is in me."[12] Indeed, Puvis de Chavannes's monumental paintings, with their peacefully laboring figures silhouetted against idealized landscapes, the "decorative rhythmicality" of their composition, their flat areas of color, and the emotional rather than realistic evocation of their subjects, had a powerful influence on the direction Roerich's art would take.

Of the many art studios in Paris, Roerich chose to enroll in the studio of the historical painter Fernand Cormon, for two reasons. First, he knew that the man was an excellent teacher at the peak of his powers, counting Van Gogh and Toulouse-Lautrec among his former students. Second, Cormon's own favorite subjects, like Roerich's, were the legendary past—the Nordic and Indian epics—and the life of prehistoric man.

Cormon had the reputation of being merciless in his criticism of his students' work and especially exacting about drawing technique. Under his tutelage, Roerich's drawing improved dramatically, becoming much more assured and precise. Cormon also recognized and encouraged the distinctly Slavic flavor of his Russian student's work. "Nous sommes trop raffinés," he said to Roerich, "and you should go your own way. We will learn from

you. You have so much that is beautiful."[13] This "overly refined" Frenchman's appreciation of the originality and vibrancy of Russian art anticipated by only a few years the veritable craving for Russian culture that would be fueled by Diaghilev's famed Russian Seasons in Paris.

Bolstered by Cormon's enthusiastic support and bursting with newfound confidence in his technique, Roerich began to paint in a much bolder, brighter, and more colorful manner. His acquaintance with the works of contemporary European artists contributed to the brightening of his palette and to the decorativeness of his composition. The first work done in this new style was *The Idols* (page 28). The idea had come to him before his departure for Paris, but he executed the painting in his Montmartre studio. The setting is a place of pagan prayer and sacrifice atop a high hill in prehistoric Russia, overlooking a deep blue river that winds its way through green hills beneath a cloudy sky. The sacred site is enclosed by a circular fence of sharpened logs on which horses' skulls have been speared. Inside the fence, a group of tall idols, crudely carved out of wood and sparsely decorated with colored ornamentation, towers menacingly above a large gray stone. Gone are the dark tones of *The Messenger* and *Meeting of the Elders;* the whole scene seems bathed in pure, cool morning light. The decorative element in this painting is as important as archeological authenticity; the severity and power of the prayer site, with its strong, rhythmically repeating verticals (fence posts, horses' skulls, and idols), are beautifully balanced by the gentle, soft curves of the hills, river, and clouds, suggesting that this man-made spot coexists harmoniously with nature.

Roerich himself was pleased with the painting and described it quite succinctly. "[*The Idols*] gladdens me," he wrote in his diary, "it's strong, vivid, there's no drama in it, no sentimentality, but there is a robust pagan mood."[14]

Roerich completed several other works on ancient Slavic subjects during his year-long stay in Paris and returned to Russia full of ideas for new paintings in the summer of 1901. Upon his arrival in St. Petersburg, he rushed to the Shaposhnikov home and was joyfully reunited with his beloved Helena. On October 28, 1901, in the church of the Imperial Academy of the Arts, at 6:00 P.M., Nicholas Konstantinovich Roerich and Helena Ivanovna Shaposhnikova became man and wife. She would be his "companion and inspiration" for the rest of his life, and he called her "Lada," an old Russian word that to him connoted a combination of "harmony, inspiration, and strength."[15]

The newlyweds moved in with Nicholas's mother. In order to support his young bride, Roerich applied for the position of secretary of the Society for the Encouragement of the Arts, having been the assistant director of the society's museum before his Paris trip. There were several candidates for this responsible, prestigious post, which entailed overseeing the society's business affairs, but to the dismay of the other candidates, all much older and with greater seniority than Roerich, it was offered to the twenty-six-year-old artist. He was hired in quite a curious way. The chairman of the society's financial committee interviewed him for several hours. In the course of their talk, the man rattled off a long list of figures. At the end of the meeting, he asked Roerich to prepare the society's annual budget in three days, using the figures that he had mentioned. Roerich had not taken any notes, assuming that if he got the job, he would be given access to the information. He was mistaken, however; the financial committee chairman had no intention of providing him with any documentation. Roerich nevertheless submitted his budget proposal to the committee in the allotted time, and the secretarial post was his.

Roerich proved to be an effective and energetic administrator, despite the resentment some members of the society's council harbored about his appointment. Fortunately, he won the support of the president of the society, Grand Duchess Evgenia Maximilianovna, who supported the exhibitions and lectures he helped organize and the young, more broad-minded teachers he suggested for appointment to the society's school.

His duties at the society kept him busy, but as always, Roerich found time to paint and continue his archeological studies. He finished works begun in Paris and started new ones, in which the features of his mature style became more clearly defined. The theme of these works was

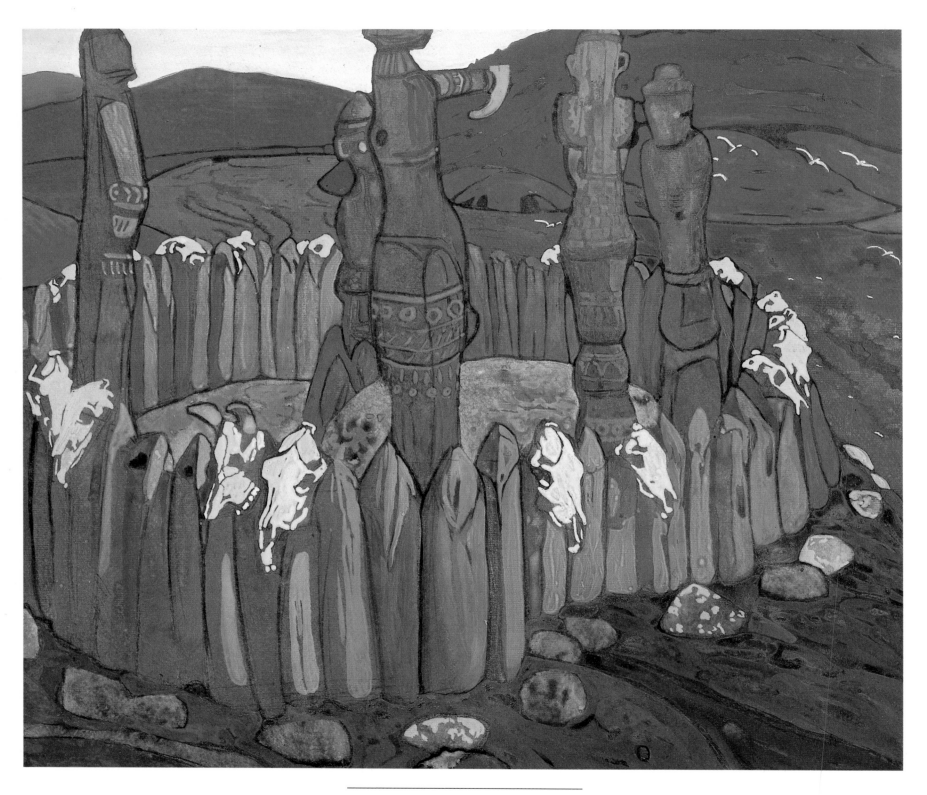

The Idols, VARIANT, 1901.
GOUACHE ON BOARD, 19¼ X 22¾ IN.
STATE RUSSIAN MUSEUM, ST. PETERSBURG.

still ancient Russia, but his treatment became more generalized and subjective. No longer did he strive to render objects and events as the human eye sees them, but as his creative impulse dictated. An example is *Ominous Ones* (1900), which depicts a flock of ravens perched on rocky cliffs above a dark, gloomy sea. Everything in the painting, from its dull, gray-green coloring to the folkloric use of ravens as heralds of trouble and misfortune, works to convey a mood of impending disaster.

The dark coloring, so effectively used in *Ominous Ones*, was, however, more typical of Roerich's early paintings than of his post-Paris works. Indeed, with every passing year his canvases became more and more saturated with intense, brilliant color. The first major work in which this explosion of color erupted was *Overseas Guests: A Folk Painting* (1901), a paean to the ninth-century Varangians who came in their great ships to bring peace to the feuding Slavic tribes (page 20). Roerich had conceived the idea for the painting several years before. In fact, the opening of his essay "On the Route from the Varangians to the Greeks" comes very close to a description of it.

> The Northern guests are sailing. The gently sloping shore of the Bay of Finland extends in a bright stripe into the distance. It is as if the water were impregnated with the azure of the clear spring sky; the wind ripples it, creating opaque-violet bands and circles. A flock of seagulls has descended upon the waves and rocks on them without a care, and only those in the very path of the first ship's keel flash their wings. . . . The ships sail in a long row; their bright colors sparkle in the sun. Their bows, topped with tall, slender dragons, turn dashingly. Red, green, yellow, and blue bands [of ripples] form alongside the ships. The dragons' mouths are red, their necks are blue, their crests and feathers green. On the wooden keels not an empty space can be seen; they are entirely covered with carving: crosses, dots, and circles are interwoven in the most intricate design. . . . On the sides of the ships near the bow
> and stern, shields are hung. They sparkle in the sun. The colorful sails cause fear in their enemies; red circles and designs are sewn on the white upper edges; the sails are rarely of one color—more often they are striped either horizontally or vertically, as the case may be. The middle of the ship is draped with a cloth covering that is also striped . . . the masts are supported by crossed wooden beams carved in a beautiful design—in rain or heat the oarsmen can sit freely under the covering.[16]

Nearly every detail of this description may be found in the painting as well, but the eye does not stop on any one of them. Rather, it follows the smooth course of the ships around a bend in the dark blue river. The objects and colors are archeologically accurate, but accuracy is subordinate to sheer decorativeness.

The subtitle, *A Folk Painting,* suggests that Roerich drew on motifs and colors of folk art in this gloriously vivid, sun-drenched work. Indeed he had; ships with dragon figureheads, red sails, and dark blue rivers are images that filled the works of Old Russian icon painters and masters of the applied arts. Yet Roerich was far from being blindly imitative; like so many of the young artists at the turn of the century, he endowed the aesthetics of the past with an entirely new sensibility. *Overseas Guests* is a celebration of the ancient Nordic spirit, and in its sensuously curving lines, large blocks of brilliant color, and decorative handling of objects and figures, it is a triumph of the modern artistic spirit. When it was shown at the 1902 Academy of Arts exhibition, it was acquired by Tsar Nicholas II himself for the imperial palace at Tsarskoe Selo.

That same year, Roerich finally accepted Diaghilev's offer to take part in the annual Mir Iskusstva exhibition. He also participated in the 1903 exhibition, which proved to be the penultimate one, for in 1904 the journal *Mir Iskusstva* was closed down and the organization, which had had such a profound effect on the course of Russian art during its short existence, disbanded.

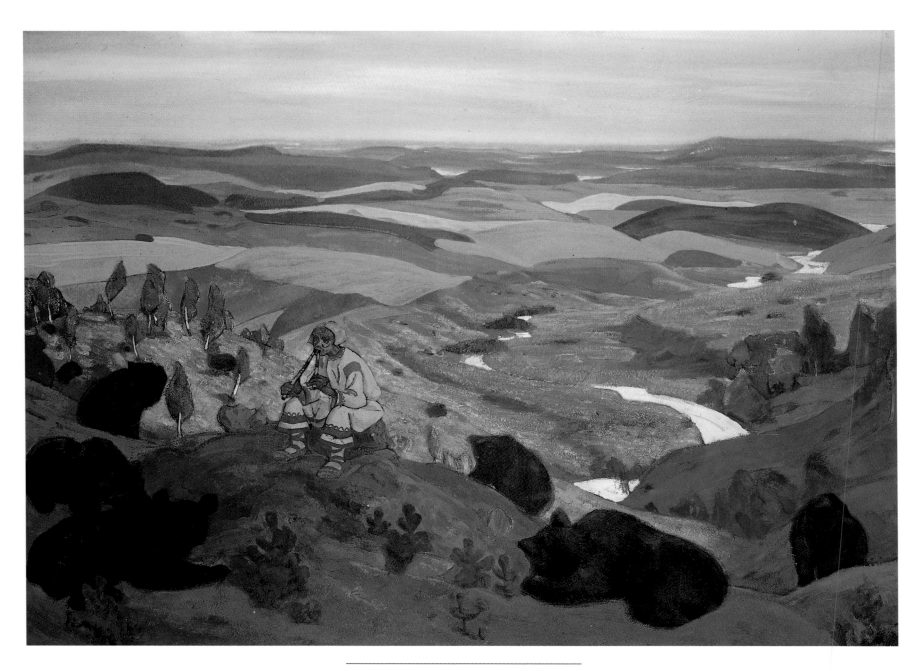

Human Forefathers, 1911.
TEMPERA ON CANVAS, 25 X 35½ IN.
ASHMOLEAN MUSEUM, OXFORD.

THE STONE AGE

Many European and Russian artists and writers at the turn of the century were concerned that increasing industrialization would rob life of its natural beauty. Hence the revival of interest in folklore, folk arts and crafts, and interior design, as well as the drive to study, collect, and preserve the art and architecture of the past. For Benois, Somov, Bakst, and other core members of Mir Iskusstva, the ideal of beauty was the ornate elegance and refinement of Baroque art, whereas for Roerich it was the primeval purity of the prehistoric past.

Benois once articulated the fundamental differences between his and Roerich's view of history and art:

> Roerich and I have different attitudes toward the history of mankind, toward man; we have *organically* different world views. I value everything that is complete, in which perfected ideals have already been attained. . . . Roerich is drawn to the wilderness, to the distance, to primitive peoples, to the forming of shapes and ideas. With all of his work, all of his inspiration, he asserts that the good is in strength—that strength is in simplification and spaciousness—and that it is necessary to start from the beginning.
>
> I value Pushkin's language, and would be happy if everyone spoke that tongue of the gods. There is so much truth in that refined speech. For Roerich the artist, for the dreamer Roerich, for his primor-

dial taste, it would not be terrible to return to the poor language of savages, as long as instincts were expressed clearly and straightforwardly, as long as there was none of the falsehood and confusion introduced by so-called civilization.

> As always, however, the real truth lies in the middle and we approach it from opposite ends.[1]

Indeed, Roerich saw the Stone Age as the golden age of mankind, when man and nature were in harmony, and work and art were one. To him this was the essence of culture and the goal toward which mankind should strive. In his view, modern civilization had lost the richest element of the ancient past—beauty. "We have become poor in beauty," he wrote in one of his articles. "Everything beautiful has disappeared from our living quarters, from our utensils, from ourselves, from our tasks. . . . Beauty is not needed in those places where the great despondency of our time—the all-powerful vulgarity—prevails, where vulgarity governs how people see and feel."[2]

Many of Roerich's paintings depict his conception of prehistoric life, and an idyllic one it is. In *Human Forefathers* (1911), for instance, a landscape of softly undulating, uninhabited hills, violet and green in the distance, transports the viewer into the far past (opposite). On a sparsely wooded hill in the foreground, a young Slav plays a reed pipe; clustered around him are six bears, lying or sitting

The Commands of Heaven, 1915.
TEMPERA ON BOARD, 29½ X 38½ IN.
STATE RUSSIAN MUSEUM, ST. PETERSBURG.

peacefully as though entranced by his melody. Even the bushes and trees seem to be gathering around to listen. The art historian Sergei Ernst interpreted this painting as a Slavic version of the Orpheus myth,[3] but the communion between this Slavic Orpheus and the bears suggests yet another myth—the ancient Slavic belief that bears were man's forefathers.

At the dawn of mankind when man and nature existed in harmony, the artist seems to be saying in this painting and others, real life and legend were indistinguishable. All of nature seemed animate and endowed with mysterious powers to primitive man, and he believed he could appeal to the forces of nature to come to his aid. In *The Conjuration by Water* (1905), a man bundled in fur gar-

ments against the bitter winter cold stands upon a rock on a snowy bank, his arms outstretched to the icy water; the waves rise up as if in response to his gesture. *Sorcerers* (1905) depicts three men covered in wolf skins performing a ritual dance around a cluster of sacred stones. In *The Commands of Heaven* (1915), a group of men raise their arms in exaltation and obeisance to the sky, which is filled with roiling masses of fiery, anthropomorphically shaped clouds (opposite).

In Roerich's prehistoric world, the sky is vast, the earth seems to stretch eternally beyond the horizon, and man often figures as a tiny speck in nature's epic grandeur. In *Battle in the Heavens* (1909 and 1912), considered by some critics to be one of the best landscapes in Russian painting,[4] storm clouds gather threateningly over a low horizon of gently rolling hills and lakes (pages 34–35). Some of the clouds are billowy and swirling; others are straight and sharp. The contrasting shapes as well as the clash of warm and cold colors create a powerful sense of movement. Rays of the sun pierce through in places, highlighting some of the fantastic cloud formations and intensifying the play of light and shadow.

The only evidence of human life in the painting is a little group of pile dwellings huddled in the far lower right-hand corner. Yet, the very minuteness of this human settlement in relation to the sky is precisely what gives the celestial battle such awesome majesty and power—the power of creation itself.

In the canvases *Building the Town* (1902), which was shown at the Mir Iskusstva exhibition of 1903 and bought by the Tretyakov Gallery, and *Building the Ships* (1903), prehistoric man has left his caves and is now busily engaged in the most basic of human endeavors (above). In the construction of wooden dwellings and ships, Roerich saw not merely the erection of primitive edifices but the very building of culture. In an essay entitled "The Stone

Battle in the Heavens, 1912.
Tempera on board, 26 x 37½ in.
State Russian Museum, St. Petersburg.

34

Age," he wrote, "Ancient man did not only know how to master the refinement of technique, he knew and appreciated the quality of his materials, and in this was expressed an inherent sense of beauty. And wherever this lofty sense is manifested, there you will find not savagery, but a distinctive culture."[5]

These two works are painted in an uncharacteristic manner for Roerich. The paint is applied in small, square, heavy brush strokes, creating a mosaic effect. This style suits the spirit of the subject superbly; it is as if the paintings, like the structures depicted in them, were put together piece by piece. The composition, with its strong verticals, horizontals, and diagonals, gives both works a tremendous dynamism that captures the creative energy of the builders.

The summers of 1903 and 1904 found Roerich and his wife traveling through Russia, stopping in city after city to study ancient architecture. In all they visited twenty-seven cities and towns, from Kazan on the Volga River in the east to Riga on the Baltic Sea in the west. Everywhere they went, Roerich painted ancient churches, monasteries, castles, city walls, and towers—the twelfth-century Cathedral of St. Dmitry in Vladimir, the twelfth-century Church of the Intercession in Bogolyubovo, the seventeenth-century Church of St. John the Divine in the kremlin at Rostov Veliky, and dozens more (pages 36–39). These oil studies were his way of calling attention to the need to preserve the cultural monuments of the Russian past and also of celebrating the great art of "building cities." He would set up his easel close to the structure he had chosen to paint and fill the canvas with it, using broad, heavy brush strokes. This technique serves to suggest the texture and weight of the stone. His intent was not to render every detail of the structure with the accuracy of a photograph or an architect's

Old Russia, Rostov the Great. Entrance to the Kremlin, 1903.
OIL ON PANEL, 16 X 12¼ IN.
MUSEUM OF ORIENTAL ART, MOSCOW.

Old Russia, Yaroslavl. Church of the Nativity of Our Lady, 1903.
OIL ON PANEL, 12½ X 16 IN.
MUSEUM OF ORIENTAL ART, MOSCOW.

drawing, but rather to capture the character of the building, its personality, much as a portrait painter approaches his subject. One of Roerich's contemporaries wrote, "All of those cathedrals, their white walls firmly rooted in the earth, the kremlins with their tent roofs, the quiet church yards, and the frowning fortress towers are not depicted by the artist the way they appear to the indifferent eye of a casual passerby. He painted their poetry, their ancient soul.

He sensed the tale of time around them. He came to love their mysterious relationship with the people. He closely scrutinized the stone face of ancient times and grasped its expression."[6]

An exhibition of Roerich's architectural studies opened at the Society for the Encouragement of the Arts in January 1904. Tsar Nicholas II came to see it and expressed the desire to have the Alexander III Museum

Old Russia, Uglich. Monastery of the Resurrection, 1904.
OIL ON PANEL, 18 X 32¾ IN.
STATE RUSSIAN MUSEUM, ST. PETERSBURG.

(now the Russian Museum) acquire the whole series. Unfortunately, the very day of his visit Russia declared war on Japan, and the matter was never pursued. Instead, later that year seventy of the studies as well as several of Roerich's other paintings, including *Meeting of the Elders,* were sent to the United States as part of the Russian exhibit at the Louisiana Purchase Exposition in St. Louis. Their return to Russia would take seventy years.

Since Russia was at war with Japan at the time of the exposition, it officially pulled out of the event when it learned that the Japanese pavilion was to be located next

to its own. But the Russian government could not prevent Edward Grunwaldt, a St. Petersburg fur merchant and member of the Russian Aid Organization for the exposition, from personally contracting with the participating artists and sending their works to St. Louis as a private citizen.

After the exposition ended, Grunwaldt shipped the seventy cases of Russian paintings, drawings, and sculpture to New York, where he hoped to sell them and make a handsome profit for the artists as well as a hefty commission for himself. The auction, held in March 1906, proved

39

not only disappointing—the paintings brought far lower prices than expected—but illegal, since Grunwaldt had not paid the customs duty required for any imported art work sold in the United States. As a result, the sale was stopped and the art works impounded in a bonded warehouse until the charges could be paid.

The Russian government refused to pay the bill, and from then until 1912 the collection was bought and sold by a series of businessmen whose claims on it were shady at best. Grunwaldt's lawyer, Colonel Henry Kowalsky, managed to have the entire collection shipped to Canada, switching ownership to himself in the process. Then Frank Havens, a wealthy California entrepreneur, attempted to buy it from Kowalsky, but on its return trip to the States the collection was once again impounded by customs. The affair eventually necessitated the involvement of the Secretary of the Treasury and several senators; even President Taft asked to be briefed on it.

Finally, on February 5, 1912, eight years after the Russian collection first arrived in the United States, and after many bitterly fought court battles and seizures by customs, the collection was sold at government auction for $39,000, to Frank Havens, who installed it in his private gallery. In 1916 he himself was forced to auction off his collection, and many of Roerich's architectural studies ended up in the Oakland Art Museum.[7]

For years, however, neither Roerich nor any of the other Russian artists who had participated in the exposition knew what had happened to their works, in spite of their persistent appeals for help to the Russian consul in Washington and other government officials. Only on Roerich's first trip to the United States in the early 1920s did he learn that thirty-five of his works were in the Oakland Museum, six others in private collections, and the rest, as far as he could determine, somewhere in Canada. For many years after that, the Oakland Museum's collection was virtually forgotten, until an admirer of Roerich rediscovered it in the late 1950s or early 1960s. A trustee of the Roerich Museum in New York then bought the collection and lent it to the museum, where it went on permanent exhibition until 1974. Then, in fulfillment of a promise made many years before to Roerich himself, the trustee presented the collection to the Soviet Union on the one-hundredth anniversary of Roerich's birth. Since 1976 these architectural studies of 1903 have been displayed in the Museum of Oriental Art in Moscow.

The inclusion of Roerich's works in the Russian exhibit at the 1904 St. Louis Exposition was an indication of his growing recognition. His paintings began to appear at all the major art shows in St. Petersburg and Moscow. In addition to the Mir Iskusstva exhibition of 1903, he participated in the *Contemporary Art* exhibition, which, in the spirit of art nouveau, presented paintings against the background of beautifully designed interiors. At the end of 1903 he joined the newly formed Union of Russian Artists and took part in its first exhibition, which was held in Moscow. This group comprised all the Moscow artists who had participated in the Mir Iskusstva exhibitions, as well as many of their St. Petersburg counterparts. Exasperated by Diaghilev's dictatorial control over the selection of works for the exhibitions, they had defected from his leadership.

Europe, too, was soon given a glimpse of Roerich's art. An exhibition of his works was mounted in Prague in the spring of 1905. It then traveled to Vienna, Venice, Munich, Berlin, Dusseldorf, and finally Paris, where it was shown at the Salon d'Automne of 1906. Paintings were acquired by the Louvre, the National Museum in Rome, and other museums.

Roerich's belief that the way toward a better future was through an understanding of the past was shared by Princess Maria Klavdievna Tenisheva, whom he met in 1903. A princess by marriage, not by birth, Maria Tenisheva was a woman of uncommon charm, beauty, and talent. A passionate devotee of the arts, she was trained as a painter and had an exceptional singing voice. Repin was infatuated with her and painted her portrait many times—in black, in white, with a palette in her hand, in a décolleté evening gown.

Equally at home in the salons of Paris and St. Petersburg, she found her true calling as an art patron and

collector. She collected oil paintings, watercolors, and folk art; participated in organizing exhibitions and founding museums; subsidized art schools in St. Petersburg and Smolensk; and funded artists' trips abroad. When Diaghilev approached her with his plans for *Mir Iskusstva,* she enthusiastically agreed to help subsidize the journal. In the beginning she took an active part in its publication, but Diaghilev succeeded in alienating her with his imperious manner, just as he had his coterie of artists. She found herself blamed by everyone for his "excesses"[8] and was driven to distraction by caricatures of her that appeared in the press. One, by the well-known caricaturist Shcherbov, depicted her as a cow being milked by Diaghilev while Repin, on his knees, presented her with a laurel wreath.

Although her sympathy for Diaghilev cooled, she nevertheless came to his aid again in 1903, donating 5,000 rubles to the foundering journal. But by then her interest had turned toward transforming her estate, Talashkino, into an artistic community. She not only renovated the manor but built a school for peasant children, workshops for applied arts and trades, a theater, and eventually a church. The designs for these structures and their interiors were done in a folk style by the leading artists of the day, including Vrubel, Malyutin, and Elena Polenova, and executed by students under their tutelage. Roerich first visited Talashkino in 1903 and immediately went to work, both as a teacher and as a designer. He contributed designs for a decorative majolica frieze entitled *Stone Age* (page 42), which depicted scenes from the life of the ancient north—walrus hunting, a ritual dance, a procession of deer. He also designed furniture that was simple in form, if somewhat ponderous, and drew on motifs of northern Russian folk art. One of his couches was decorated with a repeating image of a horseman carrying a circular shield astride a white steed. Its pillow-like arms resembled gray stones.

The Talashkino workshops were intended to educate young artists in their native folk art traditions, but the crafts they produced proved to be of such fine workmanship that they found an appreciative market in Russia and abroad. The handmade lace, embroidered linen dresses, and carved wooden cradles fetched high prices among the elite of Moscow, St. Petersburg, Paris, and Brussels.

Roerich's interest in the revival of the applied arts stemmed in part from his belief that art should not be restricted to the halls of museums and galleries but should form an integral part of daily life, as it had in the ancient past. He thus did not distinguish between major and minor art forms; to him, finely crafted dishes and fabrics served beauty no less than easel paintings.

Roerich was instrumental in the revival of yet another art form—church art. In the nineteenth century, icons and church frescoes were not generally regarded as works of art; as Roerich himself had observed on his travels around Russia, masterpieces dating back to the fifteenth century and earlier were routinely painted over by poorly trained painters. Only at the beginning of the twentieth century did the aesthetic value of old Russian church art begin to be appreciated anew. Collecting icons became the vogue, and commissions to build and decorate churches multiplied. Certain artists became renowned for their modern adaptation of old Russian and Byzantine icon, fresco, and mosaic techniques, Roerich among them.

He was commissioned to design iconostases, murals, and mosaics for several churches between 1904 and World War I: the Kamensky family church in Perm, the church at Parkhomovka (the Ukrainian estate of the orientalist Golubev), the Trinity Church in the Pochaevsky Monastery near Ternopl, a church in the village of Morozovka near Schlisselburg, a chapel in Pskov, and the Church of the Holy Spirit at Talashkino. In preparation for these commissions, Roerich studied the ancient masters of the Novgorod and Yaroslavl schools. He delighted in their bold but subtle use of color combinations, the sublime rhythms of their composition, and the smooth flow of gestures, body curves, and folds of clothing. Without copying these traditions, he borrowed from them, and his contemporaries were enthralled by the decorative beauty and deep spirituality of his frescoes and mosaics. Many of the churches he worked on were destroyed during World War II; some, such as those in Talashkino and Parkhomovka, are now being restored.

CHAIR AND COUCH DESIGNED BY
ROERICH AT THE STUDIO IN
TALASHKINO.

Stone Age, The North. Hunting for Walrus, 1904.
DESIGN FOR MAJOLICA, GOUACHE ON BOARD, 4¾ X 12½ IN.
STATE RUSSIAN MUSEUM, ST. PETERSBURG.

The subjects of Roerich's church art were traditional for the most part, including historical personages canonized by the Russian Orthodox Church, such as Prince Vladimir, who had brought Christianity to Russia, and his two martyred sons, Boris and Gleb. He also made several heads of Christ in the mid-Byzantine and early Russian manner of the *Spas nerukotvorny*.★ The one that may still be seen above the portal of the Talashkino church is a severe face, done in mosaics. The huge eyes seem to follow those en-

tering the church, reminding them of the necessity of purifying themselves and turning to exalted thoughts.

Less typical was the fresco Roerich designed for the interior of the Talashkino church. It depicts a theme he would return to time and again, the *Queen of Heaven* (opposite). Majestically seated on a throne in the Byzantine manner, the Holy Virgin is blessing travelers who sail along the River of Life, which flows at her feet. Celestial cities guarded by angels rise all around her, while saints turn toward her in prayer. Above, a procession of prophets bows to the Cross. In this highly symbolic work, Roerich incorporated elements of both Eastern and West-

★Literally, "image of the Savior not made with hands," referring to a legendary portrait of Christ miraculously imprinted on a veil during His lifetime.

ern artistic and religious traditions, creating a unique synthesis that expresses his own deeply personal spirituality.

Roerich's abiding interest in ancient culture was not limited to Russian antiquity. Whenever he traveled in Europe, as he did in the spring of 1906, he gravitated toward cities in which the ancient art and architecture were preserved. Medieval Italian towns such as Siena and San Geminiano, as well as the Belgian city of Bruges, appealed to his aesthetic sensibility far more than the crowded capitals of Rome or Paris. The beauty of these places inspired a whole series of works. One, a drawing of a medieval Italian town and its surrounding landscape, executed in 1907 after he returned from his trip, so captivated the Russian symbolist poet Alexander Blok that he asked Roerich if it could be used as the frontispiece of his *Italian Songs* cycle. Roerich not only agreed; he presented Blok with the drawing. It appeared in the literary journal *Apollon* in 1910, along with five of Blok's poems. Some time later the editor of *Apollon* asked Blok if he could reproduce the drawing again, but the great poet refused to part with it for even a short time.

For all of Roerich's appreciation of the triumphs of Western culture, he was increasingly attracted to its cultural and philosophical opposite—the East. His fascination with the East dated back to his early childhood—the picture of the magnificent snow-covered mountaintop hanging in the living room at Isvara, the stories of his parents' friends about the culture of nomadic Asian tribes, and the Eastern themes of Borodin's *Prince Igor* and Rimsky-Korsakov's *Scheherazade*. His interest was further sparked in his discussions with Vladimir Stasov about the links between ancient Russia and the East. But his growing involvement in the philosophical and spiritual teachings of the East was perhaps most directly influenced by Helena Roerich, who had a profound interest in Eastern religions and philosophy. Together they immersed themselves in the great Indian epics, such as the *Bhagavad Gita,* and studied seminal works on Indian philosophy that were translated into Russian around the turn of the century. They also developed a deep fondness for the poetry of Rabindranath Tagore.

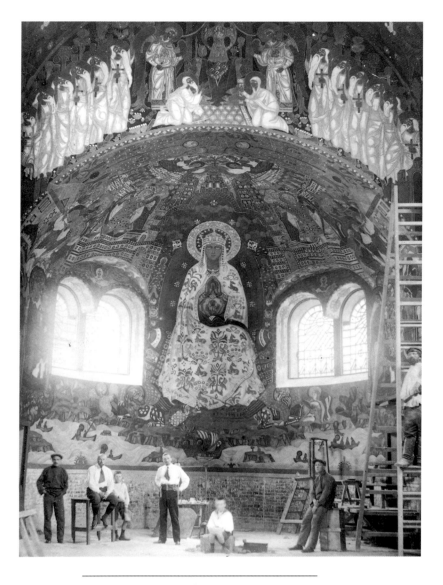

The Queen of Heaven, 1912.
FRESCO IN THE CHURCH OF THE HOLY SPIRIT, TALASHKINO. ROERICH IS SEATED ON LEFT. NEXT TO HIM IS HIS OLDER SON, GEORGE. HIS YOUNGER SON, SVETOSLAV, IS SEATED ON THE RIGHT.

Indian motifs began appearing in Roerich's writing and painting as early as 1905. That year he wrote a fairy tale based on Indian legend entitled *Devassari Abuntu.* In it, a wise woman by the name of Devassari Abuntu heeds the teachings of Buddha and leaves human society. She lives

43

among the birds and comes to understand their language. They protect her from harm. Remarkably, she never ages, but when the birds tell her it is time for her to die, she goes off in search of the stone of death. In the desert she finds many dark stones, and asking them to accept her body, she bows to them. In that position she remains, transformed into a black stone full of blue fire.

This fairy tale and two illustrations for it were published in the literary journal *Vesy* (The Balance) in 1905. In 1906 Roerich executed two paintings based on the story. As was the case with so many of Roerich's paintings, such as *Overseas Guests,* the idea first took literary form and only later was given visual expression.

Roerich wholeheartedly supported the idea of Professor Shcherbatsky, one of Russia's leading Indologists, to transport an ancient Hindu temple from India to St. Petersburg. When the plan had to be abandoned because of exorbitant shipping costs, St. Petersburg's orientalists proposed building a Buddhist temple right in the city. A committee of scholars was formed to oversee its construction, and Roerich was invited to become a member. The building was begun in 1909 and completed after six years of painstaking, detailed work.

In 1906 Roerich was promoted from secretary of the Society for the Encouragement of the Arts to director of its school, a position he had long desired. His appointment was hotly opposed by the society's council, the same group that had protested his election to the secretarial post. But the society's president, Grand Duchess Evgenia Maximilianovna, knew the school was badly in need of reorganization, and she believed that Roerich would be able to overcome his opposition and institute wide-ranging reforms. She proved to be right.

He and his family—which now numbered four, since the birth of his two sons, Yury (George) in 1902, and Svyatoslav (Svetoslav) in 1904—moved into living quarters in the society's building, and he wasted no time in introducing fundamental changes in the school's outdated curriculum. First, in the spirit of Talashkino he added to the traditional classes in drawing, painting, and sculpture a broad range of classes and workshops in the applied arts and trades, including ceramics, wood carving, embossing, weaving, glass painting, and church painting. In time, even music and singing lessons were offered. He had to hire a new faculty to teach these courses and gradually attracted a staff of eminent specialists. To maintain a trusting relationship with his staff, he established regular faculty meetings at which all proposed innovations were discussed before being implemented. Roerich himself taught composition. He also led excursions to old Russian cities, where he lectured his students on ancient Russian art and architecture.

It was of paramount importance to him that enrollment in the school be open to all, regardless of social class. Children of tradesmen and peasants studied side by side with children of generals. One of the less grateful students to benefit from this open enrollment policy was Marc Chagall, who had arrived in St. Petersburg virtually penniless in 1907. After failing the examination for admission to Baron Stieglitz's School of Arts and Crafts, Chagall was not only admitted to the school of the Society for the Encouragement of the Arts but was given a scholarship. In his autobiography, *My Life,* he writes disparagingly of the level of instruction as well as of the "cab-driver pupils who dug their erasers into their paper and sweated as if they were using a shovel."[9] Of the school's director, who had made it possible for Chagall to live and study in the capital, he says, "Our director, Roehrich [sic], wrote unreadable poems and books on history and archeology and, smiling, teeth clenched, he would read fragments of them—I don't know why—even to me, a pupil in his school, as if I understood a word of it."[10]

Roerich's approach to education may not have been appreciated by everyone, but during his time as director of the art school, it became one of the largest in Russia, with a student body of 2,000 and a nationally renowned faculty.

Every May a student exhibition was held. Under Roerich's directorship, this annual event began to attract "all of St. Petersburg," including the imperial family. One year, however, the exhibition narrowly missed being canceled. Just before the opening, the assistant to the gover-

ROERICH IN HIS OFFICE AT THE SCHOOL OF
THE SOCIETY FOR THE ENCOURAGEMENT OF THE ARTS.

within an hour his students had ingeniously "dressed" the nudes in skirts and bloomers made out of multicolored cigarette paper. The exhibition opened as scheduled, and the hall buzzed with the snickers of the distinguished public. The assistant governor's attempt to foil the school's unflappable director had backfired. A compromise was finally reached. One of the drawings was removed from the exhibition and with it all the cigarette-paper skirts from the other works.

This incident exemplifies the resourcefulness with which Roerich systematically broke down the school's outworn conventions. He gained the admiration of the imperial family and became such a favorite of the court that he was offered the post of chamberlain, which carried not only great honor and power but also great responsibility. Perhaps recalling that when similar honor was bestowed on Velásquez, the great Spanish painter's output dwindled to two paintings a year, Roerich managed to extricate himself from the position and remarked to friends that he "couldn't imagine an exhibition of the works of a chamberlain!"

Roerich's goal as director of the school of the Society for the Encouragement of the Arts was to expose his students to all the arts under one roof, in the belief that only a thorough knowledge and appreciation of beauty would advance the evolution of humanity and lead to a future as peaceful, harmonious, and rich in culture as the ancient past.

nor of the city, General Vendorf, came to inspect the works to be displayed. Embarrassed by the nudes portrayed in paintings and sculptures, he forbade the opening to take place unless the "inadmissible parts" were covered up. Roerich did not try to dissuade the general, and

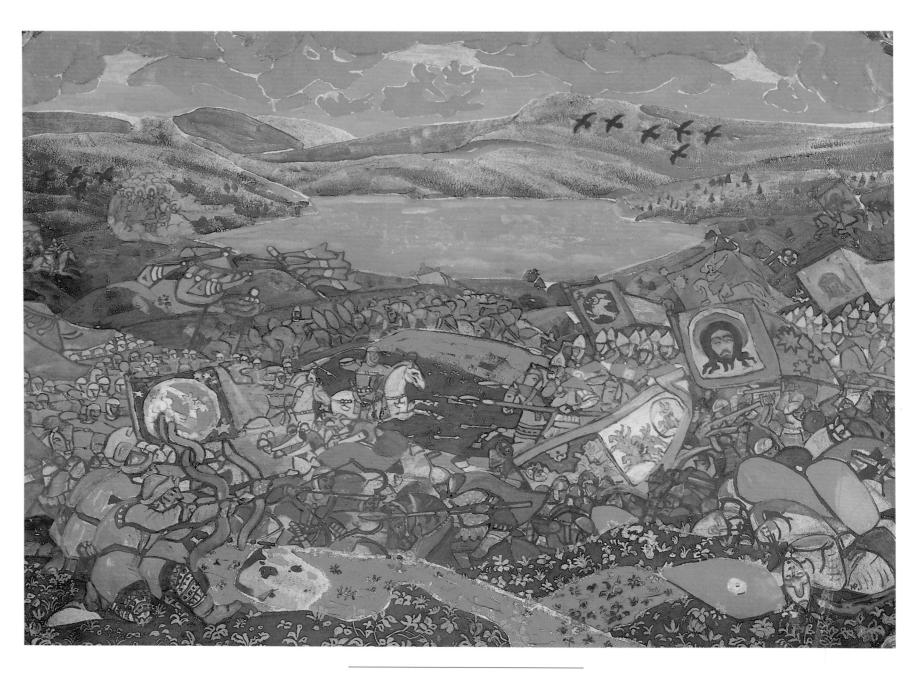

Battle of Kerzhenets, 1911.
SKETCH OF ENTR'ACTE CURTAIN FOR RIMSKY-KORSAKOV'S
OPERA *THE TALE OF THE INVISIBLE CITY KITEZH.*
TEMPERA ON CANVAS, 20½ X 27¾ IN.
STATE RUSSIAN MUSEUM, ST. PETERSBURG.

THE THEATER

A massive stone cathedral rises to the left of a cobblestone square. Surrounding the square are towers and archways made of the same rough-hewn stone. The sky lightens, and the pilgrims who have been sleeping on the square awake. An old abbot appears on the church porch and announces to the crowd that the Nativity is about to be reenacted. The pilgrims are so taken by the spectacle that they fail to distinguish between the play and reality. When "King Herod" orders the slaughter of the Innocents, they charge toward the church porch and attack the villainous ruler. Amid shouts and screams the lights go out, and the curtain comes down on the 1907 premiere of the Russian dramatist Nikolai Nikolaevich Evreinov's play, *The Three Magi*.

The idea of recreating medieval liturgical dramas and mystery plays as they were actually staged in the Middle Ages was the brainchild of Evreinov and the theater historian Baron von Drizen. Together they organized the Starinny (Old) Theater and attracted actors, composers, artists, poets, dancers, and scholars, including Roerich, who was asked to design the sets and costumes for *The Three Magi*. Everyone involved in the productions worked for maximum authenticity. Medieval French texts were first translated into modern French and only then into Russian by such poets as Alexander Blok and Mikhail Kuzmin. Baron von Drizen traveled to ancient European cities to study their architecture. The composer Ilya Sats recreated not only the music of the period but the instruments as well. The actors worked at perfecting the movement and speech of medieval theater, and the set and costume designers attempted to capture the look and feel of medieval life. Despite these meticulous preparations and appreciative reviews in the press, the productions of the Starinny Theater proved to be a commercial failure; the plays were too esoteric to appeal to a wide audience. By the end of the first season, funds had run out and the theater was forced to close down.

Roerich's sets for the ill-fated *The Three Magi* marked his debut as a stage designer, that aspect of his long and varied career for which he is perhaps best known in the West. His work for the theater, however, was inseparably linked to his easel painting; all the plays, operas, and ballets for which he chose to design sets and costumes echoed in one way or another the thematics, spirit, and images found in his painting—the primeval world, the Middle Ages, ancient folk tales and legends, authentic ethnographic, archeological, and architectural detail.

The first opera for which Roerich designed sets was Wagner's *Die Walküre,* in 1907. He was not commissioned to do them and they were never realized on stage, but the music so inspired him that he felt compelled to find visual expression for it. Years later he described his

method of discovering correspondences between the music of an opera or ballet and the color scheme of the decor:

> I never paint the scenery for an opera or a ballet without first having an intimate acquaintance with both the drama and the music. I study both deeply, in order to get at the spirit that lies behind both, which spirit must be one and the same if the work is to be great and lasting. Having steeped myself in the central idea, the inspiration that gave birth to the work, and permitted it to take possession of me, I then endeavor to express the same thought, the same inspiration in my painting, that the composer and the librettist have expressed in music and in words.
>
> Particularly do I feel myself in sympathy with music, and just as a composer when writing the score chooses a certain key to write in, so I paint in a certain key, a key of colour, or perhaps I might say a *leitmotiv* of colour, on which I base my entire scheme. Thus for example when I painted the scenery of the Valkyrie . . . I felt the first act as black and yellow. This was my ground tone, for it seemed to be the ground tone of the music with its deep-surging tragedy and sudden flashing forth of the momentary happiness of Siegmund and Sieglinde in the final scene.[1]

Roerich was justly proud that his designs for *Die Walküre* were singled out in the Darmstadt journal *Kunst und Dekorazion* (1921) as the best that had ever been done for a Wagner opera.[2]

If the monumental quality of Roerich's art was well suited to the titanic power of Wagner's music, his rich palette was a match for the multicolored sound of Rimsky-Korsakov's music, and in 1908 he was commissioned by the Opéra Comique in Paris to design the sets for Rimsky's *Snegurochka* (The Snow Maiden). He had seen many productions of both the opera and Ostrovsky's dramatic version of the ancient Russian legend and had been particularly impressed by Viktor Vasnetsov's lavishly decorative sets for the Private Opera Theater of art patron Savva

Mamontov. Vasnetsov's use of vivid color and folk ornamentation had caused a sensation when the production premiered in the 1880s. Indeed, the operas Mamontov produced heralded a new era in Russian theater in which the designer occupied an ever more prominent place.

Roerich's approach to *The Snow Maiden* differed from Vasnetsov's: he went further back in time to the ancient past of the original legend. It was his intention to combine the fantasy of the fairy tale as felt in Rimsky-Korsakov's score with the pagan spirit of Tsar Berendey and his people, whom Roerich saw as a mysterious tribe that had migrated to northern Russia from the East. He suggested the Eastern heritage of this tribe in the women's heavy necklaces and the ornamentation of their clothes. His sets for this tale of the fair Snow Maiden—the daughter of Spring and Winter, who falls in love with the shepherd boy Lel only to be melted by the sun god Yarilo—depicted the rolling hills, birch forests, lakes, and winding rivers of the northern Russian landscape. But the decor did not serve only as a picturesque backdrop for the action; rather, as in so many of his paintings, the artist captured the ancients' pantheistic view of nature—every stone and tree seemed endowed with an animate quality.

Roerich returned to *The Snow Maiden* several times after 1908. In 1912 he designed both sets and costumes for the Reinecke Dramatic Theater's production of the Ostrovsky play in St. Petersburg. He was highly dissatisfied with the execution of his sketches by the theater's artists, however, and asked to have his name removed from the publicity poster. He had a much happier experience ten years later when an opera company in Chicago invited him to design its production of *The Snow Maiden* (opposite), which premiered in November 1922 and "became the striking success of the season, both artistically and financially."[3]

It is doubtful whether Roerich—or any of the major Russian artists, singers, composers, and dancers of his generation, for that matter—could have achieved the worldwide renown they did had it not been for the efforts of one man, the indomitable Sergei Diaghilev. As Roerich said of him after his death in 1929, "Diaghilev has gone.

Snegurochka and Lel, 1921.
COSTUME SKETCH FOR CHICAGO PRODUCTION
OF RIMSKY-KORSAKOV'S OPERA
THE SNOW MAIDEN.
TEMPERA ON BOARD, 19½ X 12 IN.
NICHOLAS ROERICH MUSEUM, NEW YORK.

Something far greater than an individual force has gone with him. We may regard the entire achievement of Diaghilev as great individuality, but it would be still more exact to see him as a true representative of an entire movement of synthesis. We value him as the eternally youthful guardian of those great moments when modern art freed itself from so many conventionalities and prejudices."[4] Soon after *Mir Iskusstva* disbanded in 1904, Diaghilev began to channel his abundant energies into promoting Russian art abroad. In 1906 he mounted a highly successful exhibition of Russian painting at the Salon d'Automne in Paris. Although it was intended as a comprehensive survey of two centuries of Russian art, works by the Mir Iskusstva artists, including Roerich, predominated. Encouraged by the Parisians' understanding and appreciation of Russian painting, Diaghilev decided to introduce them to Russian music and devoted the second of his "Russian Seasons," as they came to be called, to Russian music through the ages. The performances of works by Glinka, Rimsky-Korsakov, Borodin, Mussorgsky, and a host of others proved a revelation to the Parisian audiences and inspired Diaghilev to stage a full-length production of Mussorgsky's opera *Boris Godunov* the following year, with Fyodor Chaliapin singing the title role.

Long and arduous preparations went into the production. Determined to dazzle the audience with a recreation of sixteenth-century Russia on the Paris Opera stage, Diaghilev scoured Russia for authentic costumes and embroidery while three artists worked on the elaborate sets. The effort was well worth it. The dancer and choreographer Serge Lifar reconstructs the scene on opening night in his reminiscences of Diaghilev:

> The effect it produced on Paris was indescribable. The usual cold and fashionable audience of the Opéra was utterly transformed. People stood on their seats, yelled as if possessed, waved handkerchiefs, and wept in an unrestrained and Asiatic manner very different from European tears. Europe had taken Mussorgsky and his *Boris Godunov* to its

heart. . . . Chaliapin's personal success too was tremendous. . . . After that memorable night, singing and acting became something *altogether different* from what they had been.[5]

Diaghilev himself could not have predicted that the triumph of *Boris Godunov* would be outdone the next year by the debut of his Ballets Russes on May 19, 1909, at the Châtelet Theater. The program included *Le Pavillon d'Armide* (music by Cherepnin; sets by Alexander Benois), *Prince Igor (Scenes and Polovtsian Dances)* (music by Borodin; sets by Nicholas Roerich), and the dance suite *Le Festin* (music by Rimsky-Korsakov, Glinka, Tchaikovsky, and Glazunov; sets by Konstantin Korovin). The first two works were choreographed by Mikhail Fokine, and all three pieces featured dancers such as Vaslav Nijinsky and Tamara Karsavina, whose virtuosity surpassed anything the Western world had ever seen. From Nijinsky's first soaring leap in *The Pavillon d'Armide,* the audience was held spellbound, its enthusiasm reaching a climax only when the curtain rose on the nomad camp scene of the *Polovtsian Dances.* Beneath a burning red and yellow sky, nomad tents dotted the austere expanse of the Central Asian steppe, and smoke from bonfires rose menacingly into the air. Against this background a horde of savage Tatar horsemen broke into frenzied dancing, brandishing sabers and rushing at the audience. In the brilliant color scheme of the set and the simple but authentic designs of the costumes, Roerich captured the visual equivalent of Borodin's driving music, just as Fokine found its kinetic equivalent in the choreography. There have been innumerable accounts of the effect that the *Polovtsian Dances* produced on the opening-night public. A typical one is that of Victor Seroff, biographer of Isadora Duncan:

> As if to show the civilized Europeans what the true Asia can look like, the Russian painters [sic] produced a stage setting of such fantastic colors that no splendor of the Orient, familiar through fables, could surpass the picture that was offered to the audience. And when, in addition to this background

and Borodin's exotic and powerful music, a horde of wild Tatars were seen on the stage dancing, leaping over each other with their unsheathed curved sabers slicing the air, it is not surprising that the audience rushed forward at the end of the dancing and actually tore down the orchestra rail to clasp the performers in their arms.[6]

The furor that began that night continued unabated throughout the entire six weeks of the 1909 Russian Season. In bringing together the best artists, performers, choreographers, and composers his country had to offer, Diaghilev had been the catalyst for a new, collaborative art form, as the Parisian press was quick to recognize: "The performances of the ballet astonish us by a harmony never before seen in the theater. The painting, the artists, the music, all merge creating a real, great theatrical Work of Art."[7]

Roerich returned to *Prince Igor* often. He designed the sets and costumes for Diaghilev's 1914 production of the opera in Paris and London (page 52), for London's Royal Opera Company in 1920, and again in the 1940s for the dancer and choreographer Leonid Massine, who did not use them in a production (page 53). The theme of Prince Igor's campaign against the barbarous Central Asian invaders in the twelfth century also appeared in Roerich's easel painting, notably in a 1942 work entitled *Prince Igor's Campaign,* which was clearly inspired by patriotic feelings for his homeland during World War II.

Roerich participated in another production during that same 1909 Russian Season in Paris. He collaborated with Alexander Golovin and Dmitry Stelletsky on the sets and costumes for Rimsky-Korsakov's opera *Pskovitianka* (The Maid of Pskov), renamed *Ivan Grozny* (Ivan the Terrible), designing two scenes, "Grozny's Entrance" and "Grozny's Tent." The premiere took place on May 24, just five days after the stunning debut of the Ballets Russes. Chaliapin sang the title role, and his performance, combined with the sets, unleashed yet another furor in the French press: "While our designers strive for realism and *trompe l'oeil,* the Russian insist on 'interpreting.' They are Impression-

ists on a giant scale. . . . Nothing could be more terrifying than the arrival on horseback . . . of this ravaged, bilious Ivan, with his evil, suspicious eyes. . . . In one instant we understand a whole reign, a whole epoch, a whole world."[8]

The next design Roerich executed for Diaghilev was not a set but a curtain for a musical entr'acte in Rimsky-Korsakov's opera *The Tale of the Invisible City Kitezh and the Maid Fevronia* in 1911 (page 46). The entr'acte, entitled "Battle at Kerzhenets," depicts in musical form the clash of Russian warriors with Tatar hordes. To render the epic, *bylina*-like duality of the music visually, Roerich turned to prototypes of ancient Russian painting. The highly stylized composition portrayed not the battle itself but an icon-like interpretation of it. Flatly painted, sharply outlined figures of warriors and horses collide in a blaze of green, cinnabar, and ochre. At the premiere, the brilliant color and ornamental primitivism of the curtain caused such a sensation that the Parisian audience demanded to see it eleven times!

Diaghilev saw Roerich primarily as a designer of operas and ballets on old Russian historical themes, but other theater directors called upon him to design classical plays and operas of the Western European repertoire. In 1911, after a four-year hiatus, the Starinny Theater was revived for a second and final season. Again the organizers were Nikolai Evreinov and Baron Von Drizen, and again their purpose was to present theater as it had been staged in the past—not the Middle Ages this time, but sixteenth- and seventeenth-century Spain. Roerich was invited to design their production of Lope de Vega's *Fuente Ovejuna* (c. 1612). Here, as in his design for *The Three Magi,* the artist effectively created the illusion that the drama was being performed by actors of the period at the time and in the place of its original staging. The "stage" looked like a platform of reddish-brown tree trunks. It was positioned among boulders and ponderous yellow houses with brownish-orange tiled roofs. On the backdrop to the left rose jagged leaden and violet-colored mountains surmounted by a church. The entire right side of the background was filled with golden-brown masses of ominously gathering clouds. The sharply contrasting color

Prince Vladimir Galitsky's Courtyard, 1914.
Set design for 1914 production of Borodin's opera
Prince Igor. Gouache on board, 19¾ x 27¾ in.
State Russian Museum, St. Petersburg.

scheme of the set—burning gold and reddish-browns versus leaden violet-blues—echoed the tension inherent in this drama of villagers rising against their cruel lord, who had failed in his duties to his subjects and his king. Unfortunately, Roerich's design proved more in keeping with the pathos of the play than did the rather stylized performances of the actors. Even though all of St. Petersburg's artistic world and the entire royal family

turned out for the premiere, the production was not an unqualified success.

In 1912, the year Roerich angrily broke his association with the Reinecke Dramatic Theater in St. Petersburg over the execution of his designs for *The Snow Maiden,* he was invited by Vladimir Nemirovich-Danchenko and Konstantin Stanislavsky, co-founders of the famed Moscow Art Theater, to design the sets and costumes for the

COSTUME AND SET DESIGNS FOR *PRINCE IGOR*, 1944. EACH IS TEMPERA ON BOARD,
13¾ x 19¾ IN. NICHOLAS ROERICH MUSEUM, NEW YORK.
TOP LEFT: *Warrior Shooting Arrow*. BOTTOM LEFT: *Warrior with Sword*.
TOP RIGHT: *Polovtsian Camp*. BOTTOM RIGHT: *Maiden with Rose*.

Solveig's Song (Hut in the Woods), 1912.
SET DESIGN FOR IBSEN'S *PEER GYNT.*
TEMPERA ON PAPER ON BOARD, 25½ x 33¾ IN.
TRETYAKOV GALLERY, MOSCOW.

theater's upcoming production of Ibsen's dramatic poem *Peer Gynt* (above). The director of this production was Konstantin Alekseevich Mardzhdnov, a fiery Georgian. Despite fundamental differences in temperament, the customarily reserved Roerich and the ebullient Mardzhanov shared a common vision of the play.

The actors who were to perform in the play planned a trip to Norway to familiarize themselves with Ibsen's homeland, and Stanislavsky suggested that Roerich accompany them. But the artist declined, preferring to base his sketches on his understanding of the images inherent in the play and thereby protect himself from slipping into mere ethnography. When the actors returned and saw Roerich's finished designs, they were struck by how remarkably well he had rendered the atmosphere and landscape of Ibsen's world.

Roerich made sketches for all thirteen scenes of the play's five acts. They not only convey the locales in which the action takes place, but in their coloration suggest the hero's state of mind as he progresses through life. The scenes corresponding to Peer Gynt's youth are saturated with vibrant greens, violets, blues, oranges, and ochres, ("Solveig's Song," for example), but as he squanders his strength, his youth, and his life over the course of the play, the coloration gradually dims, becoming more and more monochromatic and austere. In the final scene, "Solveig's Hut," the heroine is reunited with her long-awaited love against a background of a severe but romantic landscape. The hut, nestled in the towering pines of an icy winter kingdom, appears to be an oasis of human warmth.[9]

The Moscow Art Theater's rehearsal journals for this production testify to Roerich's scrupulous attention to

detail. He attended several run-throughs, and his remarks ranged from subtle corrections of the color of the sets ("The shade of blue for the clouds is dirty," he wrote, "it lacks freshness—the milky color is far from the sketch") to the way the decor was lit ("Light the mill at the top with violet-colored lamps . . . add orange lamps").[10] He was also greatly concerned with the texture of the sets and stressed the importance of achieving a "stony" effect here, a "mossy" quality there.[11] He paid equal attention to the costumes, wanting them to look "lived in." For instance, he suggested tearing Peer Gynt's mother's shawl and washing an overly new-looking costume, then dipping it in coffee.[12]

Although the production was criticized for being long-winded and heavy-handed, the critics were unanimous in their praise of Roerich's sets and costumes. "The whole production was a celebration of his brush," remarked one.[13]

Roerich's collaboration with the Moscow Art Theater, especially in contrast to his involvement with the Reinecke Dramatic Theater, was one of the happiest of his career in the theater. When he recalled the experience he waxed uncharacteristically enthusiastic:

> In the [Moscow] Art Theater you feel at every turn that you are just as essential to the director and actors as they are to you. Here you feel the joy of collaborative work, here you feel that you're not only not a stranger, but among your own kind, dear, close, and desired. Here you feel that everyone has but one desire—to do his very best, here you feel that Art really lives.[14]

To the year 1912 also belong Roerich's set and costume designs for Wagner's opera *Tristan und Isolde*. The commission came from Moscow theater owner Sergei Zimin, but the production was never staged because of the outbreak of World War I.

If Wagner was the Western European composer whose spirit and thematics found the greatest resonance in Roerich, Maurice Maeterlinck was the Western European dramatist he felt the deepest affinity for. In the Belgian playwright's highly symbolic, stylized passion plays, with their suggestion of universal mystery and their medieval settings, Roerich recognized his own vision of Europe. Well before he began working as a set designer, he illustrated a collection of Maeterlinck's works, published in Russian translation in 1905, and made several paintings based on Maeterlinck's plays. In 1913 he was asked to design the sets and costumes for *Princesse Maleine* for the Svobodny (Free) Theater in Moscow. Roerich completed his sketches, but the play was never staged because the theater folded six months after it was founded. In 1914 he designed the decor for an opera based on Maeterlinck's *Sister Beatrice* (page 56). It was performed at the Theater of Musical Drama in St. Petersburg, which, renamed the Bolshoi Dramatic Theater after the Revolution, is St. Petersburg's leading dramatic theater to this day.

In the sketches for both plays, a Gothic feeling is achieved through the depiction of stone chambers, staircases, vaulted ceilings, chapels, and towers. The light coming in through stained-glass windows or emanating from fireplaces casts an otherworldly glow over the heavy stone, suffusing the sketches with shimmering jewel tones—amethyst, ruby, and topaz. Through these chambers and along these staircases glide Maeterlinck's fleshless princesses and nuns; they appear transformed into shades, as though they had surrendered their life to the stones.

After the success of Roerich's sets for *Polovtsian Dances* in 1909, Diaghilev asked him to come up with an idea for a new ballet. The impresario decided to team Roerich with a young, talented composer he had discovered—Igor Stravinsky. When Stravinsky met with Roerich to discuss their collaboration in 1910, the artist offered him two ballet scenarios, "A Game of Chess," in which the action would take place on a chess board above which giant hands would direct the "game," and "The Great Sacrifice," which would depict the ancient pagan ritual of sacrificing a chosen maiden to the sun god Yarilo in order to assure the rebirth of spring. Stravinsky preferred the latter scenario, and the idea for the ballet *Le Sacre du Printemps* (The Rite of Spring) was born.

In the Monastery, 1914.
SET DESIGN FOR MAETERLINCK'S *SISTER BEATRICE*.
TEMPERA ON BOARD, 29¾ X 33¾ IN.
STATE RUSSIAN MUSEUM, ST. PETERSBURG.

Together, Roerich and Stravinsky enlarged and augmented the libretto, working throughout the summer of 1911 at Talashkino. In its final form the ballet consisted of two acts. In Act One, "The Kiss of the Earth," the members of a pagan Slavic tribe congregate near a sacred hill. A 300-year-old woman, the progenitress of the tribe, foretells the rites to come, and the tribe performs a series of games and ritual dances to induce and to celebrate the return of spring. This first part reaches its climax when an elderly sage consecrates the earth with a solemn kiss. In Act Two, "The Great Sacrifice" itself, the maidens of the tribe begin a mystical labyrinthine circle dance on the sacred hill, and Fate, or Yarilo, chooses one of them for the sacrifice. The ancestors of the tribe, clad in bearskins (an allusion to the ancient Slavic belief that the bear was man's ancestor), surround her as she, possessed, dances herself to death in order to save the earth.

From its very inception, *Le Sacre du Printemps* has been steeped in legend, controversy, and scandal. For many years it was even generally believed that Stravinsky had had the original idea, not Roerich, and that it had come to the composer in a dream. This version of the story was a surprise to Roerich, who refuted it in an essay, "The Origin of Legends," in 1939.

Stravinsky completed his jarringly dissonant, polyrhythmic score in 1912 and wrote to Roerich, "I think I have penetrated the secret of spring's lapidary rhythms and have felt them coupled with the dramatis personae of our child."[15] Meanwhile Roerich was designing sets for the two acts as well as an entr'acte curtain, the sketch of which he dedicated to Stravinsky "in honor of our child." The set for Act One depicts a rather austere landscape of rocky hills sloping toward a cold lake, a sky filled with heavy layers of clouds, and in the center an enormous bare oak tree (in the actual production the oak was replaced by a large boulder, the sacred stone that appears in so many of Roerich's paintings). Dark greens, blues, and reddish browns make up the palette of this evocation of the land just before the reawakening of spring, just as the earth was emerging from the Ice Age. The design for the second act conveys the mystery of a northern spring night. Silhou-etted against a dark, cloudy sky and flanking the sacred stone are stakes upon which horses' skulls and hides are speared. The sketch for the entr'acte curtain shows a procession of four figures, clad in elkskins, making their way from right to left across the bottom of the picture toward a hillock upon which a female figure sits, watching (page 58). In the center foreground a hunter, seen from the back, ominously aims a bow and arrow at the procession. A vast, pale blue sky fills most of the sketch, and a winged-horse configuration, perhaps a suggestion of Yarilo, can be faintly detected in the clouds.

Roerich also designed all the costumes for the ballet, and his sketches reveal his usual attention to authentic ethnographic detail—the symbolically rich ornamental patterns on the clothing, for example (page 59). When Stravinsky saw the costume sketches he exclaimed, "My God, how I like them—they're a miracle! I only hope that their realization will be good. . . . Lord! Just so long as Nijinsky manages to choreograph *Le Sacre* in time, it's so complicated! Everything indicates that the work is going to 'come out' uncommonly well!"[16]

For Vaslav Nijinsky, the choreographer, Roerich's set and costume designs, as well as his vast knowledge of archeology and ancient Slavic customs, proved inspirational. In fact, the basic postures and movements of the dancers throughout the ballet appear to owe much to the carved wooden idols that figured so prominently in Roerich's paintings of ancient Russia. With feet turned inward, elbows clutched tight to the body, and palms held flat, in defiance of the cardinal rules of classical ballet, the dancers indeed bore a physical resemblance to these pagan idols, and their restricted range of movement in this position lent their bodies an angular, wooden quality.

Moreover, some of Nijinsky's choreographic configurations echoed the shapes of the hills and the sacred stone in Roerich's backdrop. Even the decorative patterns on the costumes—a concentric circle motif on the hem of some of the garments, for instance—appear to have suggested choreographic patterns to Nijinsky. As one dance historian has pointed out, "Many of the ground patterns" that Nijinsky choreographed for *Le Sacre du Printemps*

The Great Sacrifice, 1910.
ORIGINALLY INTENDED AS THE BACKDROP FOR ACT II OF
STRAVINSKY'S *LE SACRE DU PRINTEMPS,* THIS SKETCH
EVENTUALLY BECAME THE DESIGN FOR THE ENTR'ACTE CURTAIN.
TEMPERA ON CANVAS, 29 X 32 IN.
BOLLING COLLECTION, MIAMI, FLORIDA.

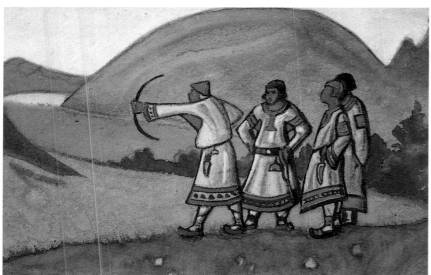
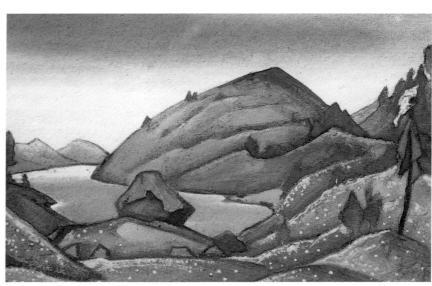

COSTUME AND SET DESIGNS FOR *LE SACRE DU PRINTEMPS*, 1944.
EACH IS TEMPERA ON CANVAS, 13¾ X 19¾ IN.
NICHOLAS ROERICH MUSEUM, NEW YORK.
TOP LEFT: *Astrologer*. BOTTOM LEFT: *Warriors with Bows*.
TOP RIGHT: *Maidens with Garlands*. BOTTOM RIGHT: SET DESIGN, ACT I.

"have antecedents in the ritual dance of shamanistic tradition—circles, concentric circles, squares, and the circle-in-the-square. Surely Roerich passed on to Nijinsky the importance of such patterns in the archaic rites of the Slavs. As designer, he would have already incorporated them as motifs on the costumes."[17]

The supposition that Roerich's costume designs influenced Nijinsky is further supported by the fact that Nijinsky would not begin work on the ensemble dances until he had seen the costume sketches.[18]

That Roerich had a profound effect on Nijinsky's vision of the ballet is also confirmed by Bronislava Nijinska, the choreographer's sister, on whom he choreographed the part of the Chosen Maiden (she never performed the role, however, because she became pregnant before the premiere). In her memoirs she relates a conversation with her brother in which he expressed his great esteem for Roerich as a painter and as a scholar of ancient Russia:

> "Roerich is not only a great artist but also a philosopher and a scholar. His studies of the Stone Age are of scientific importance. In his numerous excavations and cave explorations he has discovered vestiges of primeval ages. The beauty of the tinted stones and the wall paintings of the cave dwellers have inspired his own art. . . . Bronia, you must remember some of Roerich's paintings that we saw together at the Art Exhibition by *Mir Iskusstva* in St. Petersburg."
>
> I recalled how we had both admired not only the magnificent beauty of the colors but also the spirit of Ancient Russia so well captured in Roerich's paintings, depicting the life and rituals of those ancient tribes.
>
> "Now that I am working on *Sacre*," Vaslav went on, "Roerich's art inspires me as much as does Stravinsky's powerful music—his paintings, *The Idols of Ancient Russia, The Daughters of the Earth,* and particularly the painting called, I think, *The Call of the Sun*. Do you remember it, Bronia? . . . the violet and purple colors of the vast barren landscape in the predawn darkness, as a ray of the rising sun shines on a solitary group gathered on top of a hill to greet the arrival of spring. Roerich has talked to me at length about his paintings in this series that he describes as the awakening of the spirit of primeval man. In *Sacre* I want to emulate this spirit of the prehistoric Slavs."[19]

When she rehearsed the Chosen Maiden's solo, the Dance Sacrale that ends the ballet, Bronislava Nijinska was aided in her execution by imagining Roerich's painting of dark clouds in a stormy sky.[20]

All the other dancers, however, balked at Nijinsky's innovative choreography, considering it graceless, unnatural, and exceedingly difficult both technically and rhythmically. The more they protested, the harder Nijinsky worked them. "Only Roerich," Bronislava Nijinska comments, "supported Vaslav. He often came to the rehearsals and encouraged Vaslav, who would listen attentively. The only time Vaslav appeared relaxed during rehearsals was when he was with Roerich."[21]

By opening night—May 29, 1913, at the Théâtre des Champs Elysées—Diaghilev was well aware that the work would challenge all previous conceptions of the meaning of ballet. But the reaction of the audience was even stronger than he had anticipated. From the opening strains of Stravinsky's harsh, atonal score and the first convulsive movements of the dancers, the auditorium erupted in a cacophony of shouts, whistles, and stomping that drowned out the orchestra. One eyewitness recalled, "The young man seated behind me in the box stood up during the course of the ballet to enable himself to see more clearly. The intense excitement under which he was laboring betrayed itself presently when he began to beat rhythmically on the top of my head with his fists. My emotion was so great that I did not feel his blows for some time."[22] Nijinsky's future wife, Romola, recorded the reactions of other spectators: "One beautifully dressed lady in an orchestra box stood up and slapped the face of a young man who was hissing in the next box. Her escort rose, and cards were exchanged between the men. A duel followed next day. Another society lady spat in the face of one of the demonstrators. La Princesse de P. left her box, saying,

'I am sixty years old, but this is the first time anyone has dared to make a fool of me.' "[23] At one point in the ballet, when the maidens hold their hands against their cheeks, shouts of "Is there a dentist in the house? They've all got toothache!" rang out, followed by others retorting "Quiet . . . Shut up!"[24]

From his box, Diaghilev, perhaps secretly pleased by the publicity-making scandal, commanded, "Laissez achever le spectacle!" but after a short pause, during which the music and the sound of the dancers' stamping feet could be heard, the near riot resumed with renewed force and continued unabated throughout the intermission. While the maidens wove their mystic circle dance at the beginning of the second act, the audience quieted down, as if temporarily mesmerized by the haunting lyricism of the music and the exquisitely intricate pattern of the dance against the ominous nocturnal setting. But once the bear-skin-clad ancestors appeared and began their ritual stamping around the Chosen Maiden, the public exploded again. The shouting and booing gradually subsided, however, as the Chosen Maiden launched into her sacrificial dance. With movements resembling a bird struggling desperately to lift its body in flight—whether trying to escape her fate or striving toward it is left ambiguous—she held the audience spellbound until, with a final shudder, she expired—Yarilo's victim or, as Roerich and others interpret it, his bride.

The public outcry against *Le Sacre du Printemps*—some Parisians associated the men's white shirts with straight-jackets and the frenzied dances with the ravings of the insane—deeply upset Nijinsky and caused Stravinsky to leave his box after the first act. But Roerich saw the transformation of the sophisticated Parisian audience into a brawling, bellowing mob as an indication that on some visceral level the ballet had unleashed the crowd's own primordial instincts: "Who knows," he later wrote of the performance, "perhaps at that moment they [the audience] were inwardly exultant and expressing this feeling like the most primitive of peoples. But I must say, this wild primitivism had nothing in common with the refined primitivism of our ancestors, for whom rhythm, the sa-

cred symbol, and subtlety of movement were great and sacred concepts."[25]

The ballet was performed only eight times that season—five in Paris and three in London, where the response was more favorable—and then summarily dropped from the repertoire, in part because Diaghilev soon severed his relationship with Nijinsky. The impresario revived *Le Sacre du Printemps* seven years later, again with sets and costumes by Roerich, but with new and less controversial choreography by Leonid Massine. The music that so shocked audiences in 1913 has come to be considered a classic, and many of the twentieth century's leading choreographers, including Martha Graham and Maurice Béjart, have staged their own versions of the ballet to it. But it was not until 1987, seventy-five years after the premiere of the original production, that a recreation of it was staged by the Joffrey Ballet. Thanks to the indefatigable efforts of dance historian Millicent Hodson and Roerich expert Kenneth Archer, who painstakingly reconstructed the choreography, costumes, and sets, contemporary audiences were given the opportunity to see for themselves the ballet that is now routinely credited with breaking the ground of twentieth-century choreography. The revival may have appeared less daring to today's audiences than the original did to the crowd in the Théâtre des Champs Elysées in 1913; nevertheless, the primal, visceral passions it sent pulsing across the footlights were a testament to the elemental power of the Roerich/Nijinsky/Stravinsky evocation of that eternal and universal phenomenon, the rebirth of spring.

It is noteworthy that in her review of the Joffrey *Sacre*, *New York Times* dance critic Anna Kisselgoff praised the revival, singling out its restoration of "the essential and major role played in the ballet's creation by Nicholas Roerich, the painter who envisioned the 1913 original. By reconstituting his sets and costumes, the revival underscores his guiding role in the concept behind 'Sacre.'"[26]

Le Sacre du Printemps was by far Roerich's most significant and original contribution to the theater. In it he brought to bear not only his mastery as a stage designer and his knowledge of ancient pagan rites and customs, but

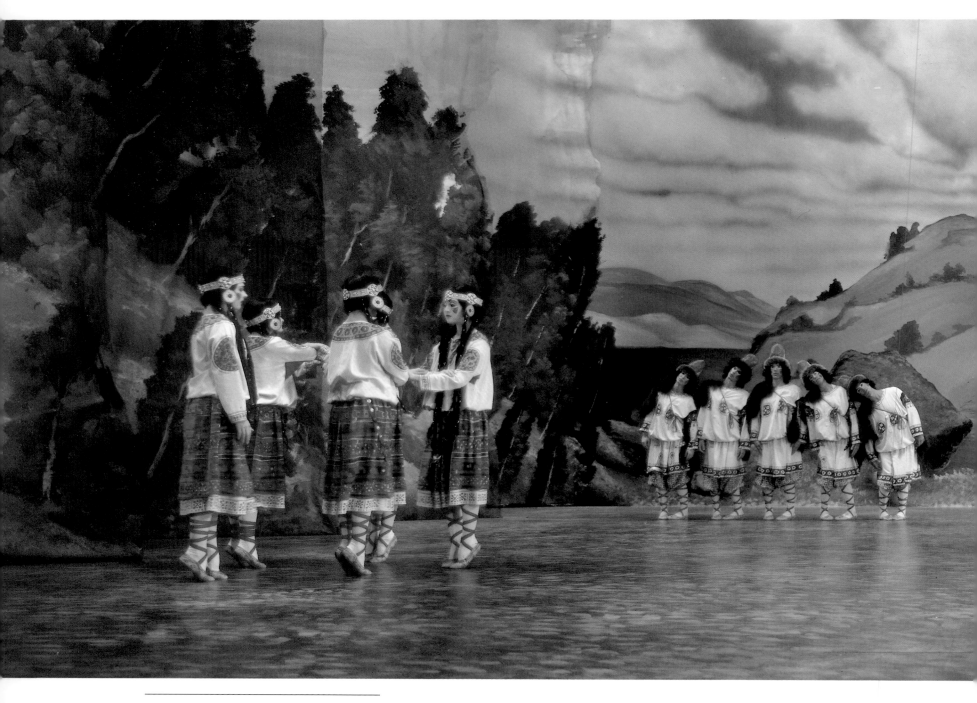

SCENE FROM ACT I OF THE JOFFREY BALLET'S 1987
REVIVAL OF THE ORIGINAL *LE SACRE DU PRINTEMPS*.
PHOTO BY HERBERT MIGDOLL.

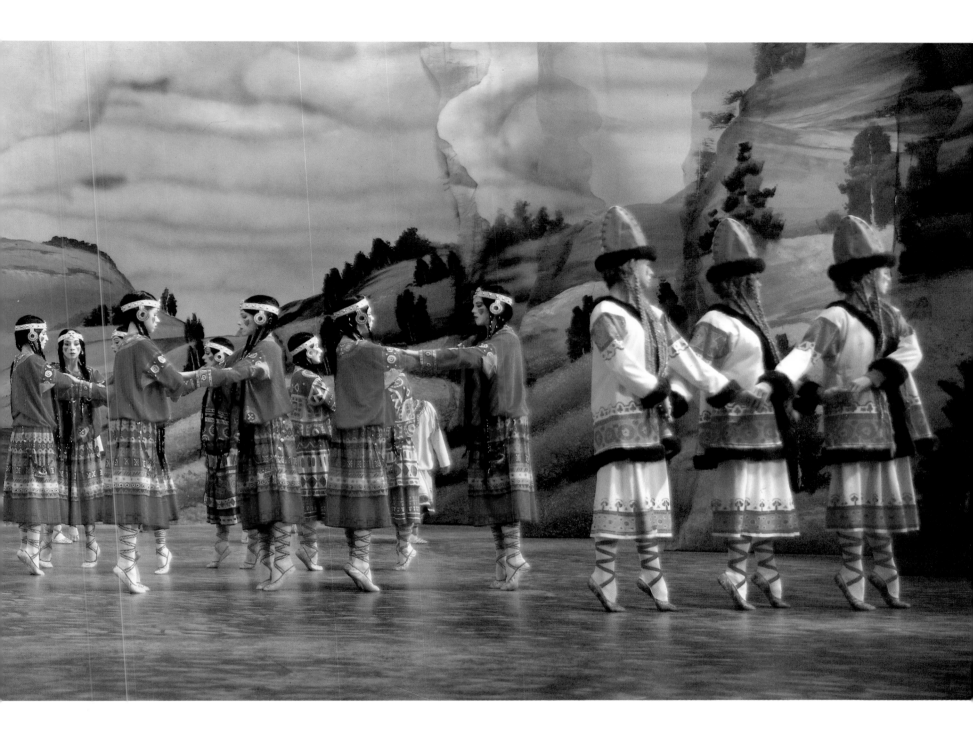

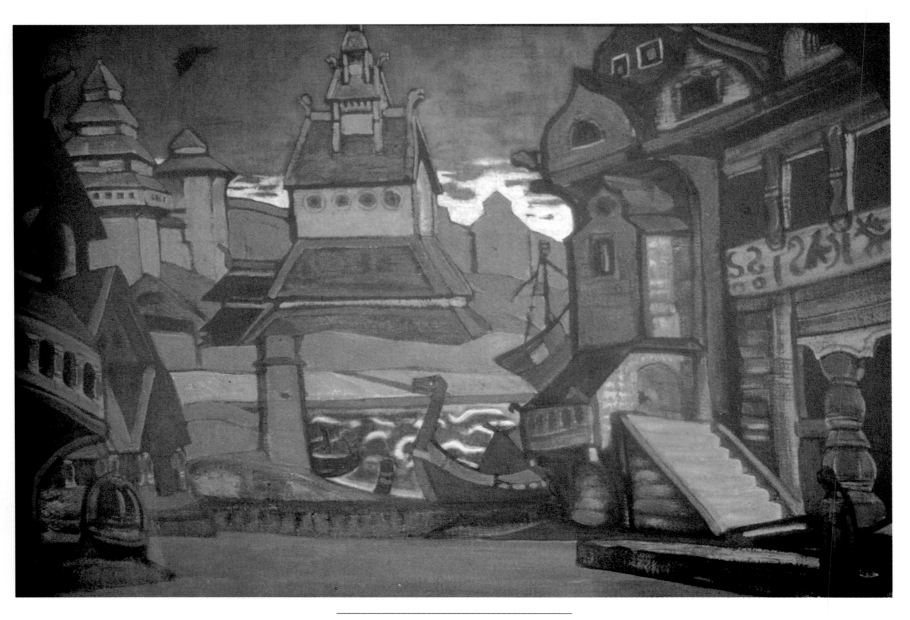

Tmutarakan, 1919.
SET DESIGN FOR RIMSKY-KORSAKOV'S OPERA *THE TALE OF
TSAR SALTAN*. TEMPERA ON CANVAS, 21 X 36 IN.
BRANDEIS UNIVERSITY, WALTHAM, MASSACHUSETTS.

his entire *Weltanschauung*. It represented the culmination, and the synthesis, of his career to that point.

He went on to design several other new productions, including Rimsky-Korsakov's operas *Sadko* and *The Tale of Tsar Saltan* (opposite), presented in London in 1920, and redesigned productions he had already become renowned for, such as *Prince Igor, The Snow Maiden,* and *Le Sacre du Printemps* itself, but never again would he play as central a role in the conception and execution of a theatrical work as he did for the original *Sacre*.

In contrast to other Russian set designers of the prewar period, such as Golovin, Korovin, Bakst, and Benois, Roerich was considered aloof and uninterested in the backstage hustle and bustle of theater life. True, he rarely helped in the actual painting of the sets as other designers did at the time; rather, he presented directors with completely finished sketches that were marvelous easel paintings in their own right and that, when enlarged to the size of the stage, became the sets. But, as the rehearsal journals for *Peer Gynt* and Bronislava Nijinska's memoirs about *Le Sacre du Printemps* attest, he did in fact take an active part in overseeing the execution of his designs and in the integration of the sets with the performance of the actors, singers, and dancers.

As a set designer, Roerich was not a mere illustrator but an interpreter. The directors who commissioned him knew that they would have to subordinate their productions to the majestic range of his colors and flow of his rhythms, rather than the other way around. Sometimes his sets simply overpowered the performers. But whenever his interpretation of the music, the action, the atmosphere of time and place, and the images of the characters coincided with the vision of the director or choreographer, composer or dramatist, and performers, the result was theater at its best, capable of stirring audiences to a frenzy and bringing them in touch, however subliminally, with their deepest emotions.

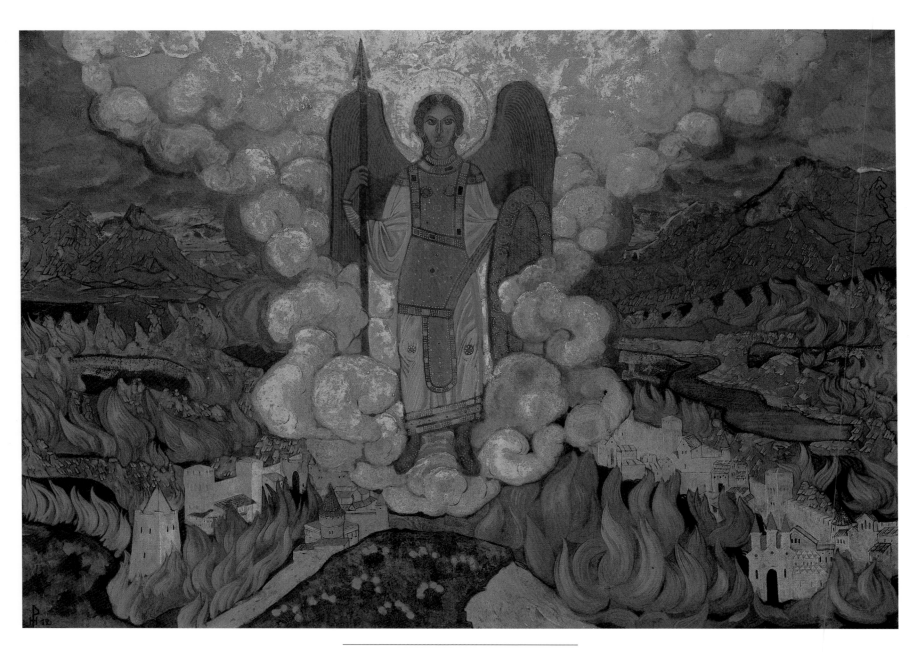

The Last Angel, 1912.
TEMPERA ON BOARD, 20½ X 29 IN.
NICHOLAS ROERICH MUSEUM, NEW YORK.

TRANSITION

Roerich's foray into the theater did not bring his other pursuits to a halt. On the contrary, he continued his easel painting and his work on various church murals and mosaics; he also completed a nineteen-panel frieze for a private home. Moreover, he kept up with his directorial duties at the school of the Society for the Encouragement of the Arts, was appointed academician of the Imperial Academy of Arts, and became a member of the Society for the Protection and Preservation of Monuments of Art and Antiquity in Russia, president of a commission to establish a museum of ante-Petrian art and culture, a member of the Rheims Academy, an honorary member of the Vienna Secession, a member of the Paris Salon, and, in 1910, president of the new Mir Iskusstva.

The artist Igor Grabar, Roerich's contemporary and a future director of the Rublev Museum, marveled at Roerich's seemingly inexhaustible ability to take on ever more responsibilities without sacrificing the quality of his art. He once observed:

> For me Roerich's life was a complete enigma. It often happened that you would visit him in his apartment at the Society for the Encouragement [of the Arts] . . . and you would find him at work on a large panel. He willingly shows you a dozen or so other works that he has done in the month or two

since your last visit; each one better than the last, no hack work, nothing banal or boring. . . . After fifteen minutes a secretary brings him a pile of papers to sign. He signs them quickly without reading them, knowing that no one is about to deceive him: his office has been set up in model fashion. Fifteen minutes later a servant rushes in:

"The grand duchess has arrived."

On the run he barely has time to shout out an invitation for me to stay for lunch. Thus he painted his superb works, signed important papers, received his visitors and guests—enemies and friends alike—with equal joy (the former perhaps even more joyfully), then returned to his paintings, constantly interrupted by telephone calls and all the usual meetings and problems. Thus passed day after day of his hectic, vital life. Over the entire course of our acquaintance he hardly changed: the same pink complexion, the same preoccupation in his eyes, even when he smiled; only his flaxen hair thinned out and his blond beard turned white.[1]

At the St. Petersburg Salon exhibition of 1909, many of Roerich's most important works of the preceding several years were shown, including sketches for murals; the paintings *Slavs on the Dnieper* (1905), *The Battle* (1906), *The Dragon's Daughter* (1906), *Song of the Viking* (1907),

The Town (1907), *Designing the Garment* (1908); landscapes of Italy, Germany, and Finland; illustrations for Maeterlinck's plays; sketches for the operas *Die Walküre* and *The Snow Maiden*—thirty-six works in all. As Benois remarked, this array created the impression that the ship had listed to one side and the whole Salon served merely as a setting for Roerich.[2]

A common feature of all the easel paintings exhibited is the medium in which they were executed. By 1906 Roerich had switched almost exclusively from oils to tempera and pastels, which lent his mature work its characteristic bright, pure colors and flat, velvety surface. In his view, "Tempera is unmatched by oils. Paint is fated to change—better to let paintings become dreams than black boots."[3] After seeing an unfinished painting by Michelangelo done on a greenish canvas in London's National Gallery, he began to experiment with colored canvases as well, intrigued by the unexpected effects they gave to the color combinations.

In *Slavs on the Dnieper*, Roerich continues his portrayal of ancient Slavic culture (opposite). Just as busily as they built their cities and boats, the members of a tribe are here seen laden with sacks of provisions, descending from their settlement on top of a green cliff, past their wooden idols, to Varangian ships that have docked at this spot on their river journey. It is one of the artist's most opulently decorative canvases. The colors are rich, clear, and pure, as if washed in a cool, moist, morning breeze. Against the deep, lush green of the cliffs, the red sails, dragon-shaped bows, shields, and painted idols stand out brightly. Despite the downward movement of the tribesmen, their figures bent beneath the weight of their load, and the many horizontal elements—the ships, the tops of the sails, the line of the cliffs—the thrust of the painting as a whole is upward, thanks to the strong verticals of the masts, bows, and idols, and the wisp of smoke emanating from one of the earthen, tent-shaped dwellings at the very top of the picture. Because the paint is applied in flat patches outlined in black, the entire work has the feeling of the ancient art of cloisonné.

The Dragon's Daughter is a haunting work (pages 70–71). It depicts a fearsome dragon locked in combat with a cloaked horseman astride a powerful, galloping steed. The end of the dragon's massive tail circles menacingly around the figure of a beautiful maiden, her face sadly lowered and turned away from the struggle, her naked body partially concealed by long, golden, serpentine tresses. On her head she wears a crown. The action takes place in a rocky field, above which threatening clouds swirl in a dark crimson sky. In the distance to the far right, the walls and towers of a medieval town can be discerned. The painting evokes many associations, ranging from ancient Slavic fairy tales of fair princesses, evil dragons, and valiant heroes to the Christian legend of St. George and the dragon.

The Battle and *Song of a Viking* belong to a cycle of works devoted to ancient Scandinavia. In this series the artist is less interested in depicting specific historical events—as he had been in earlier works such as *Overseas Guests*—than in paying poetic tribute to the homeland of his forefathers. *Song of a Viking,* for instance, depicts a beautiful young Scandinavian woman in the tower of an old castle, looking sadly, longingly, out over a desolate sea, waiting eternally for her seafaring Viking to return. In *The Battle,* which proved to be the sensation of the 1909 Salon exhibition, two fleets of Viking ships, their blood-red sails filled with wind, clash violently on a churning sea, while above them, in the ominously copper-crimson sky, heavy masses of clouds collide with equal fury. This is not a battle in which there is a winner or loser; rather, the scene suggests the very essence of battle, its inevitability and mercilessness as well as its beauty.

Other paintings in the Scandinavian series include *Triumph of the Viking* (1908), *Varangian Motif* (1910), *Varangian Sea* (1910), and *The Old King* (1910). Some, like *The Battle,* have a tremendous dynamism; others, like *Song of a Viking,* a quiet lyricism. All share a severity and sternness born of the rocky landscape and endless sea. Nature is dominant in all these works and is inextricably interrelated with the human condition—reflecting, heightening, eternalizing the figures' moods or actions, suggesting ties between the natural and the spiritual worlds. Years later

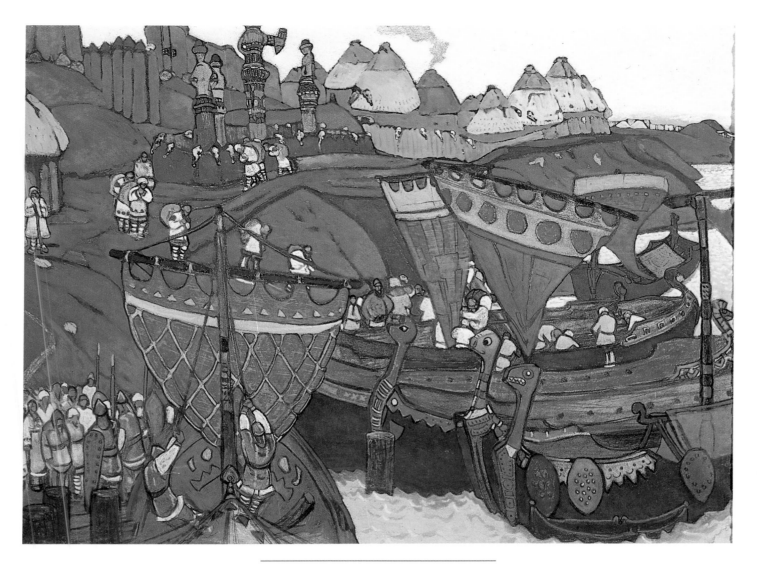

Slavs on the Dnieper, 1905.
PASTEL, TEMPERA ON BOARD, 26½ X 35 IN.
STATE RUSSIAN MUSEUM, ST. PETERSBURG.

the Russian writer Leonid Andreyev characterized the unique world the artist created in his canvases as "the realm of Roerich."

In 1907 F. G. Bazhanov, a wealthy St. Petersburg industrialist, asked Roerich to paint a frieze for the large dining room of his new home. The artist seized upon this opportunity to celebrate—on a monumental scale—his

favorite heroes of Russian folklore. Completed in 1910, *Bogatyr Frieze* consists of seven large panels, each devoted to a different legendary figure, and twelve smaller panels,

OVERLEAF: *The Dragon's Daughter,* 1906.
TEMPERA ON BOARD, 19¾ X 35 IN.
STATE RUSSIAN MUSEUM, ST. PETERSBURG.

69

era had come and a portent of what lay ahead. Many artists and writers had premonitions of impending catastrophe, and their work reflected this growing sense of alarm. Roerich produced many paintings between 1912 and 1914 that are nothing short of prophetic of the cataclysm that was about to shatter the world. They include *The Last Angel* (1912), *Sword of Valor* (1912), *Cry of the Serpent* (1913), *The Doomed City* (1914), *Conflagration* (1914), *Crowns* (1914), *Human Deeds* (1914), and *The Herald* (1914). All portend inescapable doom and destruction through powerful allegorical symbols drawn from folk and biblical art. *The Last Angel* depicts the earth and its cities being devoured by flames (page 66). Above this conflagration, amid swirling, fiery clouds, an icon-like sword-and-shield-bearing angel stands, signaling the advent of the Last Judgment. A fiery angel also figures in *Sword of Valor;* it is bringing a sword for the defense of a castle, around which negligent guards are sleeping.

The serpent as an omen of impending disaster is the dominant image in both *Cry of the Serpent* and *The Doomed City.* The first depicts a landscape of jagged, barren, desolate cliffs in front of which an enormous red serpent raises its fearsome head as it emits an anguished shriek. In the second, a gigantic green and red serpent has wound itself around a sleeping city, cutting off any hope of escape or rescue for the city's inhabitants. The writer Maxim Gorky was especially taken by this work and dubbed Roerich "the great intuitionalist."

The inevitable doom of the city is also the theme of *Conflagration,* in which a knight stands helplessly by as flames engulf a medieval walled castle, casting a crimson glow in its windows and garishly illuminating the earth and sky. That same theme is expressed in *Human Deeds,* in which a group of elders observe the wreckage of a city lying at their feet. In Roerich's iconography, the ancient or medieval city is symbolic of the achievements of human culture. Its destruction, therefore, is tantamount to the end of culture.

Crowns is an allegory for the senselessness and folly of war. Three kings fight one another bitterly on the shore of a deep violet-blue sea, their royal robes billowing in the wind, their swords menacingly raised. In the heat of battle, the kings do not notice that their crowns are no longer on their heads but have been transformed into pink clouds in the sky.

In *The Herald,* a black ship, a traditional harbinger of evil, approaches a steep, bleak cliff (page 74). The news it brings to the fortress on the cliff is ominous. Even the dove-shaped cloud in the sky, the age-old symbol of peace, does not relieve the foreboding atmosphere.

Once the war began, Roerich lent his abundant energy, talent, and personal resources to many charitable undertakings. He participated in an exhibition and an auction to benefit a military hospital, contributing valuable majolicas and other art works from his own sizable collection. He also donated large amounts of money to help injured colleagues and their families. But the main focus of his wartime activity was his fight to protect and preserve the world's cultural landmarks, a cause to which he had devoted himself ever since his 1899 trip through Russia along the great river route.

Horrified by reports of Gothic cathedrals being exploded and medieval towns being burned, just as his prewar works had prophesied, in 1914 he painted a poster entitled *Enemy of Mankind,* which depicts the destruction of cultural treasures in Louvain and Rheims. The poster was distributed to army camps and military zones. He felt that an international agreement to insure the safekeeping of educational institutions and monuments of culture in times of war was essential, and succeeded in proposing the idea to the high command of the Russian army, the governments of the United States and France, and in 1915 to Tsar Nicholas II himself. Although the proposed treaty was not rejected, no steps were taken at the time to enact it.

Roerich could also attempt to counteract the devastation of the war through the message of his paintings. Many of his works during the war years extol peace, serenity, and good deeds. A typical canvas of the period is *The Three Joys* (1916), in which a peasant, his wife, and their son are seated on a bench in front of their wooden

The Herald, 1914.
CHARCOAL, PASTEL ON BOARD, 29½ x 35 IN.
STATE RUSSIAN MUSEUM, ST. PETERSBURG.

house, its eaves and shutters decoratively carved in the northern Russian tradition. The gate to the house is open, and coming into the yard are two wandering musicians, a stooped old man with a staff in his hand and a younger man carrying a *gusli* on his back. Next to the house a river flows, and all around it stretch green hills and golden fields of rye. Three saints are helping these hospitable, righteous peasants care for the land: St. George tends the horses, St. Nicholas looks after the cows, and St. Elijah reaps the rye. Both the subject and the pure, bright colors make this painting a spiritually uplifting work, a modern icon affirming constructive, peaceful labor.

For Roerich, the ultimate symbols of spiritual love and goodness were those saints and ascetics who, through their good deeds, help and defend mankind. St. Panteleimon, for instance, was a healer and expert in medicinal herbs, according to legend. In *St. Panteleimon—The Healer* (1916), a work of extraordinary beauty, Roerich portrays this wise and gentle saint bending down over a lush, flower-carpeted field in search of curative herbs. The wildflowers appear as little sparks of brilliant color, suggesting nature's eternal variety and wonder. He returned to this subject many times throughout his life. In a later version (1931), Panteleimon's saintliness is emphasized by a halo of light circling his head (page 76).

Another favorite saint was Procopius. In the paintings *Procopius the Righteous Praying for the Unknown Travelers* and *Procopius the Righteous Averting the Stone Cloud from the City of Ustug the Great* (both 1914), this holy man is shown protecting people through the sheer power of his spirit.

Roerich's landscapes of the war period have the same tranquil, serene quality as the works discussed above. *Black Shore* (1916), done all in subtle shadings of soothing grays and greens, is an example.

The more Roerich studied ancient Slavic and Indian culture, the more convinced he became that they shared common origins. But to prove this theory he knew it was necessary for Russian scholars to examine the ancient art and customs of the East firsthand. He was convinced that time was of the essence, fearing that under English rule many of the vestiges of Indian culture would be wiped out.[7] He was thus overjoyed by his meeting in Paris before the war with the orientalist V. V. Golubev, who had recently returned from India with photographs, artifacts, and observations that supported his theory. He had hoped to join Golubev on the scholar's next trip, but the war intervened.

Eastern culture, philosophy, and religious teachings held an ever greater appeal for both Nicholas and Helena Roerich. The writings of Ramakrishna and his disciple Vivekananda left a deep and lasting impression on them, particularly the idea that devotion to God was accomplished through activity useful to society, through every person's fulfillment of his duty and obligations, and that this devotion in turn facilitated the perfection of the individual. Ramakrishna preached the necessity of spiritual perfection, which could be attained through the enlightenment of individuals, by schooling man in goodness, justice, and altruism.[8] It is likely that Roerich's paintings illustrating the good works of saints were inspired by these concepts. His written work of this period includes allusions to and quotes from Tagore, Ramakrishna, Vivekananda, and the *Bhagavad Gita*.

Roerich's belief that modern man had much to learn from ancient, prehistoric man undoubtedly drew him to a fundamental tenet of Eastern philosophy—that the history of the universe is cyclical rather than linear. The Eastern concept of "a perennial philosophy, an ageless wisdom, revealed and re-revealed, restored, lost, and again restored through the cycle of the ages"[9] was much closer to Roerich's vision than the relatively recent Western view of history as an ever-progressing phenomenon.

Theosophy (literally, divine wisdom), a spiritual doctrine developed by Helena P. Blavatsky in the 1870s, also appealed to the Roerichs. Blavatsky had traveled to the East, where she claimed to have had a meeting with a group of mysterious ancient sages—the masters or mahatmas—in whom divine wisdom resided. She became their student (*chela*), and when she returned to the West she began to impart the spiritual knowledge she had received. Blavatsky founded the Theosophical Society in New York in 1875, and it gained many thousands of adherents

St. Panteleimon—The Healer, 1931.
TEMPERA ON CANVAS, 21 X 34½ IN.
NICHOLAS ROERICH MUSEUM, NEW YORK.

throughout the world. In 1879 she transferred its head-quarters to Adyar, India, near Madras. A Russian branch of the Society was founded in 1908, and the Roerichs apparently joined it prior to World War I. Years later, Helena Roerich translated Blavatsky's monumental work *The Secret Doctrine* into Russian.

Theosophists maintain that the ancient wisdom is accessible to everyone and that it is revealed to the initiated in various ways: in dreams, in visions, or in communications from the mahatmas. Theosophy rejects scriptural

dogma but incorporates certain basic concepts of Indian philosophy, including reincarnation and karma, the interdependent unity of all natural phenomena, and the reverence of the student (*chela*) for the spiritual teacher (*guru*).

Roerich was not an adherent of any one established religion or philosophical movement. His own deeply spiritual philosophy incorporated elements of Buddhism, Hinduism, pantheism, theosophy, Russian Orthodoxy, and even the theory of relativity. He also embraced the ancient teachings of Agni Yoga, or the Yoga of Fire. A

yoga of action rather than asceticism, Agni Yoga teaches the path of cooperation with the spiritual evolution of the cosmos. It helps the individual to discern what is good and to identify the real causes and meaning behind events and personal relationships. With this understanding, human consciousness expands, giving birth to new patterns of thought, which in turn give rise to the possibility of new action. Free will empowers the individual with the option of either taking the new path and changing his behavior or falling back into old, ingrained patterns. Each incarnation gives him the opportunity to take further steps in the evolutionary process. Agni Yoga urges us to strive toward that new path in our daily lives, and for that reason it is called the Teaching of Living Ethics. In 1920 the Roerichs formed the first groups devoted to the study of Agni Yoga. Still in existence today, the Agni Yoga Society remains dedicated to the recording and dissemination of a "living ethic" that encompasses and synthesizes the philosophies and religious teachings of all ages.

Roerich's most concise expression of his understanding of the path to spiritual enlightenment is a collection of sixty-four poems in blank verse, *The Flowers of Morya,* written in large part between 1916 and 1921. It is divided into four cycles: "Sacred Signs," "The Messenger" or "To the Blessed One," "To the Boy," and "Admonition to the Hunter Entering the Forest." The last part consists of one long poem. In each of the poems, with the exception of the last, the title and the final word or phrase are the same, suggesting circularity, a widely recognized symbol of eternity or infinity.[10] The content of the cycles may be summarized briefly as follows:

In the first cycle the author/hero is a spiritual novice who searches for but has not yet found the sacred signs (verbal and nonverbal messages from higher spheres) to guide him on the way. In the second cycle, as signs begin to be revealed, he acquires a more definite sense of direction. In the third cycle he already has enough knowledge to lead another novice and, by the time we reach the fourth, his voice has taken on the authority of a guru. But his ascent is not simply vertical because, in each segment of his journey, he experiences moments of doubt and disorientation which make it necessary for him to retrace his steps on the spiralling path.[11]

Many of the verbal images Roerich uses in *The Flowers of Morya* reappear as visual images in his art and are often keys to understanding the underlying spiritual significance of his paintings. Divergent trails suggest disorientation. Mountains are symbolic of spiritual ascent. Gates or doors denote either spiritual progress, if the seeker has succeeded in crossing the threshold; spiritual arrival, if the seeker has reached the threshold; or a spiritual barrier, if the gate or door is closed. Messengers are transmitters of God's wisdom. Water in general stands for purification and renewal, and rivers, which flow in a specific direction, suggest transition and movement toward a goal.

In "The Gatekeeper," one of the poems in the first cycle, the gate/door image serves as a metaphor for a spiritual threshold that the author/hero is not yet ready to cross because he does not understand the sign that is being revealed to him. The poem is also indicative of Roerich's poetic style, which is characterized by simple syntax; a calm, solemn tone; neutral, slightly archaic language; and, to suggest the *guru/chela* relationship, much dialogue.

The Gatekeeper

"Gatekeeper, tell me, why
are you closing this door?
What are you guarding so staunchly?"
"I am guarding the secret of quietude."
"But quietude is empty. Reliable people
say there is nothing in it."
"I know the secret of quietude.
I am placed to guard it."
"But your quietude is empty!"
"It is empty to you,"
replied the gatekeeper.[12]

Early in 1915 Roerich became gravely ill with pneumonia. The many years of unabated, strenuous activity had evidently taken their toll. His doctors came to the conclusion that it was harmful for him to live in the city, and in December 1916 he and his family moved to Sortavala, Finland, on the shore of Lake Ladoga, close enough to Petrograd (as St. Petersburg was renamed at the start of World War I) to enable him to return at intervals to take care of school business. That same year—1916—marked twenty years since the start of Roerich's career, and in recognition of his artistic achievement, a large, beautifully illustrated jubilee book was published. It included appreciations of his work by other artists, art historians, poets, and prose writers; color plates of some of his major paintings; ten of his fairy tales and parables; and his long poem about Genghis Khan entitled "The Leader."

Opinions differ about Roerich's reaction to the Russian Revolution. Western scholars claim that he stayed in Finland to escape the new political system. Soviet biographers, on the other hand, maintain that he embraced the Revolution even though he was aloof from politics and naively utopian in his belief that the arts lay outside the political sphere. He did, in fact, advocate a more progressive society that would eradicate the blatant injustices of the time, and he was convinced of the irreversibility of the revolutionary movement. But in the interest of his beliefs he sided neither with the revolutionaries nor with those who yearned for a return to the old order.

Whatever his true feelings were, one fact is certain: he was very concerned about the fate of his school and about the preservation of cultural monuments under the new government. On March 4, 1917, just days after the overthrow of the Romanov monarchy, he met with a group of writers, artists, and performing artists, including Chaliapin, the poet Mayakovsky, and Benois, at Maxim Gorky's apartment. Gorky spoke of the need to create a commission to protect monuments of art and culture and to issue proclamations calling for the preservation of the cultural legacy of the past. Roerich was appointed to the twelve-member commission. In a written announcement to the newly formed revolutionary council, the Soviet of Workers' and Soldiers' Deputies, the commission offered its services on matters of art, including advice on the preservation of ancient cultural monuments and the creation of an organization to oversee people's festivals, theaters, and so on. Roerich also attended a conference on the arts that was organized by the Soviet of Workers' and Soldiers' Deputies and joined the Soviet's own art commission, several meetings of which were held in the home of Roerich's brother Boris.

In spite of his still failing health—by May 1917 his condition had worsened to such a point that he drafted a will—Roerich went to Petrograd as often as possible to try to save the school of the Society for the Encouragement of the Arts from collapse. But financial difficulties and resistance among the teachers, many of whom hoped for a return to the old regime, impeded the economic and organizational reforms he proposed. In August his health no longer permitted him to oversee the daily running of the school and he resigned as director, although he remained an advisor and member of the school committee.

Roerich's last visit to Petrograd was in January 1918. Although friends and colleagues tried to convince him to stay, telling him that he might even be offered a ministerial post in the new government, he and Helena Roerich left for Sortavala on one of the last trains out of the country before the border between Finland and the Soviet Union was closed for good in May.

The artist's long illness did not keep him away from painting or writing. The house in Sortavala was surrounded by a typically Roerich-like landscape: its towering pine trees, rolling green hills, and little steep-cliffed islands arising out of Lake Ladoga were masterfully captured by his brush. He peopled these canvases with figures standing on the shore or sitting on rocks gazing into the distance.

In addition to his painting, he wrote a short story, "The Flame," about an artist whose paintings bring him tremendous success when they are shown at an exhibition. A publisher offers to make reproductions of the works;

beknownst to the publisher, the artist gives him exact copies to print from. The copies are destroyed in a fire at the publishing house. When the artist exhibits the originals a second time, the critics take them for inferior copies. At first the artist is consumed by "a scarlet flame. The flame of anger. The flame of madness." But then he goes off to an isolated spot on a lake, his anger cools, and he even reflects calmly when he reads a newspaper report of his own death: "I know that I am working. I know that my work will be needed by someone. I know that my flame is no longer scarlet. And when it turns blue, then we'll think about departing." Though "The Flame" is fiction, its autobiographical elements are only thinly veiled. Roerich was aware that many considered his prodigious output suspect; they thought it inconceivable that a single artist could paint hundreds, even thousands, of works. In 1914 there had actually been a fire in a Moscow publishing house where an illustrated book about Roerich was being printed, and all the pages were destroyed. Like the artist/hero, Roerich went off to an isolated spot. He too continued working and waiting for a sign, a sacred blue flame, to light his way on his own artistic and spiritual journey.

Roerich also wrote a play entitled *Miloserdie* (Mercy or Charity). Written in the style of a medieval mystery play, it takes place in a castle reminiscent of Roerich's designs for Maeterlinck's plays. Messengers rush in to inform the elders that cities and their inhabitants are perishing at the hands of a fierce enemy. Culture is being destroyed. The maddened masses are burning buildings and books, beating up youths, opening prisons, and freeing all the murderers. Criminals are leading the crowds. The play is dated November 1917, coinciding with the taking of the Winter Palace in Petrograd by the Red Guards. *Mercy* is Roerich's single unequivocal indictment of the Revolution and the threat it posed to Russian culture.

Both "The Flame" and *Mercy* were Roerich's artistic means of putting the past few years behind him in order to begin a new stage in his life. "The Flame" ends with lines from the *Bhagavad Gita, Mercy* with a translation of a Rabindranath Tagore poem. The East was calling to Roerich.

In his diary for October 26, 1917, he wrote, "I bow to the ground to the teachers of India. They have brought true creativity and spiritual joy and a fruitful silence into the chaos of our life. At a time of extreme need they have sent us a call. A serene, earnest, wise call."[13]

In his painting *Karelia—Eternal Expectation* (1918), four figures—one woman and three men—sit on rocks on an uninhabited shore, their gaze directed toward the horizon. They await the sign to start on the long voyage.

By the summer of 1918 Roerich's health had finally improved, and he began to make plans for the long-desired trip to India. The first stop was the Finnish city of Vyborg; the first matter of business was to raise money. Through the efforts of several Swedes, an exhibition was organized in Stockholm. Its success exceeded all expectations. The residents of the Swedish capital embraced Roerich as one of their own, an artist of the North. From there the exhibition traveled to Norway and Denmark.

Just across the North Sea from Copenhagen lay England, where the Roerichs hoped to obtain visas to India. It was the omnipresent Diaghilev who secured their entry into England with an invitation for Roerich to design an upcoming production of *Prince Igor* in London. The family arrived in the British capital in the fall of 1919. In addition to designing *Prince Igor* for Diaghilev, Roerich was commissioned by Sir Thomas Beecham to design sets for *The Snow Maiden, Tsar Saltan,* and *Sadko.* An exhibition of his work was mounted in May 1920, and invitations then came pouring in from other cities in England as well as from Venice.

The paintings Roerich made in London reveal that even though he was living in England, his spirit was already in the East. Two decorative panels for a private residence in London, *Song of the Waterfall* and *Song of the Morning* (page 80), are delicate, shimmering works with a pronounced Indian flavor. The first depicts an Indian woman contemplating a flower at the base of a cascading waterfall; the second, an Indian woman dancing with a deer in front of a temple-like structure, on the top of which a peacock is perched. Both of these canvases belong

to a series the artist called "Dreams of Wisdom." Coincidentally, while he was working on this series, Rabindranath Tagore came to see him at his studio. It was a meeting Roerich had long dreamed of. "I remember how beautifully he entered," Roerich recalled in *Diary Leaves,* "and his spiritual appearance made our hearts palpitate."[14] Tagore invited Roerich to visit him in India. Everything seemed in order for the trip: the visas had been obtained and the tickets bought. But unforeseen financial setbacks, including Sir Thomas Beecham's inability to pay Roerich for the sets he had designed, forced the Roerichs to postpone their journey to the East.

OPPOSITE PAGE LEFT:
Song of the Waterfall, 1920.
TEMPERA ON CANVAS, 92 X 48 IN.
NICHOLAS ROERICH MUSEUM, NEW YORK.

OPPOSITE PAGE RIGHT:
Song of the Morning, 1920.
TEMPERA ON CANVAS, 92 X 48 IN.
NICHOLAS ROERICH MUSEUM, NEW YORK.

POSTER OF THE ROERICH EXHIBITION
AT THE KINGORE GALLERY, NEW YORK, 1920–21.

AMERICA

One of the invitations Roerich received while he was in London came from Robert Harshe, director of the Chicago Art Institute. When the trip to India fell through at the last moment, Roerich accepted the American's invitation and on September 23, 1920, set sail aboard the SS *Zealand* with his wife and two sons. In the cargo hold, crossing the Atlantic with them, were several hundred of his canvases, ranging from some of his earliest works to his most recent. Among them were *Idols, Overseas Guests, Varangian Sea, Human Forefathers, The Last Angel,* sketches for *Princess Maleine* and *The Snow Maiden,* and two panels from the "Dreams of Wisdom" series.

The Roerichs arrived in New York harbor on October 3, and the exhibition Harshe had arranged opened on December 18 at the Kingore Gallery in New York City. The first large exhibition of a Russian artist in America, it caused a sensation. The very Russianness of his canvases, and their subject matter, revealed a hitherto unknown world to viewers. The art critic Olin Downes wrote, "In the midst of our modern society, so positive and so limited, [Roerich] gives to his fellow artists a prophetic example of the goal they must reach—the expression of the Inner Life."[1] One of the immediate results of the exhibition was the offer from the Chicago Opera to design its production of *The Snow Maiden.* From New

York the exhibition traveled over the next year and a half to twenty-eight cities across the country, including Boston, Buffalo, Chicago, Omaha, Denver, Santa Fe, and San Francisco. Roerich's work attracted a wide following among American artists and the general public alike; America, in turn, fascinated him.

He was especially drawn to Maine, where the rocky shoreline, steep mossy cliffs, and endless expanse of sea and sky reminded him of Finland and of his native northern Russian landscape. He spent the summer of 1922 there, on Monhegan Island, and painted a large suite of works, the "Ocean" series. The powerful impact of the rugged Maine coast on him is felt in the spare, bold style of these canvases. One, aptly titled *Strength,* depicts a single cliff jutting out into the ocean (page 84). The shape of the cliff distinctly resembles the profile of a long-nosed, defiant-jawed stone giant, his eye veiled by a long thin cloud and his beard formed by the rocks against which the surf crashes.

The deserts of New Mexico and Arizona also arrested Roerich's attention and inspired his brush. The tribal customs of the native peoples of the Southwest struck him as remarkably similar to those of the ancient Slavs and other early cultures, and in their appearance he noted a close resemblance to Asian peoples, particularly Mongolians.

Strength, 1922.
TEMPERA ON BOARD, 21½ X 32 IN.
AQUARIAN EDUCATIONAL GROUP,
SEDONA, ARIZONA.

These similarities convinced Roerich that the natives of the Old and New Worlds shared common origins. He painted the adobe villages and ancient cave dwellings of the Native Americans as though they were growing directly out of the arid, rocky earth. The spectacular colors and rock formations of the Grand Canyon became the setting for *The Miracle* (1923), in which seven figures clad in long white garments have fallen to their knees and lowered their heads to the ground in reverent awe before a radiant circle of light rising just beyond a bridge (pages 86–87). This work belongs to a series called "Messiah."

As a consequence of his exhibition, Roerich was invited to give lectures in various cities at museums, universities, and even Marshall Field's department store in Chicago. There, in conjunction with the great success of his

sets and costumes for *The Snow Maiden* (page 49 and page 88), he gave a talk titled "The Spiritual Garment," in which, probably to the bewilderment of shoppers, he spoke about the integration and harmonization of clothing and the human aura.

As he traveled around the country, Roerich was struck by Americans' lack of familiarity with the art and culture of other nations and surprised that a true interest in art was not widespread, but limited to a narrow slice of the population—the professionals.[2] With these observations in mind, in April 1921 while in Chicago, he took an active part in founding an international society of artists, Cor Ardens (Flaming Heart). Then, in November 1921, in New York, he founded the Master Institute of United Arts, a school based on the same principle as his school in

ROERICH ON MONHEGAN ISLAND, MAINE, 1922.
IN THE BACKGROUND IS THE CLIFF DEPICTED
IN HIS PAINTING *Strength*.

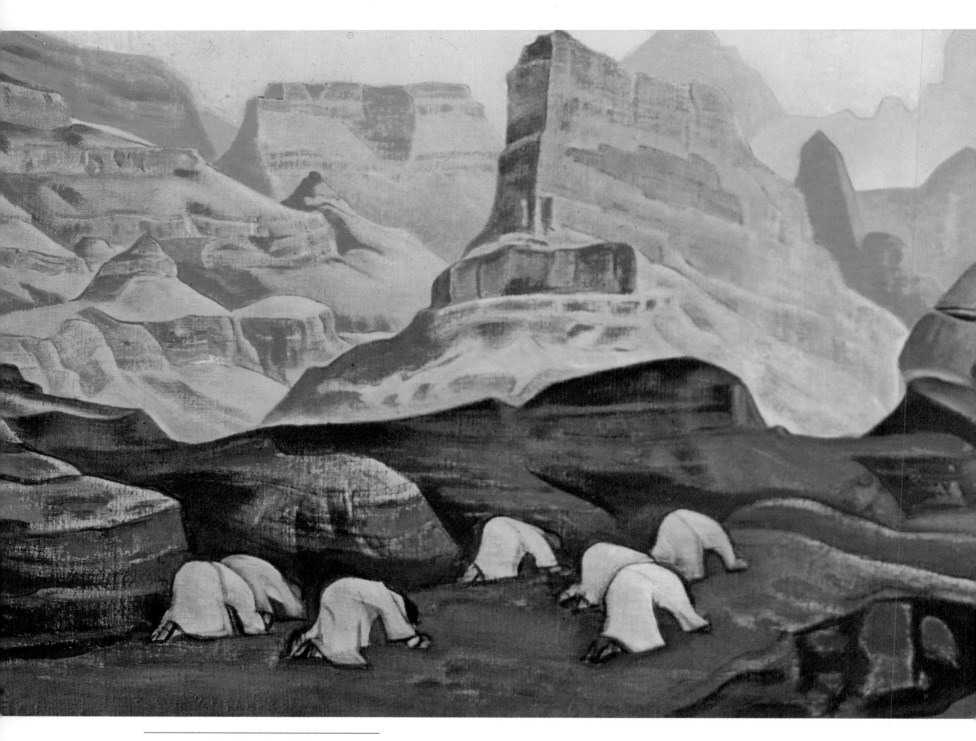

The Miracle, 1923.
Tempera on canvas, 29 x 82¼ in.
Museum of Oriental Art, Moscow.

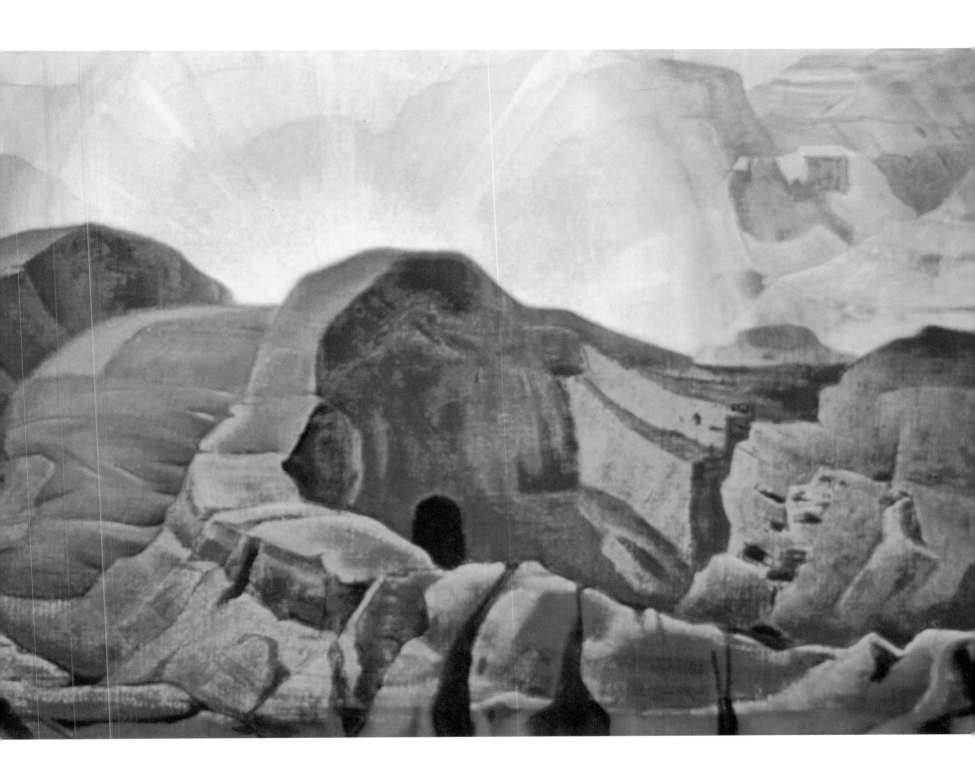

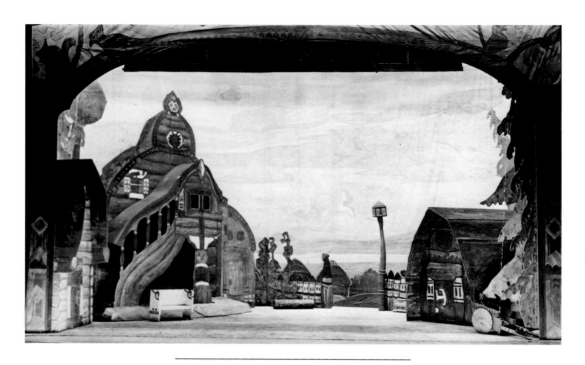

ACT II SET OF *THE SNOW MAIDEN,* CHICAGO, 1922.
IT BEARS A CLOSE RESEMBLANCE TO ROERICH'S
1916 PAINTING *The Three Joys*.

St. Petersburg—all of the arts under one roof. The institute began on a small scale, offering classes in music, painting, sculpture, architecture, ballet, and drama, as well as lectures, concerts, and student exhibitions.

Initially, most of the students and faculty were Russian émigrés, including Sina and Maurice Lichtmann, both of whom taught piano. As Roerich became more well known, the school began to attract American patrons and distinguished teachers as well. Louis Horch, a successful foreign exchange broker, who later worked for the Commerce Department under Roosevelt and Truman,[3] was particularly supportive of the school's aims and generous to the Roerichs. Music critic Frances Grant became the director; Deems Taylor taught musical theory and composition; Robert Edmund Jones and Lee Simonson, theater design; Mikhail Mordkin and Mikhail Fokine, ballet. The guest lecturers included George Bellows, Claude Bragdon,

Norman Bel Geddes, and Rockwell Kent. The enrollment and the number of courses increased quickly, and the school soon moved into a larger building on Riverside Drive at 103rd Street.

Roerich ran the Master Institute personally until he left the United States for India in 1923. He gave lectures and introduced new courses into the curriculum, including classes in music and sculpture for the blind, an idea that was far ahead of its time. He believed that the education offered by the institute would not only lead to a well-rounded knowledge of the arts, but pave the way to universal beauty and open the "gates" to spiritual enlightenment, to the wisdom of the masters. This lofty idea was embodied in the school's credo:

Art will unify all humanity. Art is one—indivisible. Art has its many branches, yet all are one. Art

is the manifestation of the coming synthesis. Art is for all. Everyone will enjoy true art. The gates of the "sacred source" must be opened wide for everybody, and the light of art will ignite numerous hearts with a new love. At first this feeling will be unconscious, but after all it will purify human consciousness. How many young hearts are searching for something real and beautiful! So give it to them. Bring art to the people—where it belongs. We should have not only museums, theatres, universities, public libraries, railway stations and hospitals, but even prisons decorated and beautified. Then there will be no more prisons.

On July 11, 1922, eight months after founding the Master Institute, Roerich established an international art center, Corona Mundi (Crown of the World) in New York. Its goal was to foster mutual understanding among all peoples through the international language—art. It opened with an exhibition of Roerich's American paintings, including the "Ocean," "New Mexico," and "Arizona" series. Then an exhibition of contemporary American artists was mounted. Other exhibitions through the years included drawings by Italian and Flemish masters; Russian icons; Tibetan art; drawings by Native Americans; Australian art; Brazilian art; contemporary artists of India, France, Germany, South America, and more. After being shown at Corona Mundi, the exhibitions traveled to museums, universities, and galleries around the country.

By 1923, both the Master Institute of United Arts and Corona Mundi were flourishing, and in tribute to their founder the Roerich Museum was established on November 17, 1923. It opened officially to the public on March 24, 1924, and at the time was the only museum in the country devoted to the work of a single artist. Occupying one floor of the Master Institute building, it initially held about three hundred works. By the early 1930s the holdings totaled 1,006. The president of the museum, as well as of the Master Institute—and its chief benefactor—was Louis Horch.

Among the works on display when the museum opened was the "Sancta" series. The title of each painting in the series begins with the words "And We," suggesting not only that the works are connected, but that taken in sequence they tell a story: *And We Are Opening the Gates, And We Do Not Fear, And We Are Trying, And We Continue Fishing, And We Are Bringing the Light, And We See*. Indeed, like the poetry collection *The Flowers of Morya,* the "Sancta" series relates a spiritual journey. The "travelers" on this journey are monks garbed in long, hooded black robes, their faces indistinct. The setting of all the works is Russia.

In *And We Are Opening the Gates,* a monk is depicted opening arched gates leading out of an Old Russian monastery (page 90). Through the open gates the rolling hills and winding river of a typical northern Russian landscape can be seen. A chapel stands on one of the hills. As in *The Flowers of Morya* and elsewhere, the opening gate and landscape suggest spiritual awakening and the path that lies ahead.

And We Do Not Fear depicts a wintry landscape; snow blankets the hills, the rocks, and a northern Russian wooden church in the distance (pages 92–93). Two monks stand in the foreground; approaching them is a large brown bear. The painting would resemble a contemplative, Kuinji-esque winter landscape were it not for the background, where a helmet-shaped mountain looms large. The top of the mountain is lavender, suggesting the reflection of the rising or setting sun on the snow. The lower part of the mountain is in shadow and shapes formed by these shadows are ominous, as if cast by an approaching but unseen evil enemy. The monks, however, show not the least apprehension. The power of the spirit, Roerich seems to be saying, will prevail over the forces of darkness in the end.

And We See is painted in the style of an Old Russian church fresco (page 94). On the left rises a church or monastery, elaborately covered with frescoes both without and within. In the arched doorway stands a monk, his gaze directed upward. Along the bottom of the canvas to the right a walled city is depicted. Above it, filling the sky, is an enormous head of Christ done in the manner of the *Spas nerukotvorny* and ringed by a golden yellow circle. An

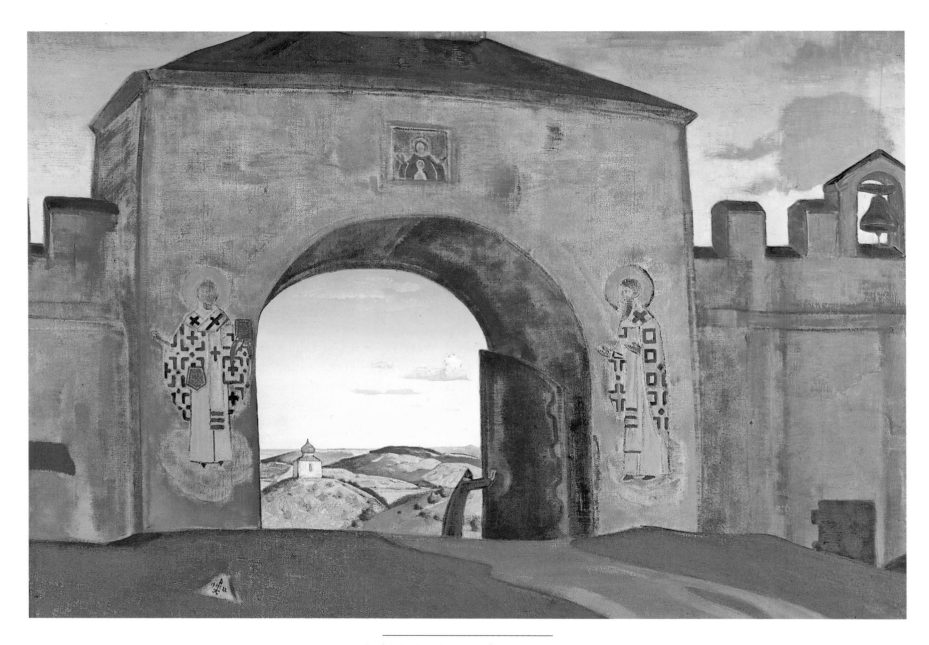

And We Are Opening the Gates, 1922.
TEMPERA ON CANVAS, 28 X 40 IN.
BOLLING COLLECTION, MIAMI, FLORIDA.

angel has just drawn back the heavenly veil that had been covering the Savior's face. The saintly monk—and we, if we do not stray from the path—can finally see.

A painting executed in 1922 in a manner similar to that of *And We See* is *The Book of Doves* (page 94). It illustrates a Russian folk legend by the same name, as retold in a poem by Boris Zaitsev, a contemporary of Roerich. According to the legend, a holy book fell to earth from a thundercloud. It was 40 *sazhens* long (about 280 feet) and 20 *sazhens* wide (140 feet). Hundreds of Christians, ranging from tsars and princes to common folk, came from near and far to see the book, but none would dare to touch it. Only the wisest tsar, David Yesseyevich, approached the book. It opened, revealing God's word to him. A prince, Volodimir Volodimirovich, then also approached the book and asked Tsar David to read it and reveal God's deeds in order to explain why our earth began, why we have a beautiful sun, a moon, so many stars, and so on. The wise tsar replied that he could not read the holy book, for it was too great. He could not hold it in his hands or place it on a lectern. But he could recite God's word from memory: Our earth began by God's will; the beautiful sun is the face of our Lord Jesus Christ; the moon is His breast, the many stars are God's robe. . . . The painting renders the scene just as the legend describes it. A dark storm cloud hovers over a medieval Russian city in front of which an enormous book lies open; its pages resemble the shape of a dove's wings in flight.

Perhaps the most hauntingly beautiful and inspirational work Roerich painted in the United States is *Bridge of Glory* (page 95), executed in 1923. A saintly monk in a long hooded black robe stands on the shore of a sea or lake in the right foreground, his back to the viewer. To the left rises a hill, on top of which are several pine trees and a little chapel. The entire foreground is cloaked in darkness, for it is night. The monk looks out over the water at the sky, which is lit by the aurora borealis. Streaks of color, ranging from deep blue to pale blue-green, shoot out in a fanlike pattern, describing an arc or bridge across the sky. The water reflects their light. For the monk, as for the artist, this blue flame is a visual bridge to the glory of the divine fire within, and a metaphor for the future spiritual bridge that will connect heaven and earth. Technically, it is remarkable for the striking color effects Roerich was able to achieve through subtle shadings of blue.

By the time Roerich came to America, his son George was eighteen. He had a strong aptitude for languages and an equally strong interest in the history and ethnography of the East. When the family was living in London, he enrolled in the Indo-Iranian Department of the School of Oriental Languages at the University of London. He continued his study of Sanskrit at Harvard and also began learning Pali and Chinese. After graduating from Harvard he was accepted into the School of Oriental Languages at the Sorbonne in Paris, where he perfected his command of Sanskrit and studied Mongolian, Chinese, Farsi, and the Tibetan language. In 1923 he received a master's degree in Indian philology.

Roerich's younger son, Svetoslav, enrolled in Columbia University to study architecture and then followed his brother to Harvard, graduating with a degree in architecture. He soon realized that painting, not architecture, was his true calling and in time distinguished himself as a fine portraitist and landscape painter.

At no time during Roerich's two-and-a-half-year stay in America did he give up on his dream of going to India. Finally, in May 1923, he, Helena, and Svetoslav left New York and joined George in Paris, the first stop on their journey to the East. The expedition, which he anticipated would last two years, was financed by the Master Institute and Corona Mundi. He gave these institutions "the exclusive right to purchase all artistic results of the Expedition, such as my paintings, drawings, and sketches, as well as such paintings as I may complete thereafter."[4] This right was transferred to the Roerich Museum when it was founded in November 1923. In addition, he gave Louis Horch power of attorney over all his financial affairs, including selling "such of my paintings or personal property at such price and on such terms as he may deem advisable."[5]

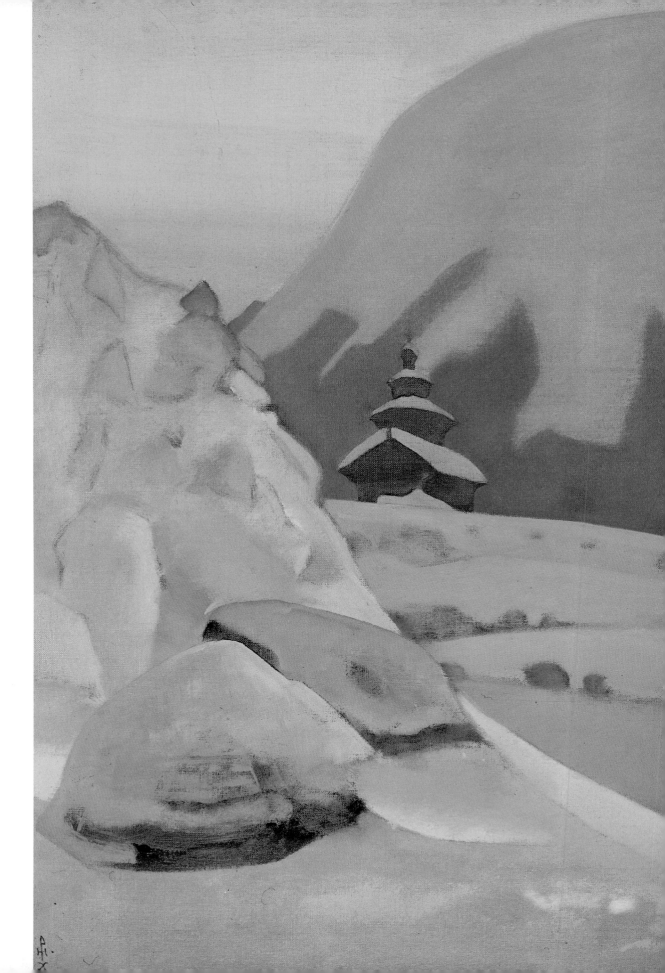

And We Do Not Fear, 1922.
Tempera on canvas, 28 x 40 in.
Bolling Collection, Naples, Florida.

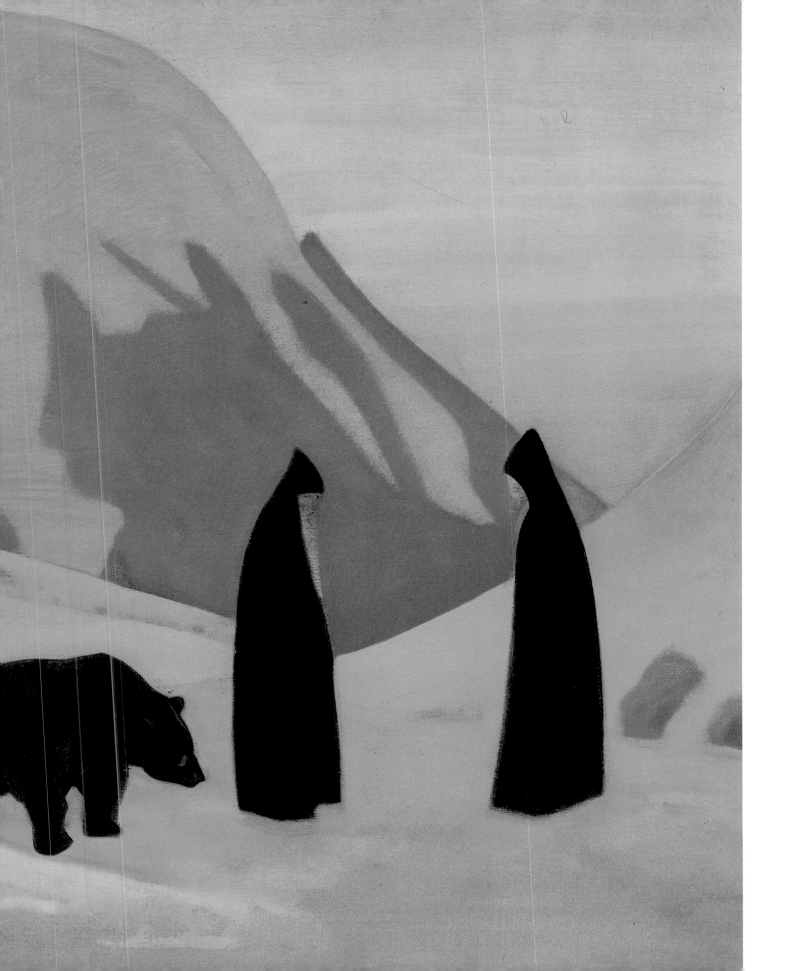

93

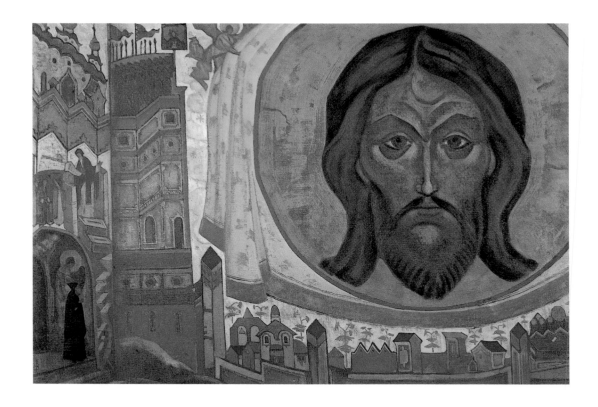

And We See, 1922.
TEMPERA ON CANVAS, 28 X 40 IN.
NICHOLAS ROERICH MUSEUM, NEW YORK.

The Book of Doves, 1922.
TEMPERA ON CANVAS, 29½ X 40 IN.
MUSEUM OF ORIENTAL ART, MOSCOW.

Bridge of Glory, 1923.
TEMPERA ON CANVAS, 32½ x 64½ IN.
NICHOLAS ROERICH MUSEUM, NEW YORK.

During the expedition, which took him through India and most of Central Asia and lasted nearly five years, Roerich painted some five hundred works, almost all of which were acquired by the museum. The arrangement worked as follows: the paintings would be mounted as a "loan exhibit," and the museum would then buy them at one-third the market price that Roerich had set.[6] Thus, Roerich was able to continue financing his trip. Of course, the person who bought the paintings on behalf of the museum was Louis Horch.

Roerich returned to the United States only three times. The first was in the fall of 1924, after he had spent almost a year in India. The purpose of this trip was to formalize American sponsorship of his forthcoming expedition through Central Asia. Roerich then headed back to India via Europe to begin the expedition.

As Roerich began sending more and more paintings to New York, the museum soon had too little space to display them all. The officers decided to construct a new building on the site of the old one, and with Roerich's approval, architectural plans for a twenty-four-story "skyscraper" were drawn up by Harvey Wiley Corbett. The first three floors were designated for the museum, the Master Institute, and Corona Mundi. Lecture halls, concert halls, and even a small

ROERICH IN THE TIBETAN LIBRARY OF THE NEW
ROERICH MUSEUM, 1929(?). THE SHELVES CONTAIN
VOLUMES OF THE *KANJUR-TANJUR*.

opera and drama theater were planned, as was a Tibetan library, in which the 333-volume *Kanjur-Tanjur,* the holy scripture of Tibet, would be housed. Several floors were to be made available to cultural and scholarly organizations and societies, and the remaining floors were reserved for residential apartments. To make the apartments accessible to artists, singers, actors, musicians, and scholars, a low rent was stipulated, and the lectures, exhibitions, and concerts were to be free to residents. In the original plans, the building was to be topped by a stupa, a Buddhist memorial shrine in the shape of a hemispherical mound or staggered pyramid surmounted by a spire. When the building was actually constructed, however, the stupa was left off; instead, five more stories were added to the planned twenty-four.

The second time Roerich came to New York, at the end of his Central Asian expedition in April 1929, the building was near completion. By then his renown had spread widely, in part because he had been nominated for the Nobel Peace Prize one month earlier. The nomination came from the University of Paris and was supported by scientific institutions throughout the world. In it, Roerich was recommended for his efforts to achieve peace "through raising the cultural levels of nations, the constant promotion of brotherhood and the creation of culture and . . . beauty in all spheres of life." Mayor Walker welcomed him at City Hall, other prominent Americans wired greetings,[7] and President Hoover invited him to the White House to discuss the findings of his expedition.

The opening of the new Roerich Museum took place on October 17, 1929. Dignitaries, scholars, and artists from around the world attended. The president of the United States and the heads of many other countries sent congratulations. The Parisian engraver Henry Dropsy designed a medal for the occasion.

But Roerich had not come to New York just to receive honors and congratulations. The main object of his trip was to renew his efforts to win support for an international treaty to protect and preserve cultural institutions and monuments in times of war. The text of the Roerich Pact had been drafted under his supervision by Dr. Georges Chklaver, professor of international law at the University of Paris, in 1928. It read in part:

> . . . educational, artistic and scientific institutions, artistic and scientific missions, the personnel, the property and collections of such institutions and missions . . . shall be deemed neutral and, as such, shall be protected and respected by belligerents. Protection and respect shall be due to the aforesaid institutions and missions in all places in the entire expanse of territories subject to the sovereignty of the High Contracting Parties [the heads of state of the nations of the world], without any discrimination as to the State allegiance of any particular insti-

tution or mission. . . . The monuments, institutions, collections and missions thus registered may display a distinctive flag . . . which will entitle them to especial protection and respect on the part of the belligerents, of governments and peoples of all the High Contracting Parties.[8]

The "distinctive flag" mentioned in the pact was designed by Roerich and came to be known as the Banner of Peace. It consists of three red spheres surrounded by a red circle on a white field. The design has been interpreted as symbolizing religion, art, and science encompassed by the circle of culture, or as the past, present, and future achievements of humanity guarded within the circle of eternity. Roerich discovered this configuration in Russia and on his travels throughout Europe and the East. In India it is the sign of happiness, or Chintamani. In China it appears in the Temple of Heaven. It is found in the Three Treasures of Tibet, on the breast of Christ in Memling's well-known painting *The Adoration of Christ,* on the Madonna of Strasbourg, on the shields of the Crusaders and coat of arms of the Templars, on the blades of the Caucasian swords known as *gurda,* on ancient Russian icons; on Ethiopian and Coptic antiquities, on the rocks of Mongolia, on the breast ornaments of all the Himalayan peoples, on the pottery of the Neolithic Age, on Buddhist banners, on the images of the legendary heroes Gesar Khan and Rigden Djapo. Because of its universality and agelessness, Roerich believed that no symbol was more appropriate for the preservation of the world's treasures. The Banner of Peace was meant to represent the protection of mankind's cultural achievements just as the Red Cross banner stands for the protection of human life.

This time his efforts to promote his pact were not in vain. A Banner of Peace Committee was founded in New York in 1929 and in Paris and Bruges the following year. The idea of the pact received support from such prominent persons as George Bernard Shaw, Albert Einstein, H. G. Wells, and Rabindranath Tagore. Satisfied with the

ROERICH NOMINATED FOR PEACE AWARD

Artist and Scientist Named With Four Prominent Statesmen for the Nobel Prize

KELLOGG ALSO PRESENTED

Senator Jouvenel, Edouard Herriot and Ramsay MacDonald Are the Other Nominees

According to a cablegram received from Paris by the Roerich Museum, 310 Riverside Drive, the names submitted to the Nobel Commission for the Peace Prize, which comprises members of the Norwegian Parliament at Oslo, include those of Secretary Kellogg of the United States, Senator Jouvenel of France, Professor Nicholas Roerich, former Premier Ramsay MacDonald of Great Britain and former Premier Herriot of France.

Professor Roerich's name was presented officially through the Department of International Law of the University of Paris, and the committee of presentation comprised officials and members of the universities of various countries. As far as is known, this is the first time that an artist and scientist has been nominated as a candidate for the peace award, on the basis that efforts for international peace through art and culture have brought about better understanding of international relations.

In presenting the name of Professor Roerich, the committee of presentation states, among other things:

"Since 1890, Nicholas Roerich, through his writings, through his lectures, researches, paintings and through the many fields into which his broad personality has led him, has forcefully expounded the teaching of international brotherhood. His propaganda for peace has penetrated into more than twenty-one countries and the recognition of its influence has been testified by the widely different activities which have invited his assistance.

"As an artist, one of the greatest that history has produced, his paintings have illustrated the great volume of beauty and spiritual light symbolized by his teaching. The significance of their universal appeal is seen in the foundation in New York of the Roerich Museum that the people might have permanent recourse to his teachings.

"We firmly believe that eventual and lasting international peace will come only through the education of the people and through that steady and impressive propaganda for brotherhood created by culture, by poetry and by beauty in every field. The works of Roerich have, for the last thirty years, been one of the great summons to the world for love among men."

NEW YORK CITY MAYOR JIMMY WALKER *(FIRST ROW, CENTER)*
WELCOMING ROERICH *(SECOND FROM RIGHT)* AT CITY HALL,
APRIL 1929. ALSO PRESENT ARE LOUIS HORCH *(FIRST ROW,
SECOND FROM LEFT)*, GEORGE ROERICH *(SECOND ROW, THIRD
FROM RIGHT)*, AND SINA AND MAURICE LICHTMANN
(SECOND ROW, SECOND AND THIRD FROM LEFT).

progress that had been made in promulgating the peace pact, Roerich returned in the fall of 1929 to India, where he had decided to live permanently.

Over the next six years international conferences were held in cities around the world to promote adoption of the pact, and on Pan-American Day, April 15, 1935, in the presence of President Roosevelt and representatives of the twenty Latin American countries constituting the Pan-American Union, the Roerich Pact treaty was signed at the White House. This document represented the culmination of Roerich's thirty-six-year effort to focus international attention on the importance of preserving and protecting the world's cultural legacy.

Meanwhile, in the early 1930s, at the height of the Depression, the Roerich Museum fell on hard times. Its officers were unable to pay the mortgage on the new building. In 1932 the New York Supreme Court appointed a receiver and ordered a tax audit, but on appeal the receivership was voided. For a time the museum was able to continue its cultural activities. One of the notable lectures given in 1932 was a talk on the problems of the modern woman by Eleanor Roosevelt.[9]

ROCKS IN MONGOLIA COVERED WITH THE THREE-SPHERE
CONFIGURATION THAT BECAME THE SYMBOL OF THE ROERICH
PACT AND APPEARS ON THE BANNER OF PEACE.

Roerich returned to the United States for the third and last time in 1934, to accept a proposal of the Department of Agriculture to lead an expedition through China and Mongolia to search for drought-resistant grasses that might help relieve conditions in the Dust Bowl. The offer came from Secretary of Agriculture Henry Wallace, who had met the artist in 1929 and had become an ardent supporter of the Peace Pact and a devout believer in Roerich's philosophy. On this trip, incidentally, Roerich suggested to Wallace that the symbol of the Great Pyramid on the Great Seal of the United States might be a fitting image for the dollar bill. Wallace conveyed the idea to Secretary of the Treasury Henry Morgenthau, and the pyramid has been engraved on the dollar ever since.

This government-funded expedition in 1934, followed by the signing of the Roerich Peace Pact in 1935, marked the pinnacle of the artist's recognition in America. Within a short time, however, attitudes toward him became sharply divided, one camp branding him a money-hungry charlatan and the other upholding him as their master and a prophet of the new era. Emotions ran so high that even relatively recent accounts of the events that triggered this split tend to be heavily weighted in favor of one side or the other, making objective analysis difficult.

One incontestable fact is that in the fall of 1935 the Internal Revenue Service audited the Roerich Museum and found the artist, in absentia, "guilty of not filing a tax return for 1926 and 1927 and of tax fraud in failing to report any income at all in 1934," when he was being funded by the Department of Agriculture. The I.R.S. also claimed that Roerich owed back taxes for the sale of Russian art in America. The Roerichs appealed, but in 1938 the I.R.S. findings were upheld,[10] undoubtedly tarnishing the artist's reputation and image in many people's eyes.

HENRY WALLACE SIGNING THE ROERICH PACT ON
APRIL 15, 1935, AS PRESIDENT ROOSEVELT AND
REPRESENTATIVES OF THE PAN-AMERICAN UNION
AND THE ROERICH MUSEUM LOOK ON.

In July 1935, after more than a decade of generous and seemingly selfless support, Louis Horch summarily severed his ties with Roerich and closed down the museum and its affiliated institutions, all of which, he claimed, officially belonged to him. Two of the museum's officers sided with him. The remaining four, including Sina Lichtmann, were shocked by his actions and brought suit against him, believing that his claims to ownership were unfounded.[11] The case dragged on until the end of 1940, when the court decided in Horch's favor. By that time he had thrown the remaining museum officers out of the building (giving them two days advance notice) and removed all of Roerich's paintings, as well as valuable art objects, books and periodicals published over the years, scholarly materials, and archives.[12]

Whether or not Horch did have a valid claim to ownership of all of Roerich's institutions and their holdings, including the artist's 1,006 paintings and drawings, may never be known. Sina Fosdick (Sina Lichtmann after her remarriage) maintained that he had surreptitiously had false ownership papers drawn up.[13] Robert Williams, in his book *Russian Art and American Money: 1900−1940,* states that in February 1935 Horch "transferred shares in the Roerich Museum from the Lichtmanns, Roerichs, and Frances Grant [another officer of the museum loyal to the artist]; he thus took over legal control of its operations."[14] Whether this was a legal maneuver, Williams does not say. Nor does he question Horch's claims to ownership, since according to Williams (who is convinced that Roerich peddled art and

mysticism for personal financial gain), between 1922 and 1933 Horch had personally given well over $1 million to the Roerich family.[15]

Horch did try to sue Roerich in the late 1930s in an attempt to recover $200,000 in IOUs, but was unsuccessful.[16] Since Roerich's only major source of income was the sale of his paintings, and Horch was financing their purchase by the museum—at cut-rate prices at that—how could he have expected Roerich to pay back such an enormous amount of money? Moreover, Roerich had trusted Horch enough to give him power of attorney over his financial affairs. In that capacity, it would seem, Horch should have seen to it that Roerich's tax returns were properly filed and that the "loan" arrangement of the paintings to the museum was legal.

Henry Wallace also turned against Roerich in late 1935. Sina Fosdick claimed that Wallace was influenced by Horch, who had offered to help him out financially when the Secretary of Agriculture had fallen into debt.[17] Roerich himself held this view. In an essay entitled "Find a Vaccination," he wrote, "[Horch] is leading the government astray. . . . In his dark soul Horch knows perfectly well that he is lying and faking, but he is a real American gangster."[18]

Wallace's association with Roerich later had repercussions on his political career. In 1948, one year after Roerich's death, when Wallace was running for president on a third-party ticket, the Hearst columnist Westbrook Pegler published a series of letters written by Wallace to Roerich in 1933 and 1934. Since Wallace addressed Roerich as "Dear Guru" in these letters, they became known as the "guru letters." Although their authenticity is indisputable, Wallace himself neither confirmed nor denied that he had written them.[19] The very suggestion that Wallace had such "unorthodox" spiritual leanings did not help him at the polls.

The officers of the museum and the Master Institute who remained devoted to Roerich were resolved to keep the activities of the institute going. Because they had almost none of his paintings, they asked for and got Roerich's permission to rename it the Roerich Academy of the Arts. It moved from one building to another over the next several years. Meanwhile, the officers and other friends of Roerich gradually began gathering works held in private collections and museums in the United States and abroad, with the intention of founding a new museum. They also managed to continue the activities of the Roerich Pact and Banner of Peace Committee and of the Agni Yoga Society. In collaboration with Urusvati, the scientific institute Roerich founded in India, they published *Flamma,* a cultural journal, from 1938 to 1940. And, on Roerich's initiative, they founded ARCA, the American-Russian Cultural Association, during World War II. Finally, in 1949, a permanent home for the Roerich organizations was acquired, a five-story brownstone on 107th Street and Riverside Drive in Manhattan. And on December 19, 1958, the Nicholas Roerich Museum was chartered. It has been in operation ever since. Until her death in 1983, Sina Fosdick served as its director.

Time has not brought the two sides in the Roerich debate any closer together. His admirers continue to revere both his teachings and his art, and their number keeps growing worldwide. His detractors, including John Bowlt, one of the country's leading Russian art historians, persist in dismissing him as a charlatan. Not long ago there was another confrontation in this ongoing debate. The lavish praise for the Joffrey Ballet's reconstruction of *Le Sacre du Printemps* in the fall of 1987 elicited an editorial in *The New York Times* entitled "The Two Roerichs Are One."[20] The author, Karl E. Meyer, finds it hard to believe that the Nicholas Roerich who created the sets and costumes for the original production of *Sacre* was the same Nicholas Roerich who was "once scandalously linked to former Vice President Henry Wallace." Relying almost entirely on the information in Robert Williams's book *Russian Art and American Money,* Meyer tells the story of Roerich's association with Wallace, portraying the artist as a power-hungry mystic "given to oracular statements" who used his influence

over the gullible Wallace to get his Peace Pact signed in Washington.

This editorial, in turn, prompted a letter to the editor from a woman who defended Roerich against Meyer's portrayal. Her letter concludes:

> Nicholas Roerich was far ahead of his time. He thought about the planet as a whole and worked for the betterment of all people. Maybe for that type of thinking, back in the 1930's, in the United States, some individuals did not understand him, and therefore condemned him as a mystic. I'm sorry to read that in the 1980's he is so little understood by the media.[21]

The debate is not likely to be resolved soon.

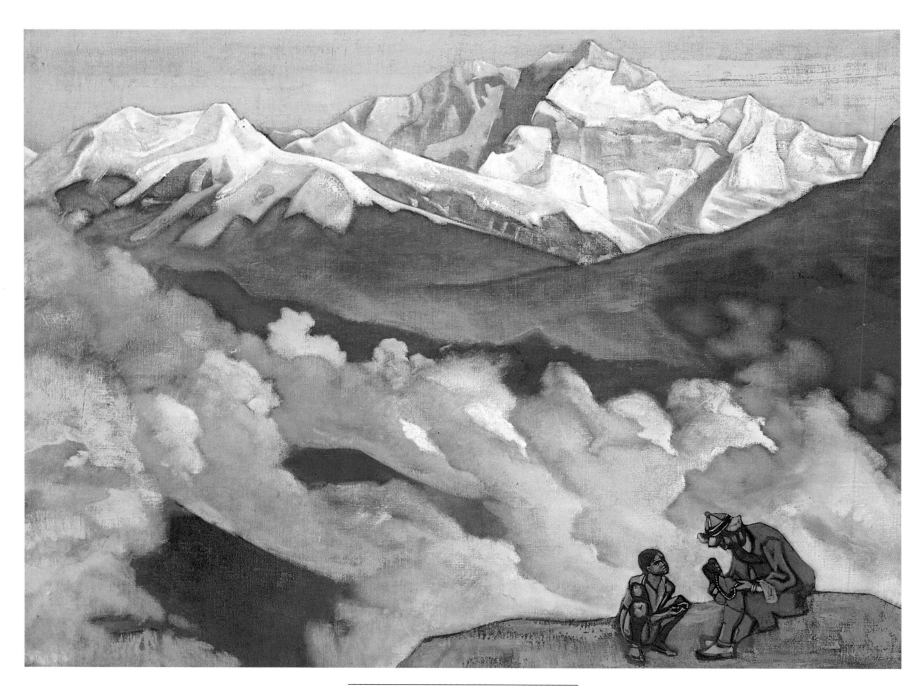

Pearl of Searching, 1924.
TEMPERA ON CANVAS, 35 X 46 IN.
NICHOLAS ROERICH MUSEUM, NEW YORK.

HEART OF ASIA

The summer and fall of 1923 found the Roerichs in Paris making final arrangements for their long-awaited journey to India. On November 17 the family boarded the SS *Macedonia* in Marseilles, bound for Bombay.

They arrived in the teeming port on December 2 and immediately set off on a tour of major cultural centers and ancient sites, including the island of Elephanta, Jaipur, Agra, Sarnath, Benares, and Calcutta. As he had done on his trip through the ancient cities of Russia twenty years before, Roerich kept a record of his observations:

> Sarnath and Gaya—sites of Buddha's glorious deeds—lie in ruins. Now they are only places of pilgrimage, just as Jerusalem remains but a place of pilgrimage for Christians. Well-known are the sites of Buddha's deeds by the Ganges. Well-known are the sites of the Teacher's birth and death in Nepal. According to certain indications, his enlightenment took place farther north still—beyond the Himalayas. . . . The legendary Mount Meru of the *Mahabharata* as well as the legendary lofty eminence Shambhala of the Buddhist teaching—both lay to the north.[1]

By the end of December they had reached the posh English resort of Darjeeling, near the border of Sikkim on the southern slopes of the Himalayas. And there, rising above the terraced tea plantations, was the very peak that had so captured Roerich's imagination as a child at Isvara—the sacred Kanchenjunga.

In Darjeeling the Roerichs lived in a house with a breathtaking view of the Himalayas. Legend had it that the fifth Dalai Lama had once resided there. Ever since that time the house had been considered a holy site, and it was often visited by Tibetan pilgrims and lamas. Roerich's arrival in Darjeeling coincided with the flight of the Tashi Lama—the spiritual leader of Tibet—from his country. This event astounded the Buddhist world because it was a sign that the coming of the New Era, the era of Shambhala, was at hand. As a lama told Roerich:

> For centuries and centuries it was predicted that before the time of Shambhala, many astonishing events would occur. Many savage wars would devastate countries. Many kingdoms would be destroyed. Subterranean fire would shake the earth. And Panchen Rinpoche would leave Tibet. Verily, the time of Shambhala has already come. The great war devastated countries, many thrones perished. The earthquake in Japan destroyed old temples. And now our revered ruler [the Tashi Lama] has left his country.[2]

THE ROERICH FAMILY SIGHTSEEING IN INDIA, 1924.
LEFT TO RIGHT: NICHOLAS, SVETOSLAV, HELENA, AND GEORGE.

This news had profound significance for Roerich. He had heard of Shambhala in St. Petersburg many years before, when he was first exposed to Eastern spiritual thought, and during his involvement with the construction of the Buddhist temple.[3] He knew that Shambhala is believed to be the earthly link to heaven and that its realm on earth is a secret valley somewhere deep in the Himalayas. There the great masters or mahatmas of all ages reside, guarding its sacred mysteries until such time as Rigden Djapo, the legendary ruler of Shambhala, assembles his unconquerable army and leads his warriors in a last battle against the forces of evil. When the enemy has been destroyed, the era of Shambhala—of peace, beauty, and truth—will begin. He also knew that for Buddhists the path to Shambhala is the path to enlightenment and that righteous seekers are guided on their way by a multitude of symbols, signs, and messages. It was this path, Roerich

believed, that had led him to India and would soon lead him into the Heart of Asia, as he was to name one of his books about his expedition.

While in Sikkim, Roerich painted a series of works entitled "His Country" (1924), which was inspired as much by the physical grandeur of the Himalayas as by the spiritual mysteries harbored within them. Indeed, for the artist these towering peaks represented the very summit of beauty and spirituality:

All teachers journeyed to the mountains. The highest knowledge, the most inspired songs, the most superb sounds and colours are created on the mountains. On the highest mountains there is the Supreme. The high mountains stand as witnesses of the great reality. The spirit of prehistoric man already enjoyed the greatness of the mountains.[4]

In the painting *Pearl of Searching,* a guru and a *chela* sit on a mountaintop in the lower right foreground (page 104). Behind them stretches a sea of clouds, above which rise magnificent snow-covered peaks. The guru examines a pearl necklace in search of the one pearl without which the present day would be lived to no purpose. The necklace—a symbol of eternity—signifies that this daily seeking is destined to go on forever. The mountain landscape is at once realistic and suggestive of the spiritual ascent that lies ahead for the *chela*. The mountains themselves symbolize a spiritual world separate from earth but accessible to those who are attuned to the higher realities. The composition of this work—the human figures in the lower foreground, an expanse of clouds or mist in the middle ground, and an exquisite mountain vista in the distance—is to be found in hundreds of Roerich's works. It has the effect of bringing the viewer directly into the picture: our eye is drawn to the figures and we identify with them, experiencing the panorama that unfolds behind them from their perspective.

He Who Hastens, another work in the "His Country" series, has a similar composition (page 108). A rider on a reddish-brown horse is seen galloping through the air between two mountaintops in the foreground. Clouds fill the middle ground, and jagged mountain peaks, glowing pink in the rays of the setting sun, rise majestically in the background. The horseman may be a messenger of the masters racing to the aid of a righteous seeker. In this painting, as in so many of Roerich's Himalayan paintings, there is a sense of urgency—a message to send or receive, a traveler to greet, a mission to perform. As a subtext they urge man on to his spiritual destiny and remind him of his duty to prepare for the New Era in which Rigden Djapo will gather his army and under the banner of light defeat the hosts of darkness.

In *Treasure of the World—Chintamani* (page 109) and *Burning of Darkness* (page 110), we enter the mountains. Both are highly symbolic works illustrating Roerich's belief in the divine fire—*agni*—that in the New Era will be brought out of the mountains to illumine human consciousness. The first work is a visual representation of the Tibetan legend of the steed of happiness, on whose back the sacred stone Chintamani—the treasure of the world—is to be carried down from the mountain heights. As the horse descends a craggy mountain pass, everything around it is illuminated by the blue flame emanating from the chest that contains the sacred stone. The cliffs that line the pass seem to be sentinels carved out of stone, guarding the steed's descent.

In *Burning of Darkness* the sacred fire is being carried out of an opening in a mountain by a figure in a long white robe. A halo rings his head. Behind him are two similarly garbed and haloed figures. All three are mahatmas. Following them are several other figures, their heads just visible above a rock. One of them is haloed; the others are not. They include a bald figure with a long beard, apparently a rare self-portrait of the artist. The entire nocturnal landscape is bathed in the unearthly blue light of the sacred flame.

In *Fire Blossom,* a fur-clad seeker, barely discernible in the late evening shadows, is ascending a mountain in the foreground. On the crest of the mountain is an opening in which a white, rose, and blue phosphorescent flower, aconite, is glowing. The fire-like warmth emanating from this flower contrasts with the jagged wall of icy blue peaks in the distance. Their forbidding beauty suggests the arduousness of the seeker's ascent. His dedication to his quest is about to be rewarded, however, in the revelation of the glowing blossom.

In the Himalayas, the traveler comes upon certain wonders of nature such as hot springs and rich vegetation in the midst of barren, snow-capped mountains. In *Drops of Life* (1924), a painting in the "Sikkim" series, Roerich illustrates this phenomenon (pages 112–113). A dark-haired young woman in a yellow robe sits on a promontory overlooking a landscape of clouds and barren mountaintops stretching as far as the eye can see. Yet behind her, drops of life-giving water from some underground source are being channeled through a duct into an earthenware vase, and palm trees flourish nearby, indicating that this spring

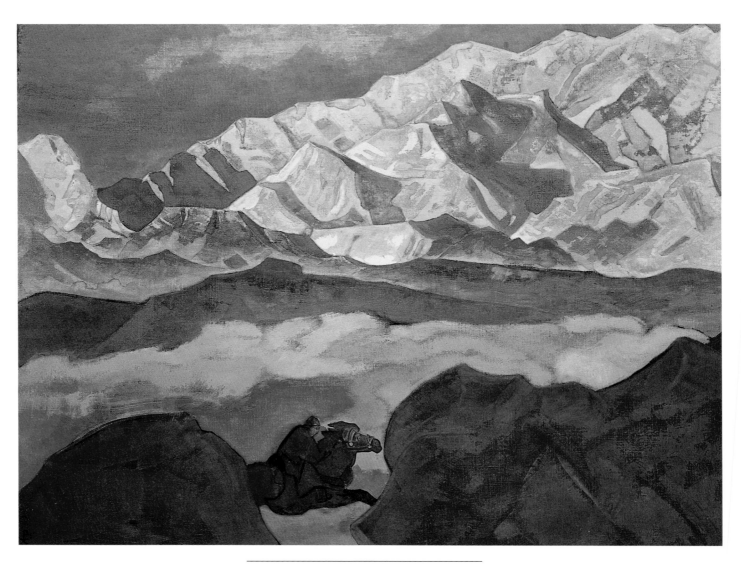

He Who Hastens, 1924.
TEMPERA ON CANVAS, 35½ X 45¾ IN.
NICHOLAS ROERICH MUSEUM, NEW YORK.

high above the clouds has created a subtropical microclimate. Such phenomena have natural explanations, of course, but they can also be seen as manifestations of a higher order, signs of Shambhala.

Roerich's plans for a major scientific and cultural expedition through Central Asia took final shape in Sikkim.

The route he mapped out involved crossing the Tibetan uplands twice: from south to north through the western Himalayas into Chinese Turkestan, the Altai Mountains in Siberia, and Mongolia; then from north to south through the Gobi Desert, across the Tibetan plateau and the eastern Himalayas back into Darjeeling. The second part of the journey would pass through places rarely if

Treasure of the World—Chintamani, 1924.
TEMPERA ON CANVAS, 36 X 46 IN.
NICHOLAS ROERICH MUSEUM, NEW YORK.

ever traversed by a European scientific expedition.

Before he could set off on this ambitious itinerary, he had to obtain the necessary visas. Since the Altai was on Soviet territory, Roerich knew he would need permission from the Soviet authorities to cross the Soviet border. He also hoped to be able to visit Moscow. Thus, in the fall of 1924, on his way back to India from the United States, he went to Berlin for a meeting with Soviet diplomatic representative N. N. Krestinsky who conveyed Roerich's wishes to Moscow. The People's Commissar for Foreign Affairs, Chicherin, who had known Roerich personally during his university years, apparently approved the artist's request. But by the time Chicherin's authorization reached Berlin, Roerich had already left Europe.[5]

He was accompanied on the return trip to India by Vladimir Shibayev, a theosophist from Lithuania who would later work as the artist's secretary. On the way they stopped in Port Said, Egypt, and traveled from there by car to Giza and then by camel to the Pyramids, against the background of which a photograph of them was taken. Closer to India they visited Ceylon (now Sri Lanka), and arriving on the eastern shore of the Indian peninsula, they went to Adyar to visit the Theosophical Society's headquarters, then made their way to Darjeeling.

Before his trip to the United States and Europe in 1924, Roerich had begun another series of works, "Banners of the East," which he completed upon his return. Each of

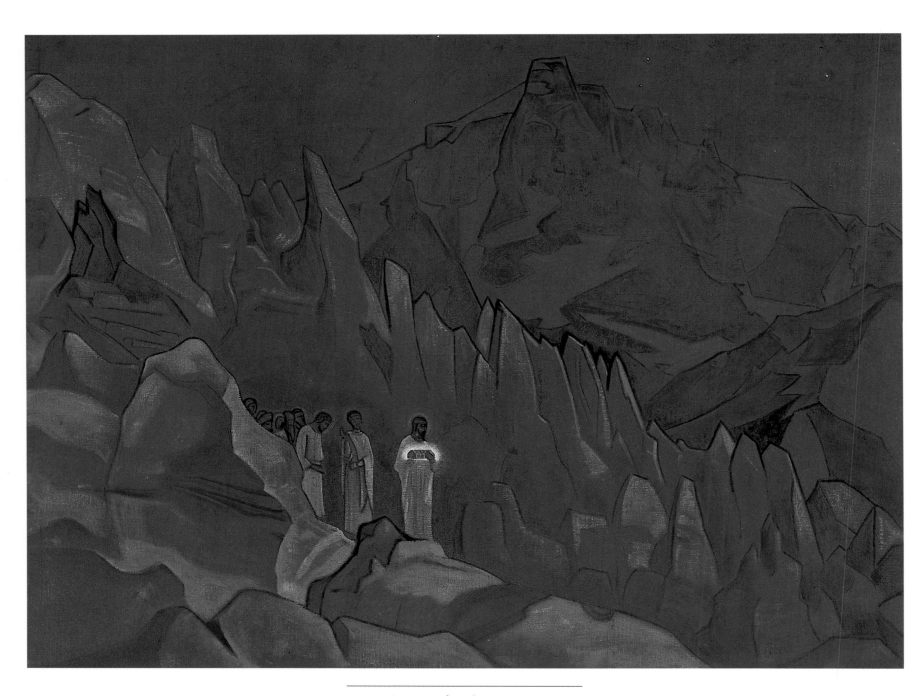

Burning of Darkness, 1924.
TEMPERA ON CANVAS, 30 X 46 IN.
NICHOLAS ROERICH MUSEUM, NEW YORK.

ROERICH ON SEATED CAMEL *(RIGHT)* AND
VLADIMIR SHIBAYEV ON SEATED CAMEL *(CENTER),*
VISITING THE PYRAMIDS, 1924

the nineteen paintings in the series depicts one of the great spiritual teachers of humanity, including Jesus Christ; the Chinese philosopher Lao-Tse; Padma Sambhava, who brought Buddhism from India to Tibet; Moses; Buddha; Mohammed; Confucius; St. Sergius; Dorje, the daring Tibetan lama; Milarepa, the hermit and seer; Oirot, the spiritual leader of an Altai tribe and messenger of the tribe's messiah, the White Burkhan; and one feminine figure, the Mother of the World.

Roerich does not always deify these holy figures, but portrays most of them in the time and place in which they lived, carrying out their spiritual tasks. In this respect the "Banners of the East" series resembles Tibetan spiritual paintings, or tankas. As a lama tells a seeker in Roerich's book *Himalayas: Abode of Light,* "By our symbols, by our images and tankas, you may see how the great Teachers functioned; among the many great Teachers you see only few in complete meditation. Usually they are performing an active part of the great labour. Either they teach the people or they tame the dark forces and elements; they do not fear to confront the most powerful forces and to ally themselves with them, if only it be for the common well-being."[6] Lao-tse is shown astride an ox on a path through a bamboo grove on his way to the sacred Mount Kailas (page 114). Confucius rides in a wooden horse-drawn cart through a landscape that looks as if it had been painted by a Chinese artist, complete with a mountain rising out of the mist in the distance (page 114). St. Sergius is chopping

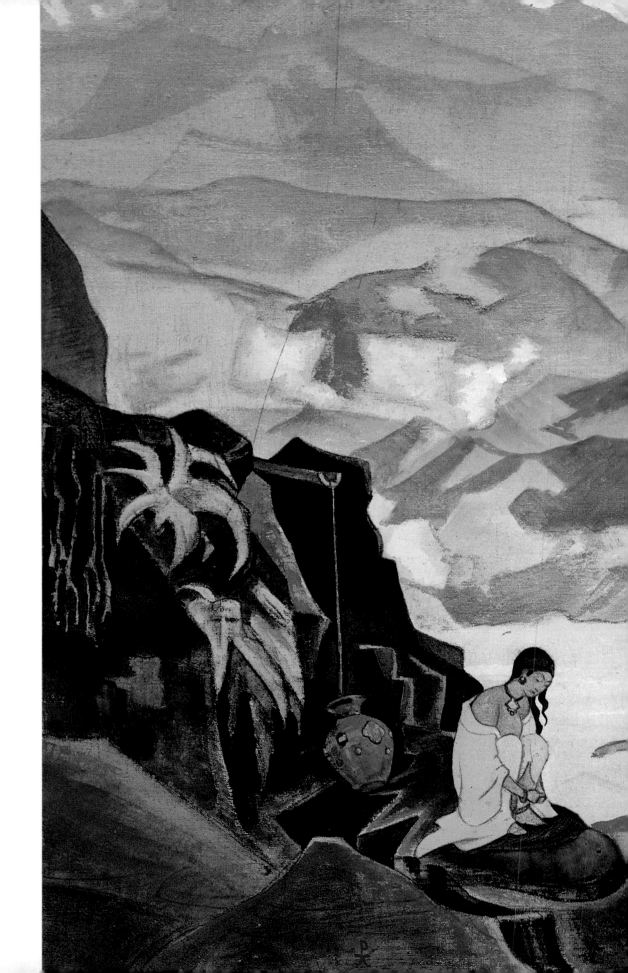

Drops of Life, 1924.
TEMPERA ON CANVAS, 31¾ X 52 IN.
NICHOLAS ROERICH MUSEUM, NEW YORK.

TOP: *Lao-tse,* 1924.
TEMPERA ON CANVAS, 29 X 46 IN.
BOLLING COLLECTION, MIAMI, FLORIDA.

BOTTOM: *Confucius the Just One,* 1925.
TEMPERA ON CANVAS, 29 X 46 IN.
BOLLING COLLECTION, MIAMI, FLORIDA.

Sergius the Builder, 1925.
TEMPERA ON CANVAS, 29 X 46 IN.
BOLLING COLLECTION, MIAMI, FLORIDA.

wood in a stylized northern fir-tree forest as a bear looks on (above). Mohammed stands atop Mount Hira receiving the Koran from the Archangel Gabriel (page 116). Moses kneels on Mount Sinai, his arms outstretched to the Lord, who appears as a great ribbon of cloud (pages 118–119). Milarepa (alternately, Milaraspa), the "One Who Hearkened," sits in meditation on a stone, listening to the voices of the Devas, just as the sun is rising above the Himalayas (page 117). He "knew the strength of the hour before dawn, and in this awesome moment his spirit merged with the great spirit of the world, in conscious unity."[7] Padma Sambhava is portrayed in the subtropical verdure of a stylized Sikkimese landscape, receiving

Buddha's command to bring his teaching to Tibet (page 120). Dorje, the "Daring One," is seen confronting a fiery vision in the mountains (page 120). He holds a bell and a dagger—ritual objects of Tibetan meditation. The sight before him is a terrifying face engulfed in flames, which seems to be rising out of the barren mountain landscape and has three red eyes, a crown made of skulls, and a tongue of flame shooting out of its gaping mouth. The Oirots, a Finno-Turkish tribe in the Altai Mountains, have their own version of the Shambhala legend. They believe that the New Era will begin when the White Burkhan comes. His messenger, the holy Oirot, appears to believers riding a white horse. In Roerich's painting, a

Mohammed on Mt. Hira, 1925.
TEMPERA ON CANVAS, 29 X 46 IN.
BOLLING COLLECTION, GRAND HAVEN, MICHIGAN.

tribesman bows down before a vision of Oirot on his horse above the clouds (page 121). The light of a full moon illumines the stark, snow-covered peaks of the Altai and casts a golden glow around the figure of Oirot.

Roerich's depiction of Christ, entitled *Signs of Christ,* shows Him seated, His back to us, on a mound of sand in the desert and tracing images in the sand with His staff. It illustrates a passage from the teachings of Agni Yoga:

During the night-march the guide lost his way. After some seeking, I found Christ seated upon a sand mound looking at the sands flooded by moonlight. I said to him, "We've lost the way. We must await the indication of the stars."

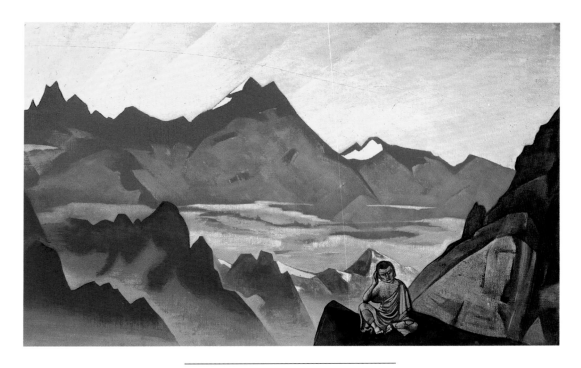

Milarepa, the One Who Hearkened, 1925.
TEMPERA ON CANVAS, 29¼ X 46¼ IN.
NICHOLAS ROERICH MUSEUM, NEW YORK.

Then, taking His bamboo staff, He traced a square around the impression of His foot, saying, "Verily, I say, by human feet."

And, making the impression of His palm, He surrounded it also with a square. "Verily, by human hands."

Between the squares He drew the semblance of a pillar surmounted by an arc. He said: "O, how Aum shall penetrate into the human consciousness! Here I have drawn a pistil and above it an arc, and have set the foundation in four directions. When by human feet and human hands the Temple will be built wherein will blossom the pistil laid by Me, then let the Builders pass by My way. Why should We await the way, when it is before Us?"[8]

The inclusion of both Western and Eastern deities, saints, and sages in this series indicates Roerich's deep-seated belief in the fundamental unity of spiritual teaching. But to him the most universal of all the great teachers, the very symbol of spiritual and cultural unity, is the Mother of the World, and he painted this subject many times throughout his career (page 122). Compositionally, *Mother of the World* closely resembles the 1912 *Queen of Heaven* mural in the church at Talashkino, minus the Christian imagery. A woman in a cloak ornately embroidered with flora and fauna sits upon a cushion on a semicircular throne made of stone. The throne is supported by rocks, at the base of which flows the river of life. The woman's hands are brought together in front of her chest in a stylized gesture of prayer. A veil conceals her eyes, signifying that certain mysteries of the universe are not yet known to man. An aureole circles her head, another her body. The colors make it appear that light is radiating from within her: the area within the aureoles is a pale,

Moses the Leader, 1925.
TEMPERA ON CANVAS, 29 X 46 IN.
BOLLING COLLECTION, NAPLES, FLORIDA.

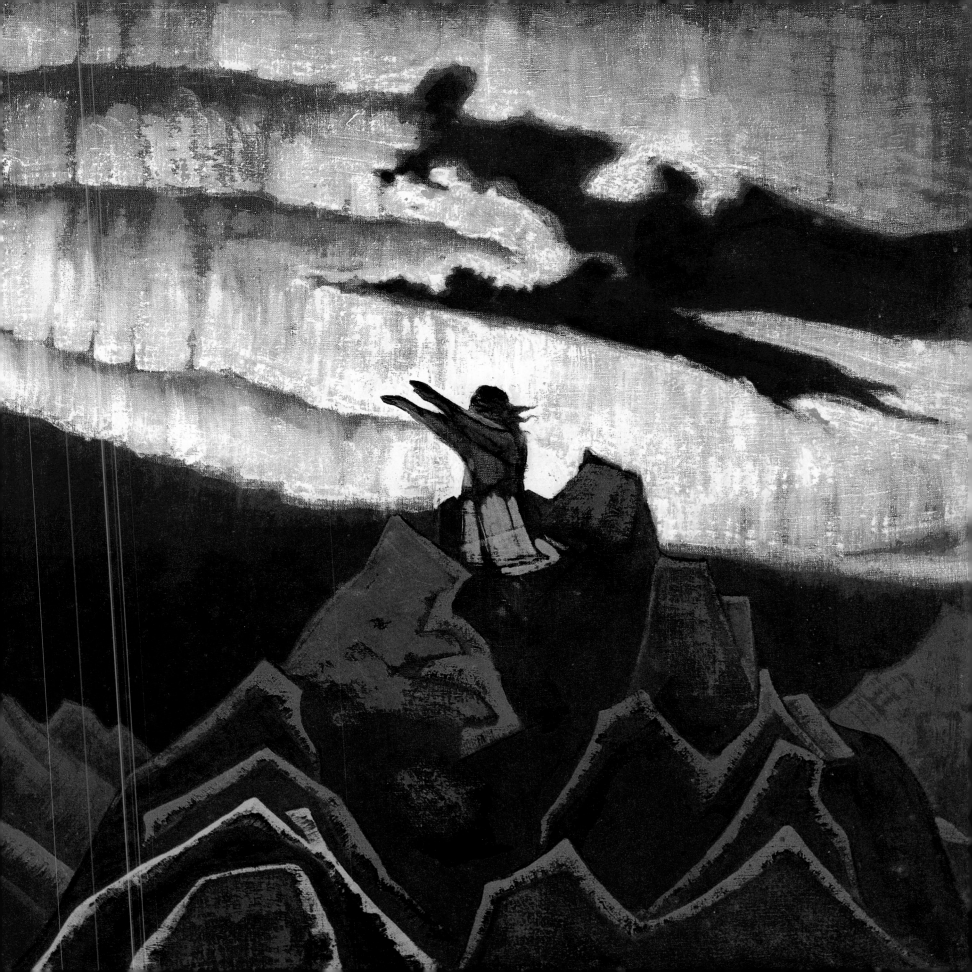

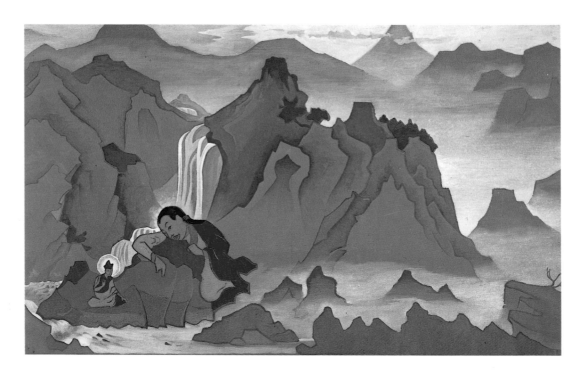

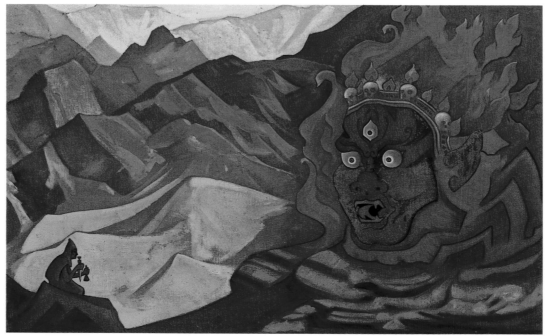

TOP: *Padma Sambhava,* 1924.
TEMPERA ON CANVAS, 29 X 46 IN.
NICHOLAS ROERICH MUSEUM, NEW YORK.

BOTTOM: *Dorje the Daring One,* 1925.
TEMPERA ON CANVAS, 29½ X 46 IN.
NICHOLAS ROERICH MUSEUM, NEW YORK.

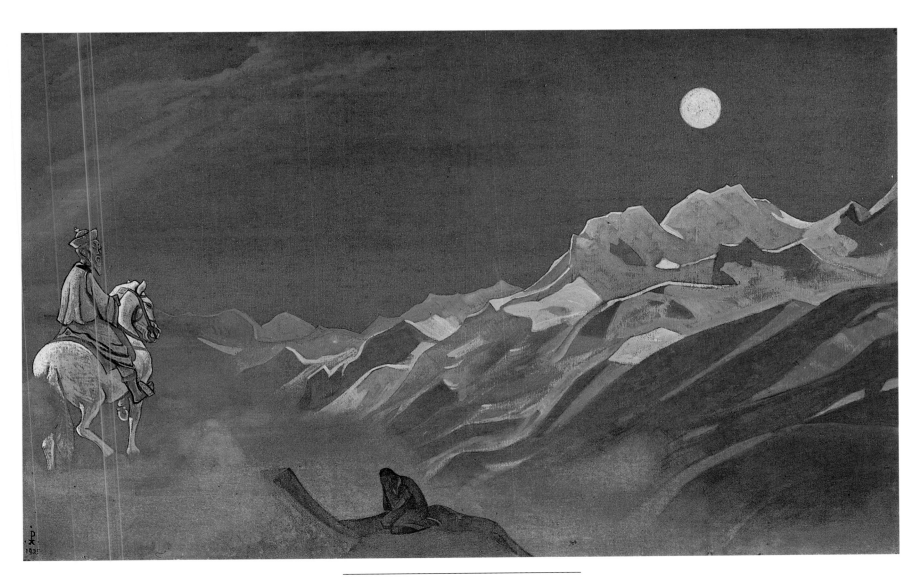

Oirot—Messenger of the White Burkhan, 1925.
TEMPERA ON CANVAS, 29 X 46 IN.
BOLLING COLLECTION, MIAMI, FLORIDA.

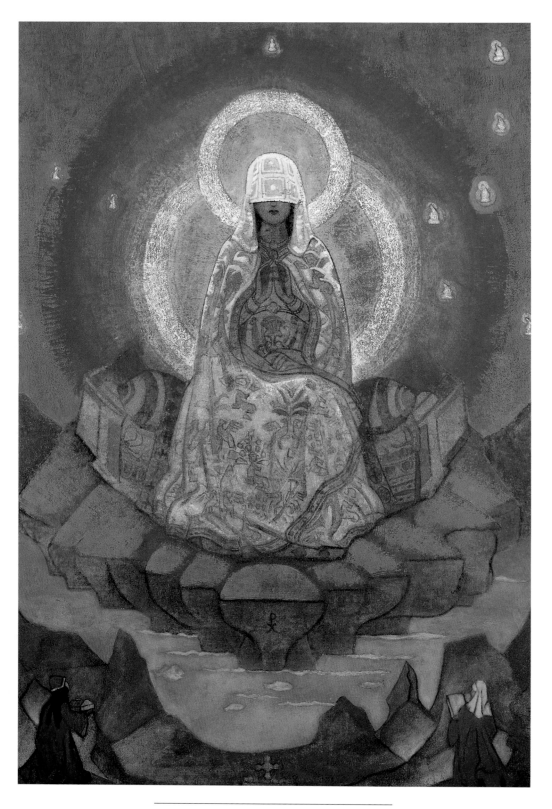

Mother of the World, VARIANT, N.D.
TEMPERA ON CANVAS, 40¾ X 28½ IN.
NICHOLAS ROERICH MUSEUM, NEW YORK.

ethereal blue; the aureoles are surrounded by rings of light purple and then dark blue. The sky is dotted with tiny golden bodhisattvas that seem to twinkle like stars. Two small female figures kneel in the foreground on either side of her. One is dressed in a nun's habit and holds a book, presumably the Bible. The other is clothed in Eastern garb and holds a chest similar to the one containing the divine fire in such works as *Burning of Darkness*. These symbols of Western and Eastern spirituality underscore the unifying power of the Mother of the World. As Roerich himself expressed it: "To both East and West, the image of the Great Mother—womanhood—is the bridge of ultimate unification."[9]

In March 1925 Roerich's Central Asian expedition began. He was accompanied by Helena Roerich and George; Svetoslav returned to the United States to continue his studies and direct Corona Mundi. Their point of departure was Srinagar, the capital of Kashmir in the western Himalayas. Kashmir was once a crossroads of the many trade routes connecting India and the Middle East with Tibet. Mountains surround it on all sides, creating a temperate climate that has attracted people of diverse cultures through the ages. It was a major center of Buddhism from the third century B.C. until the sixth century A.D., when Hinduism started to dominate. In the eleventh century Islam began to take hold and gradually became the primary religion. All of this makes the area especially rich for the study of ancient artistic and religious traditions. In Srinagar the Roerichs investigated the legend about Christ's appearance in Kashmir after the Crucifixion. According to local Muslims, Jesus, or Issa, as they called Him, did not die on the cross, but was rescued by disciples who nursed Him back to health and brought Him to Srinagar, where He continued His teaching and eventually died. His tomb, marked by an inscription reading "Here lies the son of Joseph," was located in the basement of a private home. Roerich subsequently heard similar legends in other parts of India and Central Asia, indicating to him how much people of other faiths wanted to embrace Christ within their own religious traditions.

From Kashmir the expedition headed northeast along the ancient caravan route to the kingdom of Ladakh (Little Tibet) and its capital, Leh. The trip was not without incident. Still on Kashmir territory, the travelers were attacked by an armed band and held at gunpoint for six hours. Roerich wouldn't have attributed any special significance to the raid, but he began to wonder once it was over when the police drafted a telegram in the Roerichs' name that said they (the Roerichs) had been mistaken—there had been no attack. "Then who wounded seven of our men?" he asks rhetorically in *Heart of Asia*.[10]

Along the way they stopped at sites of ancient fortresses and monasteries such as Maulbek and Lamayura, which were fascinating to Roerich both ethnographically and artistically. Carved onto rocks near the road he found images of mountain goats, yaks, hunters with bows and arrows, and figures performing circle dances and other rites, all dating back to the Neolithic Age. He had seen similar images in Scandinavia and would discover them all over Central Asia, Siberia, and the Himalayas, leading him to develop hypotheses about the transmigrations of ancient peoples.

Between Kashmir and Leh, the Roerichs also came upon the first of many carved images of Maitreya—the future Buddha—who, it was believed, would reign once the New Era began. Maitreya is always depicted standing or sitting, and if sitting, then "not in Eastern position but in Western, with lowered feet, ready for the advent."[11]

When the expedition was not far from Leh, at an altitude of 11,000 feet, an extraordinary event occurred. It was a clear, calm day. Around ten in the evening Helena Roerich was preparing for bed in their tent. She was about to open a woolen blanket, but no sooner had she touched it than a large, pinkish-violet flame of electricity about a foot high flared up. She cried, "Fire, fire!" and tried to put it out with her hands, but to no avail. Strangely, it felt only warm to her touch and produced not the slightest burn, sound, or odor. Gradually it subsided and disappeared, leaving not a trace on the blanket.[12] The Roerichs experienced many electrical phenomena in the Himalayas, but this was by far the strongest and most dramatic.

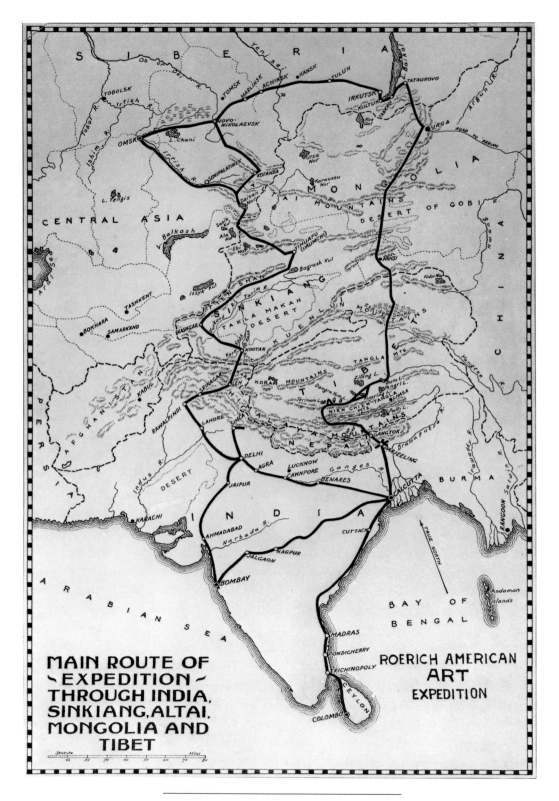

MAP OF THE ROERICHS' CENTRAL ASIAN EXPEDITION, 1925–28.

The expedition spent about two months in Ladakh. The vizir of the region invited the Roerichs to stay in his palace, offering them the top floor of the eight-story residence, which was built on a cliff overlooking Leh. The view of the city's many temples and stupas was spectacular—Roerich depicted it in a number of paintings—and more than compensated for the decrepit condition of the palace. The top floor often swayed in the wind, and while the Roerichs were in residence one of the walls caved in.

Ladakh is thought to be the homeland of the legendary hero Gesar Khan, whom Roerich had heard about since his childhood. Buddhists believe that Gesar Khan's next incarnation "will take place in Northern Shambhala, where he will unite with his associates and leaders who followed him in his previous life." With this army he will "destroy evil and establish justice and prosperity in all lands."[13] This legend associates him closely with Rigden Djapo, ruler of Shambhala. When the time for Gesar to return approaches, the legend goes, the two horses near the entrance to his temple in Ladakh will begin to neigh. High in the rocks one may see a white spot that the local people say is the door leading to Gesar's castle. Nearby an image of a lion is carved into the rock; it is also associated with the hero.

The symbols of Gesar Khan are the arrow and the sword. The arrow "is said to be of lightning and the tips that are sometimes found in the fields are said to be crystallized thunderbolts. War is declared by the shooting of an arrow."[14] In 1932 Roerich would paint *The Sword of Gesar,* which depicts a dagger carved on a stone in the foreground and behind it a menhir, or cluster of stones—an ancient holy site similar to the Druids' Stonehenge. Roerich saw such swords and menhirs in disparate places, just as he did petroglyphs of animals and human figures. The data he collected about these findings later proved invaluable to anthropologists.

The Roerichs' caravan left Leh on September 19, 1925, en route to Khotan in Chinese Turkestan (Sinkiang). To get there they had to traverse seven mountain passes at an altitude of more than 15,000 feet. As they were leaving the city some local women came up to them and, wishing them a safe journey, rubbed their foreheads with conse-crated yak's milk. "They were right," Roerich commented understatedly in *Heart of Asia,* "because the trip through the mountain passes can be very severe."[15] Indeed, there were some close calls. At one point they were climbing the slippery surface of a glacier when the horse George was riding almost slipped into the abyss. But the dangers, the cold, and the blizzards did not diminish the exaltation Roerich felt being in the mountains:

It is impossible to describe the beauty of this snowy kingdom these many days. Such variety, such expressiveness of line, so many fantastic cities, so many multicolored brooks and streams, and such memorable purple and moonlit cliffs.

Moreover, the astonishing ringing silence of the wilderness. And people stop quarreling among themselves, and all differences are obliterated, and everyone without exception soaks in the beauty of the mountain wilderness.[16]

It was too cold for Roerich to draw or paint during this part of the trip, but he had an enviable memory and later was able to recapture what he had seen on canvas.

The border of Ladakh and Chinese Turkestan cuts through this forbidding realm, and when the expedition descended from the mountains it was well into Chinese territory. Roerich had been warned that the local Chinese authorities could be unscrupulous, but in Khotan, his first encounter with the amban and daotai (the administrative and spiritual leaders of the city) did not seem to bode ill. Both officials were courteous and promised the expedition their full cooperation. However, as soon as they examined Roerich's Chinese visa, which he had obtained at the Chinese embassy in Paris, they declared it invalid. They ordered the confiscation of all arms from the members of the expedition and prohibited any scientific research in the Khotan area. They even forbade Roerich to sketch outdoors because they thought he was drawing topographical maps.

During their forced stay in Khotan, Roerich painted a series of seven works called "Maitreya," all of which are

TOP: THE TANKA OF SHAMBALA AND THE
AMERICAN FLAG FLYING OVER ROERICH'S TENT
AT SHARUGON, TIBET, 1927.

BOTTOM: ROERICH HOLDING THE TANKA OF
SHAMBALA, MONGOLIA, 1927.

held in a Russian museum. The series is devoted to the appearance of signs that the era of Shambhala is imminent. One of the works, *The Banner of the Coming One*, illustrates a scene Roerich witnessed on his journey through the western Himalayas and described in *Heart of Asia:*

> In a valley surrounded by high, jagged cliffs, three caravans came together and stopped for the night. At sunset I noticed an unusual group. A multicolored Tibetan painting was leaning against a large rock. A group of people was crowded in front of it, sitting in deeply reverent silence. A lama in a red robe and yellow cap was pointing out something on the picture to the others with a stick he held in his hand and giving explanations rhythmically. Coming closer, we saw the familiar tanka of Shambhala.[17]

Roerich had first seen a tanka of Shambhala in Darjeeling. It depicts the ruler of Shambhala, Rigden Djapo, in the middle and beneath him the fierce battle in which his enemies are destroyed. Photographs taken of the expedition in Central Asia show that it flew not only the American flag, but a tanka of Shambhala as well.

Despite Roerich's repeated appeals to the British consul in Kashgar and futile attempts to contact Paris, New York, and Peking, nothing was done for months to help the expedition leave Khotan. Not having had any word of the Roerichs for weeks and weeks, the American and European press began reporting that they had disappeared in the mountains or deserts of Central Asia. In the beginning of December 1925 Roerich even wrote to the Soviet consul in Kashgar, asking him to inform the authorities in Urumchi, the capital of Chinese Turkestan, of the expedition's plight and to forward several telegrams to Moscow.

Meanwhile, the situation in Khotan worsened to such a point that the members of the expedition tried to escape without retrieving their weapons. But on January 2, 1926, they were all put under house arrest. Roerich managed to get word of this to the British and Soviet consuls in Kashgar. Finally, toward the end of January, they were all released.[18]

The next leg of the journey took the party through the desert and steppes of Chinese Turkestan to Urumchi, with stops in Jarkend, Kashgar, Aksa, Kuchar, and Karashar. This part of the trip took seventy-four days. Outside of Kashgar they came upon a site called Miriam Mazar, which, according to legend, was the grave of the Virgin Mary, who allegedly fled to Kashgar from Jerusalem after the Crucifixion. The environs of Kuchar were famed for their many Buddhist cave temples, the walls of which were covered with fine examples of Central Asian painting. Roerich was dismayed to learn how much of this art had been carried off to museums in Europe, but evidence of the destruction of ancient Buddhist wall paintings by Muslims who had settled in the area disturbed him even more. In some cases whole caves had been scorched by fire; in others, faces had been scratched away with knives.

On April 11, 1926, the expedition arrived in Urumchi, the largest and most lively city in Chinese Turkestan, ruled by the tyrannical Yan-Dutu. Roerich paid him a visit, and the Chinese governor greeted the artist warmly, assuring him that the members of the expedition would be accorded every consideration. Meanwhile, the Urumchi police were conducting a search of the caravan's luggage and equipment. Here, as in other cities in Chinese Turkestan, the Roerichs were horrified by the open buying and selling of people. A young woman slave could be purchased for less than twenty dollars, children for two to four dollars.[19]

While in Urumchi, the Roerichs received permission to enter the Soviet Union. Before leaving the city, on May 16, Roerich gave the diary he had been keeping during the expedition to the Soviet consul for safekeeping and also drew up a will, in which he stipulated that all of the expedition's property, including his paintings, would go to the Soviet government in the event of his death. This seeming gesture of goodwill was undoubtedly the artist's way of ensuring a safe sojourn in his native land, because the expedition's property in fact belonged to the museum in New York.

By June 13 Nicholas, Helena, and George Roerich

were in Moscow, where Sina and Maurice Lichtmann traveled from New York to see them.

Roerich met with People's Commissars Chicherin and Lunacharsky. He presented Chicherin with a small chest containing a piece of the sacred Himalayan earth and delivered a message from the mahatmas to the Soviet people, which read:

> In the Himalayas we know of your achievements. You abolished the church, which had become a breeding ground of falsehood and superstition. You wiped out Philistinism, which had become the champion of prejudice. You demolished the educational prisons. You destroyed the family of hypocrisy. You did away with the army of slaves. You crushed the spider of profit. You closed the gates to the thieves of the night. You freed the land of wealthy traitors. You recognized that religion is the teaching of universal matter. You recognized the insignificance of personal property. You understood the evolution of the commune. You pointed out the importance of knowledge. You bowed down before beauty. You brought children the full power of the Cosmos. You saw the urgency of building new homes for the Common Good ! We stopped an uprising in India when it was premature; likewise, we recognized the timeliness of your movement and send you all of our help, in affirmation of the Unity of Asia![20]

It was a message clearly intended to encourage the development of the New Russia's best possibilities, but it was not meant to condone the Soviet system or suggest closer ties in the future.

Roerich gave Commissar of Education Lunacharsky his "Maitreya" series as well as a work called *The Time Has Come,* in which a giant head rises above the peaceful earth and looks vigilantly to the East.

Roerich and Lunacharsky discussed the possibility of an exhibition of the artist's work in Moscow, but the idea was not pursued. After all, Roerich was the head of an American expedition, and the United States had not yet recognized the Soviet government. Moreover, the artist had to return to China and British-ruled India, and both governments were suspicious enough of his political allegiance without getting word of an officially sanctioned exhibition of his work in Moscow.

After requesting permission from the Commissariat of Foreign Affairs to return to India through Mongolia in order to carry out certain "missions for the mahatmas," [21] the Roerichs, accompanied by the Lichtmanns, left Moscow, taking the Trans-Siberian railroad east to Omsk. From there they made their way to the Altai, reaching this remote mountain range in August 1926.

The Altai is considered to be the ancient homeland of the Finnish people. The Polovtsians, who danced before Prince Igor, also originated here. The true natives of the Altai were Turkish tribes who worshipped the mountain Belukha, just as the Indians and Sikkimese worshipped Kanchenjunga. They were conquered by the Oirots, a western Mongolian tribe, whose Messiah was the White Burkhan. After the schism in the Russian Orthodox church in the seventeenth century, Old Believers settled in the Altai to escape persecution. They had their own version of Shambhala, which they called Belovodye (White Water).

The coexistence of so many different peoples provided the expedition with a wealth of anthropological, linguistic, religious, and cultural material to study. Roerich discovered many customs and legends linking the peoples of the Altai with cultures far away, once more confirming his belief in the common origins of man. The Altai legend of the Chud, a tribe that went to live in underground caves at the approach of white men from the north and would remain underground until such time as the wise men returned from Belovodye, closely resembled a legend about a subterranean people in the Himalayas. The artist had known of this legend for some time and had made a painting of it in 1913. Nevertheless, he was amazed to learn that in the Altai the cry of a serpent in the mountains was, just as in his pre-World War I painting, an omen of imminent destruction.

While in the Altai the Roerichs stayed with a family in the Old Believer village of Upper Uimon. They collected minerals and medicinal herbs, explored ancient archeological sites, and studied rock carvings. Although they spent only two weeks in Upper Uimon, the villagers never forgot their visit. The house in which they lived now bears a memorial plaque in honor of the artist. Next to it a Roerich museum stands, built by volunteers from all over the Soviet Union, and the surrounding mountain peaks have been named for the members of the Roerich family.

From the Altai the Roerichs traveled through Ulan-Ude, capital of Buryatia, and the city of Kyakhta on the border of Mongolia—once a rich trading center on the Great Silk Route between China and Europe—to Urga (now Ulan Bator), the capital of Mongolia. There the family began preparations for the most difficult part of the expedition—through the Gobi Desert, the Tibetan plateau, and the Trans-Himalayas. It was Nicholas and George Roerich's dream to visit the holy sites of Lhasa, the capital of Tibet and home of the Living Buddha, the Dalai Lama. The Tibetan representative in Ulan Bator gave them letters of introduction to the Dalai Lama and his entourage, and helped them obtain Tibetan visas.

In Mongolia, Roerich discovered, belief in the imminence of the era of Shambhala was very strong. On the streets of Ulan Bator he encountered detachments of Mongolian cavalrymen singing a song of Shambhala composed by Sukhi-Bator, the national hero of Mongolia and a leader of the growing "movement for freedom." The words of the song were as follows:

> Chang Shambalin Dayin,
> The war of Northern Shambhala!
> Let us die in this war
> To be reborn again
> As knights of the Ruler of Shambhala.[22]

Before leaving Ulan Bator, Roerich presented the Mongolian government with a painting, Rigden Djapo—Ruler of Shambhala (The Great Horseman). It was executed in tempera, but it might as well have been painted on silk and hung in a Buddhist temple, so close does it come to traditional tanka painting in its treatment of figures, color combinations, flatness, and the symbolism of every detail. Other paintings, such as Song of Mongolia, Mongolia I (page 130), and Mongolia II, all made in 1937 and 1938, share these qualities.

The expedition, complete with dozens of porters, a doctor, the caravan leader, several Buryat lamas, and two young Russian women—Lyudmila and Iraida Bogdanova★—headed out of the city on April 13, 1927. The Mongolian government provided the caravan with automobiles for the first part of the journey, to the Yum-Beise monastery. There they acquired some hundred pack animals and continued the trip by camel.

As always, Roerich collected minerals, plants, soil samples, and ancient artifacts along the way. In the mornings and evenings he would sketch and paint the Mongolian people, their tentlike dwellings (yurts), and their ornaments, rugs, and clothes. The members of the expedition took numerous photographs and shot many rolls of movie film.

When Roerich had first seen the Indians of New Mexico and Arizona, he was astonished by their physical resemblance to Mongolians, and now he showed pictures of American Indians to Mongolians, who were certain they were looking at themselves. His belief that "something ineffable, fundamental, beyond any external theories, links these peoples"[23] was confirmed by a Mongolian tale about two brothers who were separated by a fiery subterranean serpent that had split the earth. To this day the brothers were waiting for a fiery bird to appear and reunite them.[24]

★Lyudmila Bogdanova had been helping Helena Roerich in Ulan Bator, became very attached to her, and wanted to go along on the expedition. Since she had no one to leave her thirteen-year-old sister with, Iraida went along as well. They remained devoted to the Roerichs, staying with the family in India until 1957, when they returned to the Soviet Union with George.

Mongolia I, 1938.
TEMPERA ON CANVAS, 35¾ X 49 IN.
SVETOSLAV ROERICH COLLECTION,
BANGALORE, INDIA.

Between Mongolia and Tibet lay the Gobi Desert. The route the expedition took through this rocky, waterless wilderness had never been traveled by Europeans before. It had been suggested to them by the lamas of the Yum-Beise monastery, who warned them of one danger—the possibility of running into roving bands of the notorious brigand Djelama, who had been killed two years before by Mongolians. He had built a whole city for himself in the central Gobi, where hundreds of his captives had worked. The city was abandoned after his death, but from time to time his former comrades would amass and attack passing caravans.[25]

The Roerich caravan did in fact come upon Djelama's deserted city. The local people accompanying the caravan were so afraid of the brigand that none of them dared to go near the city until George, carbine in hand, scouted it out and gave the all-clear sign.

The expedition encountered only one other caravan on its twenty-one-day trip across the desert, and that meeting almost resulted in armed conflict. The leader of the caravan, a Chinese merchant, mistook the expedition for bandits and fired on it. Fortunately, George Roerich, who headed the expedition's guard, did not return fire and in this way avoided a shoot-out.

The expedition spent June and July of 1927 encamped on a meadow high in the Sharagola foothills of the Humboldt mountain range. While there, they were visited by the great lamas of the area and they erected a stupa. It was an important and sacred time for the entire expedition, as illustrated by Roerich's painting *The Greatest and Holiest Thangla*. They also continued collecting and researching, and replenished their provisions in preparation for their trip through Tibet. Their chosen route was the shortest one, but highly dangerous. It passed through the Tsaidam salt deposits, where it was hazardous to the health to stop even for a short rest. As a result, they had to keep moving day and night without a break. After crossing this strange and treacherous landscape of hardened salt formations resembling "an endless cemetery"[26] without a hitch, the expedition narrowly escaped an ambush by local tribesmen. By this time they had already

ROERICH DURING THE CENTRAL ASIAN EXPEDITION.

crossed the Tibetan border and could see the towering peaks of the Himalayas. From Tsaidam, at 8,000–9,000 feet, they climbed to the northern Tibetan plateau, 14,000–15,000 feet above sea level.

They came upon the first Tibetan outpost on September 20. Some tattered-looking guards demanded their passports. The Roerichs handed over their Tibetan visa

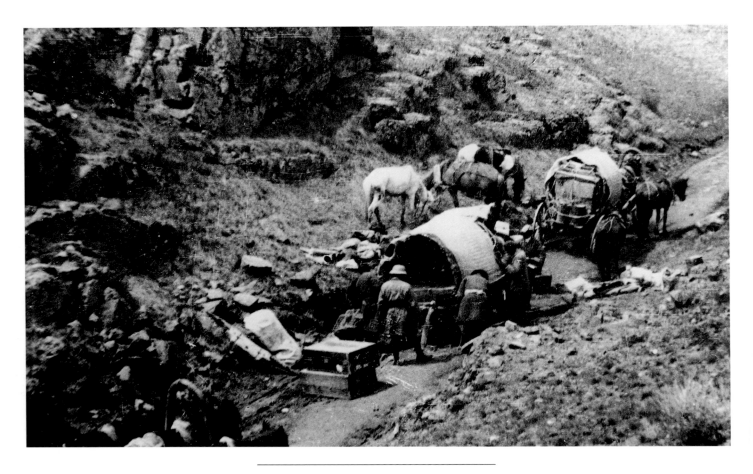

and were allowed to proceed while the visa was sent to the Tibetan authorities for approval. On October 6 the expedition was stopped and told to wait until permission to go on had been granted by the general in charge of northern Tibet. Two days later the members of the caravan were taken to the general's headquarters. He greeted them with a cannon salute and a formation of soldiers in filthy, buttonless jackets. He was as friendly and courteous as the Chinese officials in Khotan, assuring them that there were no obstacles in the way of their going to Lhasa. His only request was that they move their camp to his headquarters for three days so that he could inspect their belongings personally. As he told them: "The hands of little people should not touch the belongings of great

people."[27] He also promised to stay with them until approval of their travel plans had been received. But after a week, when no word from the authorities had come, the general informed them that he had duties elsewhere and left them in the care of a major and five soldiers.

Instead of three days, the expedition remained in that forbidding spot for five months. Winter soon set in, bringing with it fierce blizzards and Arctic temperatures, which the party had to endure in summer tents. They had not brought winter camping gear, not having expected to spend the winter months on the Chantang plateau—the coldest place in Asia.

They sent letters to the Dalai Lama and the governor of Nagchu, a fortress in northern Tibet only three days

from the Chantang plateau, but the letters were returned. They asked the governor of Nagchu to forward letters to the American consul in Calcutta, the British resident in the Sikkimese capital of Gangtok, and the Roerich organizations in New York, by telegraph from Lhasa via India. But they were told that the telegraph line no longer existed. This they knew was an out-and-out lie. They requested permission to turn back or relocate to the general's headquarters, but they were prohibited from moving either backward or forward. Their money, their medicine, and their food dwindled fast. It was so cold that their cognac froze in its flask and their rolls of film were destroyed. Their animals perished before their very eyes. "Every night, freezing and hungry animals approached the tents as if to say farewell before they died. In the morning we found them lying near the tents, and our Mongols carried the carcasses away from the encampment to a spot where packs of wild dogs, condors, and carrion vultures awaited their prey. Of our hundred and two animals, we lost ninety-two."[28] Five people also did not survive the ordeal: two Mongols, one Buryat, one Tibetan, and the wife of the major who was guarding them. Helena Roerich's pulse often went up to a dangerously high 145.

Finally, in early March 1928, the expedition was permitted to move on, but the Roerichs' request to visit Lhasa was denied on the flimsy excuse that their visa was unacceptable. Several of the lamas on the expedition were given permission to go to the Tibetan capital, however, and were promised a hospitable welcome. They did indeed go to Lhasa, although they ended up in jail rather than at Potala, the Dalai Lama's residence and the major monastery in the city.[29]

The route assigned to the Roerichs skirted the capital city to the west. They then crossed several mountain passes and traveled along the Brahmaputra River to the border of Nepal and across another Himalayan pass before descending into Gangtok. On May 26, 1928, after covering 15,500 miles and traversing thirty-five of the world's highest mountain passes in the course of their three-year journey, they arrived back in Darjeeling. It had been not only a scientific expedition but a spiritual quest. Roerich's book *Heart of Asia* makes this dual purpose explicit in its very structure. The first half presents the factual details of the trip: the places they visited, the religious leaders they met, the events they lived through, the archeological and cultural discoveries they made. The second half, entitled "Shambhala," reveals the spiritual import of these same places, people, events, and discoveries. This blending of the scientific and the spiritual is also present in the hundreds of paintings Roerich made throughout the expedition. His eye captured the shapes and colors of the mountains, monasteries, rock carvings, stupas, cities, and peoples of Central Asia; his soul understood their spirit; and his brush forged a synthesis of ineffable beauty.

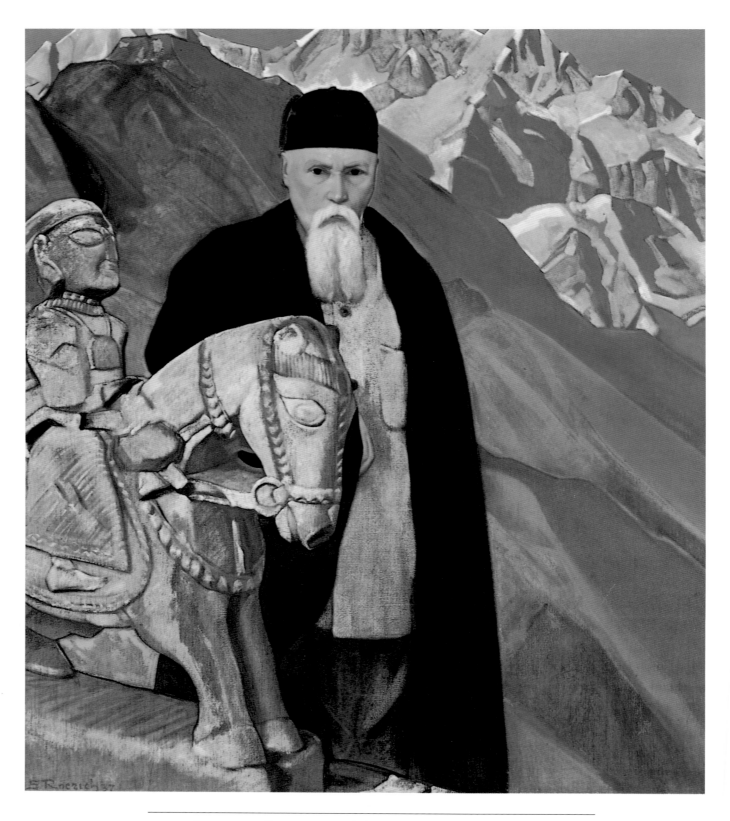

SVETOSLAV ROERICH, *Nicholas Konstantinovich Roerich*, 1937.
OIL ON CANVAS, 54 X 59 IN.
NICHOLAS ROERICH MUSEUM, NEW YORK.

KULU

To continue the study of the botanical, linguistic, archeological, and historical findings of the Central Asian expedition, on their return to Darjeeling the Roerichs established a Himalayan research institute, Urusvati, which in Sanskrit means "light of the morning star." The family did not want to remain in the bustling Sikkimese city, however, and Roerich began searching for another location. He discovered a place that suited him in all respects and would become his home for the rest of his life—the Kulu Valley. Situated in the Punjab in the foothills of the western Himalayas, Kulu occupies an honored place in Indian literature and history. On the banks of the Beas River, which runs through it, the Rishi Vyasa compiled the *Mahabharata* and many of the *Puranas*. Alexander the Great was reputed to have reached Kulu with his army. According to legend, Buddha and Padma Sambhava visited the valley; Arjuna and other descendants of Pandu, one of the heroes of the *Mahabharata,* lived there. Legend also has it that beneath the mountains are underground passages in which a people similar to the Chud lives.

Kulu is the site of cultures dating back thousands of years. Ancient temples nestle in its innumerable gorges. One can find bronze artifacts from the fourth and fifth centuries and exquisite Himalayan miniatures from the fourteenth and fifteenth centuries.

Mountains surround the valley, shielding it from the harsh Himalayan winters. The altitude of more than 6,000 feet protects it from sweltering heat in summer. In this temperate climate, cedar, silver fir, blue pine, maple, alder, and birch trees flourish, and in spring the mountain meadows are carpeted with wildflowers. To the south of the village of Naggar, which is licked by the tongue of a glacier, apple and peach orchards, vineyards, and wheat fields abound.

The population of Kulu is a mixture of Hindus and Muslims who have lived side by side for hundreds of years. They call their home the "valley of three hundred sixty gods."

The Roerichs visited the Kulu Valley in December 1928 and saw a two-story house high on a mountain slope with a spectacular view of the valley. It belonged to the Rajah Mandi but had stood empty for years. Moreover, a bit higher up the slope was a group of buildings that, once reconstructed, could accommodate Urusvati. After lengthy and frustrating negotiations with the rajah's financial minister, the Roerichs purchased the eighteen-room villa, which was called the Hall Estate, along with the nearby plot of land for the research institute. The final settlement stipulated certain curious rights and obligations, including a contract between the god Djammu, the British government, and the new owners about the use of water.[1]

ROERICH POSING AS AN ARCHER, DARJEELING, 1928.

The *gur,* or priest of the gods in Kulu, informed Roerich that the local gods were very satisfied with the family's presence in the valley. As an act of reverence for the gods, Roerich collected their images and placed them near the house. Among the statues was one of the horseman Guga Chohan, the revered protector of the valley. This little statue appears in Roerich's paintings, in photographs, and in Svetoslav's 1937 portrait of his father (page 134).

During Roerich's trip to New York in 1929 to promote his Peace Pact, he also developed contacts with several scientific organizations in order to establish a working exchange of information between them and Urusvati.

Once the Himalayan research institute was in operation, dozens of Asian, European, and American scientific organizations cooperated with it. George Roerich was director of Urusvati and headed its ethno-linguistic and archeological departments. Under his supervision, ancient and exceedingly rare Eastern literary and reli-gious manuscripts were collected and translated into European languages, all-but-forgotten dialects were studied, and a Ti-betan-English dictionary was compiled. Svetoslav Roerich, who had come from New York to work with the family, ran the departments of ancient Asian art, and Tibetan and local pharmacopoeia. Botanical samples were gathered and sent to botanical gardens and natural history museums all over the world. With the help of Tibetan doctor-lamas, the Urusvati staff compiled the world's first atlas of Tibetan medicinal herbs. A biochemical laboratory with a department for the study of cancer was installed. In 1931 the institute began issuing its own journal, an annual in which the scholarship of Indian and Western orientalists was published.

One of the fundamental principles of Urusvati was "continuous mobility of work." Roerich felt it was essential for the staff to go on frequent expeditions in order to broaden their knowledge and extend the limits of their specialized fields. Narrow specialization was anathema to him because it went directly against his greatest hope for mankind—the linking of all scientific and creative disciplines to advance true culture and international peace.

Roerich himself continued to travel extensively until the end of the 1930s, when failing health prohibited him from too much physical exertion. He explored the entire Kulu Valley on foot and on horseback, led caravans across the Rohtang Pass into the northwest Himalayas, and traversed India from the border of Afghanistan in the north to its southeastern tip. In 1934 and 1935 he and George led the United States Department of Agriculture expedition to Manchuria and Inner Mongolia in search of drought-resistant grasses. They also collected medicinal herbs and, in an ancient Manchurian monastery, discovered a rare Tibetan medical manuscript that they were able to transcribe.

While in Manchuria, Roerich took the opportunity to visit the city of Harbin, which at that time had a large and thriving community of Russian émigrés, the majority of whom were virulently anti-Soviet. Although some regarded Roerich with great suspicion, he won the support of many. During his five months there he published a book of essays, was often written about in the local press, and witnessed the establishment of a Roerich Pact committee, whose members included the Russian Orthodox archbishop of Harbin and Vladimir Roerich, the artist's brother, who had emigrated there.

From Harbin the expedition went on to Peking to prepare for the second leg of the journey, which was to take them to Inner Mongolia. In March 1935 they set off for the Gobi Desert, where in the course of several months they researched more than three hundred kinds of plants that were helpful in fighting erosion and sent about 2,000 packages of seeds to the United States.[2]

Throughout the seventeen-month expedition, Roerich found time to sketch and write, conduct archeological digs, collect medicinal herbs, and gather linguistic and folkloric material. On April 15, 1935, the Banner of Peace was raised over the expedition's camp to commemorate the signing of the Roerich Pact in Washington. It must have been a euphoric moment for Roerich, but by the time the expedition ended in September 1935 and arrived in Shanghai on the 21st of that month, he was agitated by the rumors that had reached him of Louis Horch's takeover of the Roerich Museum. He and George hurriedly left for India three days later.

When Roerich was not traveling, his days in Kulu followed a regular routine. The whole family would awake early, have breakfast together, and then disperse, each to his or her own workplace. After a short break for lunch, they would all continue working until evening, when they would take walks, discuss their work, have long talks on philosophical and spiritual subjects, and listen to music. This schedule was interrupted only when they had visitors.

Vladimir Shibayev, the secretary of Urusvati from 1929 to 1939, provides a rare glimpse into Roerich's daily life:

ROERICH IN HIS STUDIO IN KULU.

Every morning Nikolai Konstantinovich came downstairs after breakfast to his studio or the adjacent little room that served as my office. I waited for him there, knowing that he would have prepared not only a new article, but usually several letters as well. He dictated the article to me and I typed it as he spoke. Once it was typed I read it to him with short pauses; he listened attentively and sometimes added or corrected something, after which I continued reading. But the dictation system had been worked out so well that in most cases the article or letter was ready to be signed and sent on the first try. All copies were carefully filed in his archive.

In those instances when he had to write in English, Nikolai Konstantinovich nevertheless preferred to dictate in Russian and I translated each phrase

aloud into English. Sometimes he reworked my translation, usually to insert certain expressions characteristic of his style. In this way his articles and letters took shape without handwritten first drafts. In general, Nikolai Konstantinovich rarely changed a dictated text, just as he rarely went over his paintings while working on them. This was the result of a very precise, logical mind. Like a chess grand master, Roerich always saw many moves ahead. . . . N. K. Roerich worked very assiduously and methodically. He was in no way a pedant, but considered a precisely regulated work rhythm obligatory for himself as well as for all of his coworkers. Time was apportioned so rationally that not a minute was lost in vain. On Sundays and other holidays none of the Roerichs interrupted his daily activities. Over the many years we spent together, I never saw Roerich idle, inactive, scattered, or fussy.[3]

Shibayev also gives a detailed account of the villa in Kulu. His description of one room in particular offers an intimate portrait of the Roerich family's private life:

On the second floor of the house was the "holy of holies," so to speak—the most beautiful and cherished spot, a real museum, one might say. From the vestibule you came upon a central, windowless room, the walls decorated with many tankas and a large gilded statue of Buddha above the fireplace. . . . A table, sofa, and armchairs were positioned in the corners of the room. On the floor was an enormous Persian rug. Next to a tall standing lamp (there was no electricity at that time) was a fine American phonograph, again, not electric but the old hand-cranked variety. . . . Every evening after supper Elena Ivanovna, Nikolai Konstantinovich, Yury Nikolayevich [George], and Svyatoslav Nikolayevich, when they weren't traveling, gathered in this large central room. Here they conversed, discussed plans for forthcoming work, or quietly listened to music. Elena Ivanovna and Nikolai Konstantinovich would select a program and I would crank the phonograph

Roerich in Kulu, wearing his black opera cape.

and put on the records, about three or four an evening. The repertoire may not have been the most extensive, but it was varied and in excellent taste. The evening hours spent silently in the weakly lit room every day from 1929 to 1939 remain in my memory as being ineffably exalted. I always awaited with a thrill the approach of evening, the heart-to-heart talks, usually on philosophical subjects, and the deep meditation to the sounds of music.[4]

Visitors to the villa high above the Kulu Valley were struck by the intensity of their host's gaze and the solemn calmness of his face. Over the years Roerich's long beard turned completely white, and an oriental quality became ever more pronounced in his features. He usually wore a round, close-fitting cap and could often be seen walking

139

ROERICH WITH LEOPARD IN KULU.

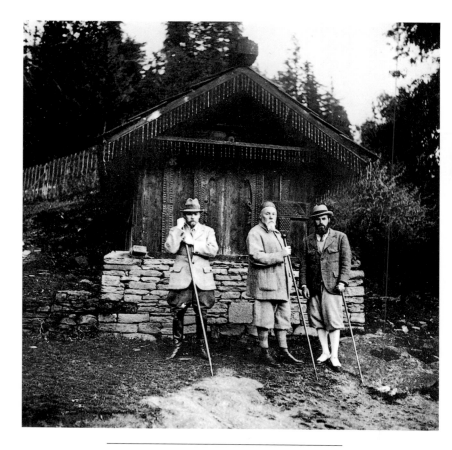

GEORGE, NICHOLAS, AND SVETOSLAV ROERICH IN KULU.

along the valley paths in a flowing black wool opera cape that dated back to his theatergoing days in Paris. George bore a marked resemblance to his father, although he had inherited his mother's high cheekbones. The strikingly handsome and nattily dressed Svetoslav combined the best features of his mother and his father. Helena Roerich, as attested to in Svetoslav's 1937 portrait of her, exuded feminine softness and grace (opposite). Her thick, luxuriant hair turned gray, but her face remained young and her features delicate and refined.

People who encountered Roerich on his walks would bow reverently, whether they were local residents, pilgrims, or traders on their way across the mountains to Ladakh. They called him "Guru" or even "Gurudev" (great teacher). He came to be known as a wise man, even a prophet. Some

believed that bullets could not harm him and that a glow appeared above his house at night; others claimed he had the power to heal people and revive withering plants with his glance.[5] Rumors circulated that his wife was in fact the sister of the last Russian tsar, that the family kept Russian slaves, that they were spies, that they were Americans.[6]

The path to enlightenment, spiritual ascent, the sacred signs of Shambhala, *Satyam, Shivam, Sundaram* (Peace, Beauty, Truth)—these are the themes at the heart of most of Roerich's paintings and writings of the Kulu period. In seemingly infinite variety he continued to paint the holy places he had visited on his travels through the Himalayas— the monasteries, temples, and ancient fortresses rising organically out of the mountains. In such works as *Gompa* (1932) (page 142), *Star of the Morning* (1932) (page 142),

Tibet (1933) (page 143), *Castle of Ladakh* (1933), *Mount Shatrovaya* (1933) (pages 144–145), and *Island of Rest* (1937), our eye is drawn upward toward these strongholds of the spirit as though we were approaching them from below, and our own spirit is moved by their sublime composition and palette.

In dozens of works, nameless yogis, hermits, and lamas demonstrate the wondrous power of the human spirit. They meditate in perfect stillness atop sheer cliffs, arms raised toward the heavens *(Ecstasy);* they sit in the lotus position on the surface of the icy waters of mountain lakes *(The Lotus,* pages 146–147). "If one can walk through

Gompa, 1932.
TEMPERA ON CANVAS ON BOARD, 12 X 16 IN.
NICHOLAS ROERICH MUSEUM, NEW YORK.

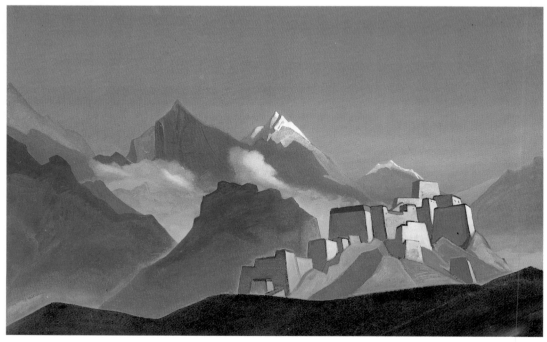

Star of the Morning, 1932.
TEMPERA ON CANVAS, 24½ X 38 IN.
NICHOLAS ROERICH MUSEUM, NEW YORK.

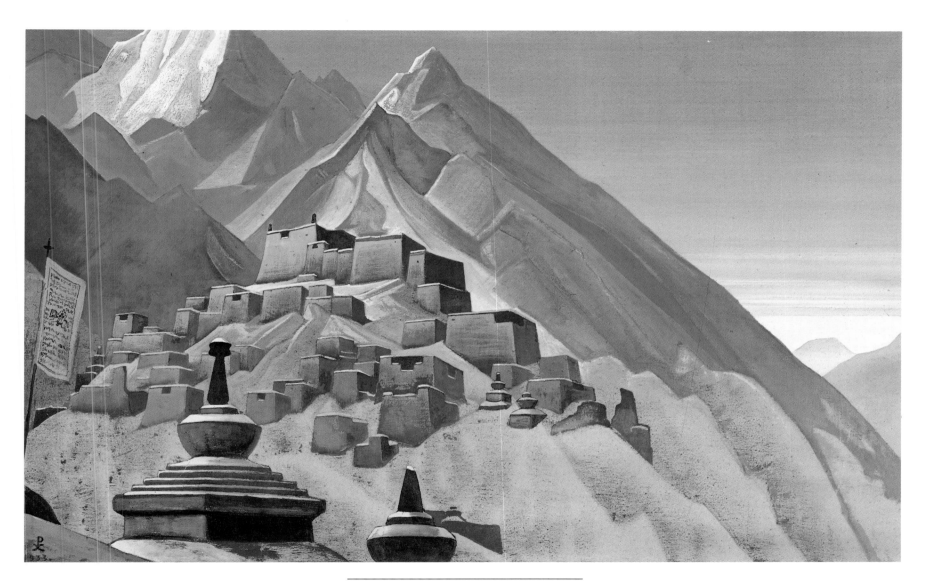

Tibet, 1933.
TEMPERA ON CANVAS, 29½ X 46¾ IN.
NICHOLAS ROERICH MUSEUM, NEW YORK.

144

The Lotus, 1933.
TEMPERA ON CANVAS, 30 x 46 IN.
NICHOLAS ROERICH MUSEUM,
NEW YORK.

146

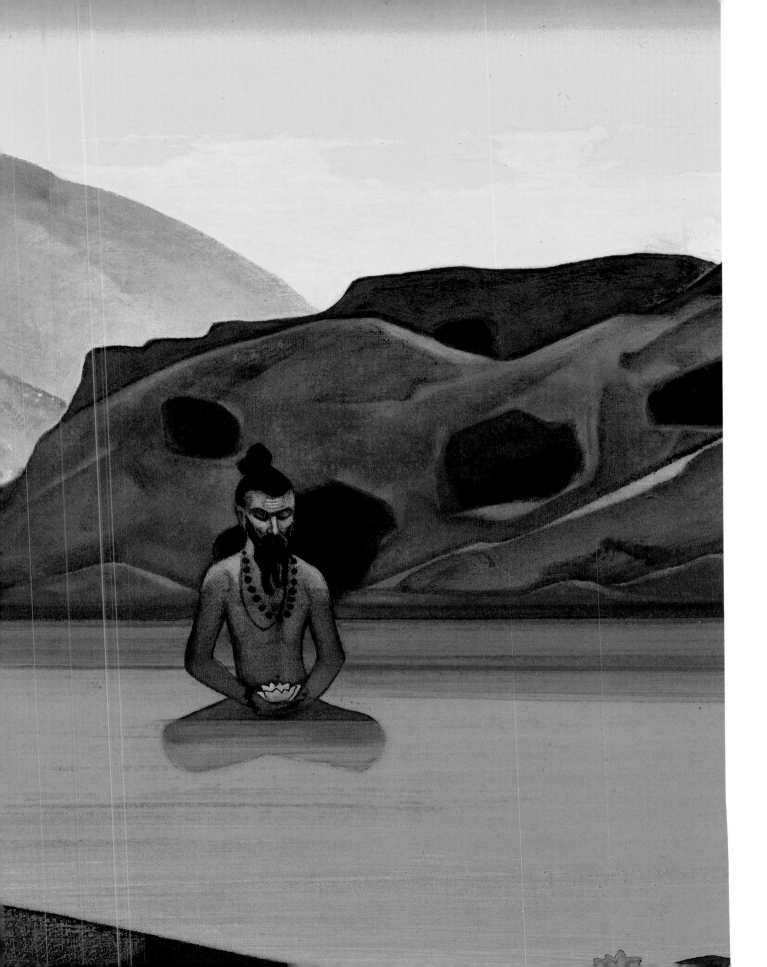

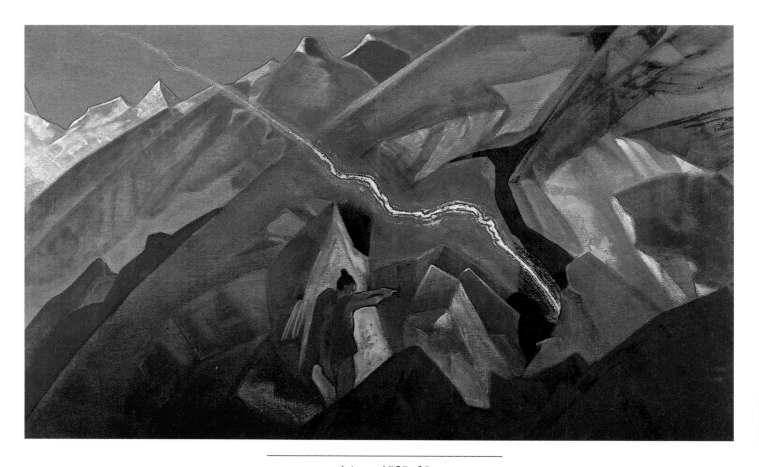

Arjuna, 1929–30.
TEMPERA ON CANVAS, 30 X 47 IN.
BOLLING COLLECTION, NAPLES, FLORIDA.

fire," Roerich wrote, "and another can sit on water, and a third remain suspended in the air, and a fourth repose on nails, and a fifth swallow poison, and a sixth kill with a glance, and a seventh lie buried without harm, then one may collect all those grains of knowledge in himself. And thus the obstacles of lower matter can be transmuted!"[7]

Roerich continued to portray legendary holy men and deities as he had in his "Banner of the East" series. In *Arjuna* (1929–30), the disciple of Krishna is shown blasting a path through the mountains that will lead him to the hot springs of Manikaran (above). As he directs his out-

stretched arms toward the mountain it miraculously splits open and emits a lightning-like beam of energy.

Krishna, the deified hero of Indian legend, is seen in a work called *Krishna: Spring in Kulu* (1930). Roerich portrays him as he is often depicted in Indian art—as a shepherd boy playing his flute (opposite). The setting is the view from Roerich's studio windows. The time is early spring, and the branches of the apple trees under which Krishna sits are covered with frostlike pink and white blossoms. The iciness of the first signs of spring, combined with the towering snow-covered peaks glinting in the still-cold sun in the background, call to mind

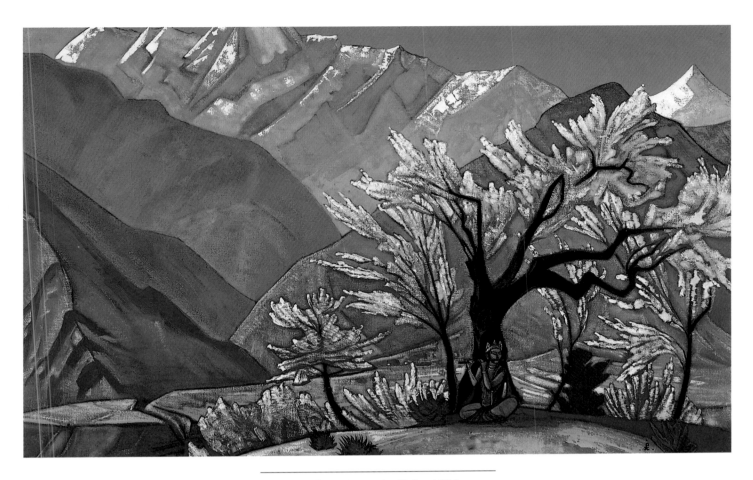

Krishna: Spring in Kulu, 1930.
TEMPERA ON CANVAS, 27 X 46 IN.
NICHOLAS ROERICH MUSEUM, NEW YORK.

Roerich's set design for the first act of *Le Sacre du Printemps*. The artist himself saw parallels between Krishna and the legendary Slavic shepherd boy Lel, beloved of the Snow Maiden. The return of spring in India, Roerich seems to be saying, is just as full of mystery and power as it was for the ancient Slavs.

The ancient (sixth century B.C.) Persian priest Zoroaster (known also as Zarathustra), whom legends associate with a cult of sun and fire and who has been the subject of paintings and operas for centuries, had special significance for Roerich. His cult, like Agni Yoga, was symbolized by

a flaming chalice. In the dramatic canvas *Zoroaster* (1931), the priest stands atop a high cliff holding the sacred chalice (page 150). The divine fire is pouring out of it in a golden stream. In the distance the sun is just about to rise above the horizon, and the sky glows the same golden color as the fire. Zoroaster is seen in profile; the outline of the cliff on which he stands echoes his profile.

In *St. Francis* (1932), the Catholic holy man stands on a mountaintop holding a dove in his left hand and blessing crowlike birds perched on the branches of a little flowering tree with his right (page 151). His head is ringed by

149

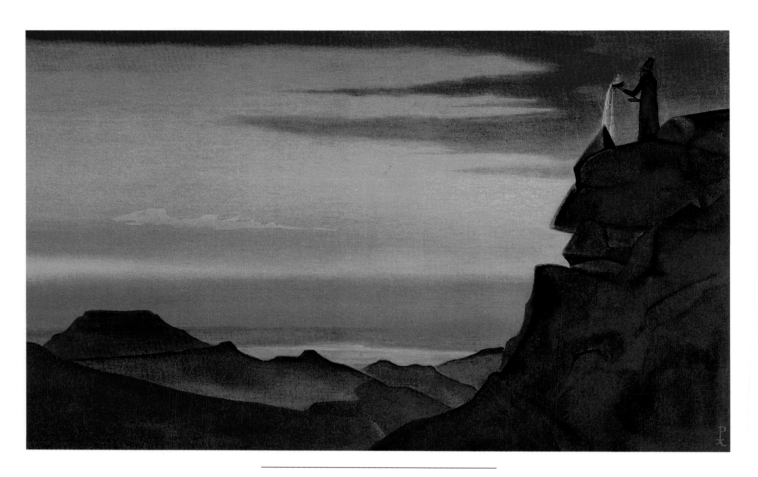

Zoroaster, 1931.
TEMPERA ON CANVAS, 29 X 46 IN.
SVETOSLAV ROERICH COLLECTION, BANGALORE, INDIA.

a large golden halo. In the background a highly stylized European medieval city nestles at the base of two stark, sharp-peaked mountains that resemble the Himalayas much more than the softly rounded mountains of St. Francis's native Umbria. In the spiritual realm, if not geographically, the artist seems to imply that East and West converge. "The saints," he believed, "become pan-human, they belong to the whole world as steps to the true evolution of humanity."[8]

St. George is treated in an entirely different manner. In *Glory to the Hero* (1933), a diptych connected by a double-arched wooden frame designed by Roerich himself, the right panel consists of a stained-glass window depicting the saint mounted on his horse in the sky above the towers of a medieval city (page 152). In the left panel, a nun in a white habit and holding a burning lamp is walking through a vaulted corridor, on one wall of which are stained-glass windows. The whole canvas is bathed in a lavender glow cast by the light coming in through the stained glass. This luminous work recalls Roerich's set designs for Maeterlinck's plays.

In Roerich's iconology, women are the disseminators and guardians of universal Culture and Beauty, the bearers of the Banner of Peace. "Women, indeed you will weave and

150

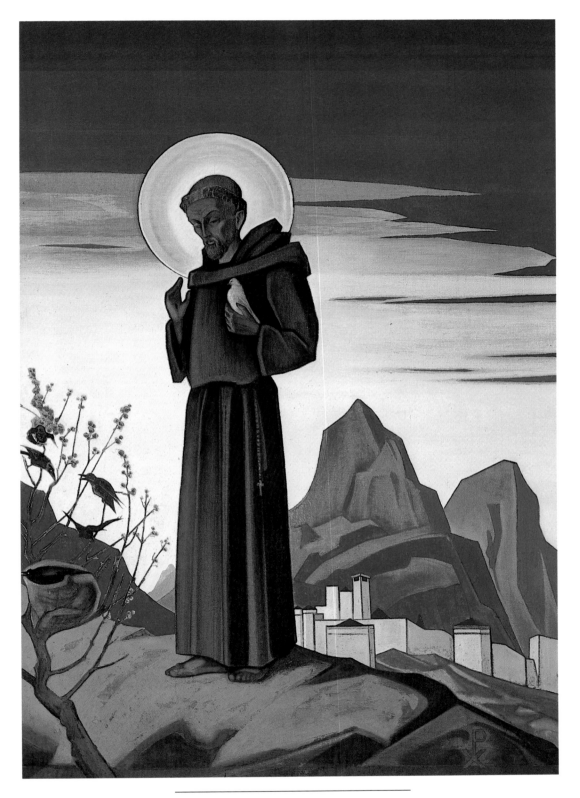

St. Francis, 1932.
TEMPERA ON CANVAS, 60 X 42 IN.
NICHOLAS ROERICH MUSEUM, NEW YORK.

Glory to the Hero, 1933.
TEMPERA ON CANVAS, 33 X 39½ IN.
NICHOLAS ROERICH MUSEUM, NEW YORK.

unfold the Banner of Peace," he wrote. "Fearlessly you will rise up to guard the improvement of life. You will light a beautiful fire for each hearth that will create and will encourage. You will say to the children the first word about beauty. You will pronounce the sacred word Culture."[9]

There is little doubt that his image of Woman was inspired and influenced by Helena Roerich, who devoted much of her own writing to the destined role of women in the New Era. In a letter to a friend, written in 1937, she eloquently expressed her vision of this role:

> . . . woman should realize that she herself contains all forces, and the moment she shakes off the age-old hypnosis of her seemingly lawful subjugation and mental inferiority and occupies herself with a manifold education, she will create in collaboration with man a new and better world. Indeed, it is essential that woman herself refute the unworthy and profoundly ignorant assertion about her passive receptivity and therefore her inability to create independently. But in the entire Cosmos there is *no* passive element. In the chain of creation each manifestation in its turn becomes relatively passive or active, giving or receiving. Cosmos affirms the greatness of woman's creative principle. Woman is the personification of nature, and it is nature that teaches man, not man nature. Therefore, may all women

152

realize the grandeur of their origin, and may they strive for knowledge. Where there is knowledge, there is power. Ancient legends actually attribute to woman the role of the guardian of sacred knowledge. Therefore, may she now also remember her defamed ancestress, Eve, and again hearken to the voice of her intuition in not only eating of but also planting as many trees bearing the fruits of the knowledge of good and evil as possible. And as before, when she deprived Adam of his dull, senseless bliss, so let her now lead him on to a still broader vista and into the majestic battle with the chaos of ignorance for her divine rights.[10]

In *Madonna Oriflamma* (1932), the work Roerich chose to represent the Peace Pact, a golden-haloed madonna in a purple velvet robe, seated on a cushion, holds up the Banner of Peace (page 154). The three circles of the banner's symbol are repeated on her headpiece. She is a direct descendant of the Queen of Heaven and the Mother of the World. Flanking her are two narrow arched windows through which a landscape punctuated by the spires and turrets of an old European city can be seen, in the manner of Renaissance painting. This visual allusion to the Renaissance may be a symbolic tribute to the Christian era's greatest period of humanism and culture.

The Banner of Peace also appears in *St. Sophia—The Almighty's Wisdom* (1932), which depicts a warrior on a white steed riding across a flaming sky and holding the banner. Below, a walled city, symbolizing the cultural landmarks that are to be protected by the banner, is set off in sharp relief by the blazing light.

The path to Shambhala and signs of Shambhala are the subjects of virtually countless Roerich paintings. Many works depict images of Maitreya carved onto rocks. In one, simply called *Maitreya* (1932), the stone image of the future Buddha wears a helmet, as if he is ready for the final battle to begin (page 155). Behind the image rise lofty, snow-covered, seemingly insurmountable peaks; beneath them is a series of smaller peaks of a blue-green color, suggesting a sea of stone surging through this forbidding landscape. *Warrior of Light* presents another, much more

ethereal sign of Shambhala—a vision of a winged white horseman and his steed in the clouds (page 155). It is "warriors" such as this one—armed with Beauty and Light—that will defeat the enemies of Shambhala. In *Star of the Hero* (1932), a lone Tibetan is seated in the lower right foreground (page 156). He is silhouetted against a group of buildings that are lit up by an unseen bonfire. It is night and the mountain peaks in the distance are darkly etched against a starry sky. The Tibetan watches as a shooting star traces a path across the sky. Such cosmic phenomena as shooting stars and the aurora borealis (as in *Bridge of Glory,* page 95) are also signs of the heavenly Shambhala's imminence.

From Beyond (1936) depicts a Tibetan woman sitting on a rocky riverbank, wearing a robe ornamented by the three-circle emblem of the Banner of Peace (page 157). Toward her, on a precariously thin wooden plank spanning the raging river, walks a female figure who has come from the vast mountain kingdom "beyond." With her palms touching in a gesture of prayer and her serene countenance, she is clearly a holy figure, come to guide the seated woman on the path to Shambhala.

In painting after painting, pilgrims are seen walking through the mountains on their spiritual journeys. *Stronghold of the Spirit* (undated) depicts three seekers, walking sticks in hand, descending a mountain in the lower right foreground. Immediately behind them is a large stone on which the words of the most well-known Tibetan Buddhist mantra are carved: *Om Mani Padme Hum* (Hail, jewel in the heart of the lotus!), followed by the words *Maitreya Sangha* (community of Maitreya). In the distance, rising out of the mists, is their destination, a chain of jagged, snow-covered peaks. Will they find Shambhala there?

In *Wanderer from the Resplendent City* (1933), a man with a walking stick and a sack on his back is seen heading in the direction of a cluster of Russian Orthodox churches situated on the shore of a sea or lake (page 158). Is this wanderer one of the select few who found the "resplendent city" and returned to tell of its wonders? The Old Believers Roerich met in the Altai told him of people who had reached the legendary Belovodye. The most

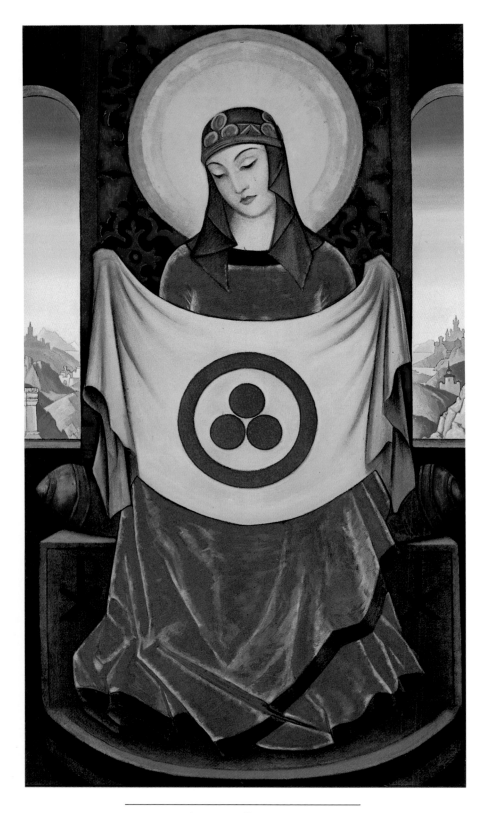

Madonna Oriflamma, 1932.
TEMPERA ON CANVAS, 68 X 39¼ IN.
NICHOLAS ROERICH MUSEUM, NEW YORK.

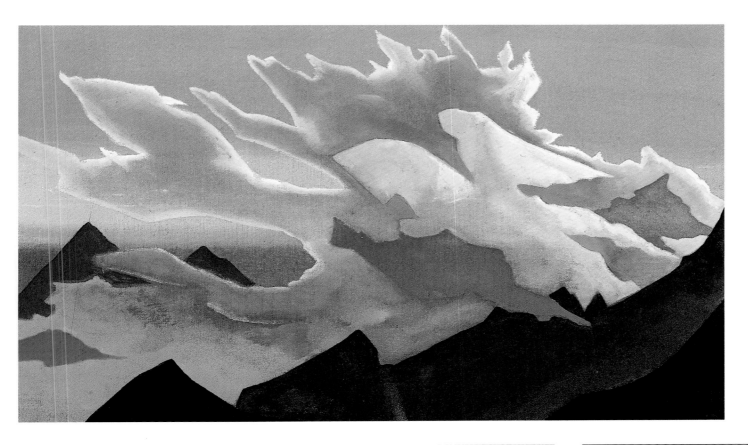

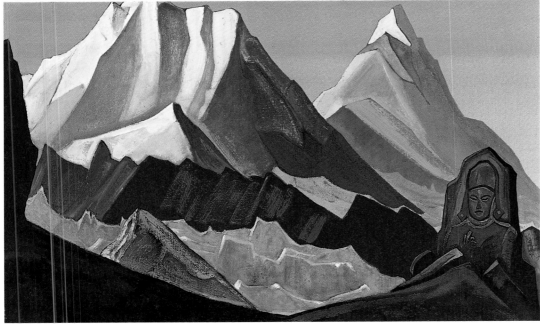

TOP: *Warrior of Light,* 1933.
TEMPERA ON CANVAS, 19 x 31 IN.
STIBBE COLLECTION,
GREENWICH, CONNECTICUT.

BOTTOM: *Maitreya,* 1932.
TEMPERA ON CANVAS, 19 x 32 IN.
MUSEUM OF ORIENTAL ART, MOSCOW.

155

Star of the Hero, 1932.
TEMPERA ON CANVAS, 41 X 53 IN.
NICHOLAS ROERICH MUSEUM, NEW YORK.

From Beyond, 1936.
TEMPERA ON CANVAS, 41 X 53 IN.
NICHOLAS ROERICH MUSEUM, NEW YORK.

spiritually ready among them were asked to stay in the holy place; the others were not permitted to remain and returned home.[11]

The holiest mountain in all Asia is Mount Kailas. Hermits "until now live in the caves of this wondrous mountain, filling the space with their evoking calls of righteousness."[12] In these caves, it is believed, "is the threshold of Miracle";[13] north of Kailas lies Shambhala. In *Path to Kailas* (1932), Roerich depicts three pilgrims riding on buffaloes through a snowy, powder-blue mountain landscape toward a monastery that glows pink in the first rays of the morning sun (page 159). The mood is one of quiet, expectant joy; *Satyam, Shivam, Sundaram.*

In his writings Roerich often refers to the great treasures stored deep within the Himalayas. The very name Kanchenjunga, he tells us, means the Five Treasures of the Great Snow, because it contains "the five most precious things in the world. What things? Gold, diamonds, and

Wanderer from the Resplendent City, 1933.
Tempera on canvas, 24¼ x 38¼ in.
Nicholas Roerich Museum, New York.

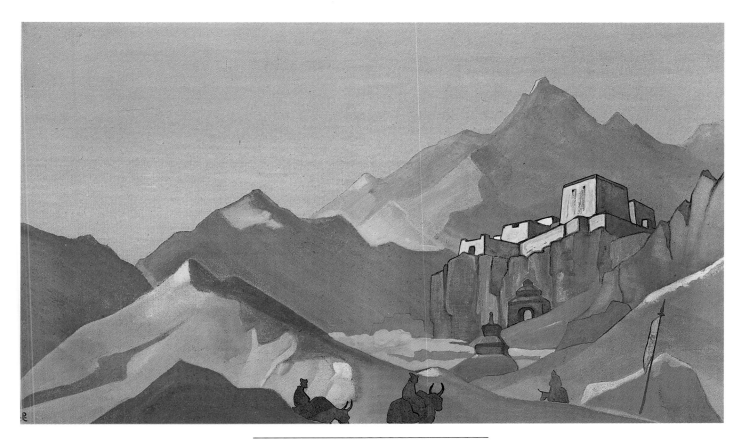

Path to Kailas, 1932.
TEMPERA ON CANVAS, 19 X 31¼ IN.
NICHOLAS ROERICH MUSEUM, NEW YORK.

rubies? By no means. The old East values some other treasures."[14] He alludes to them in the painting *Treasure of the Mountain* (undated). The setting is deep inside a mountain cave (page 160). Large stalactites and stalagmites of pure crystal fill the foreground, but the focus of the work is not on these rare and precious minerals. Rather, our eye is drawn to the background, where, in a vaulted chamber, a group of robed figures has gathered. One of them holds a burning lamp that brightly illuminates the chamber. These figures are mahatmas, and it is their wisdom that is the true treasure of the mountain.

The mahatmas, rishis, and all the nameless *gurus,* hermits, and lamas depicted by Roerich may appear to live in isolation from the world, but their lives are in fact devoted to helping the world through their spiritual activities and deeds:

> . . . man must dedicate himself entirely to creative labor. Those who work with Shambhala, the initiates and the messengers of Shambhala, do not sit in seclusion—they travel everywhere. Very often they perform their works not for themselves but for the great Shambhala; and they are without possessions. Everything is for them but they take nothing for themselves. Thus, when you dedicate yourselves to Shambhala, everything is taken and everything is given to you. If you have regrets, you yourself become the loser; if you give joyously, you are enriched. Essentially, the Teaching of Shambhala

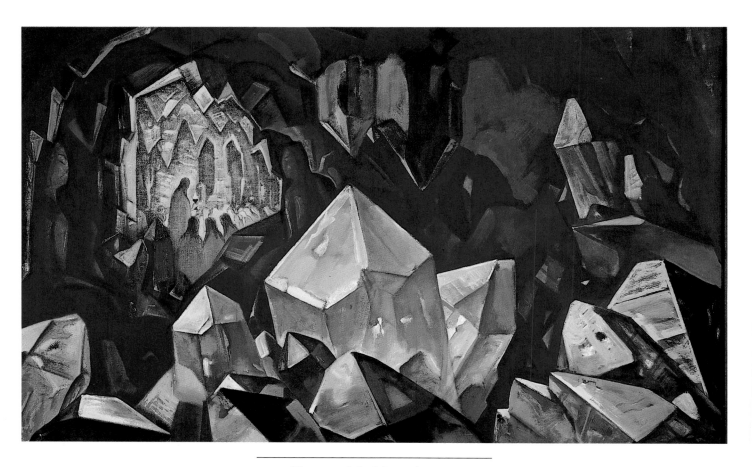

Treasure of the Mountain, N.D.
TEMPERA ON CANVAS, 29 X 46 IN.
NICHOLAS ROERICH MUSEUM, NEW YORK.

lies in this—that we do not speak of something distant and secreted. Therefore, if you know that everything may be achieved here on earth, then everything must be rewarded on earth.[15]

Roerich dedicated many years of his life to Shambhala. His creative labor—his paintings, writings, the institutions he founded, and his Peace Pact—formed both his personal quest as a *chela* for spiritual enlightenment and his way as a *guru* of guiding others toward it. In the early part of his career, this quest was symbolized in his work by the Stone Age, that time when man lived in complete harmony with nature, when work and art were one. Later, the main

symbol of this quest in his art was the Himalayas:

Himalayas! Here is the Abode of Rishis. Here resounded the sacred Flute of Krishna. Here thundered the Blessed Gautama Buddha. Here originated all Vedas. Here lived Pandavas. Here—Gesar Khan. Here—Aryavarta. Here is Shambhala. Himalayas—Jewel of India. Himalayas—Treasure of the World. Himalayas—the sacred Symbol of Ascent.[16]

He painted them at dawn, when the valleys were still in shadow and the peaks glistened in the first rays of the

sun. He painted them at sunset, when the valleys were already in shadow and the peaks glowed in the last rays of the sun like burning embers. He painted the snow-capped peaks of Kanchenjunga floating in a clear blue sky on a cushion of clouds. He captured the mountains at every time of day and in every season. He captured their eternity. He captured their ever-changing colors, the constant play of light and shadow on them. Above all, he captured their incomparable beauty, toward which all people are drawn and in the presence of which "the human spirit comes closest to divinity."[17]

That Roerich created his works in service to a spiritual ideal and with a messianic purpose was praised by some and criticized by others. In 1939, a monograph on Roerich was published in Riga, Latvia. His authors, Vsevolod Ivanov and E. Gollerbakh, all but deify their subject: "Roerich. . . . This name has long come to signify an entire cosmos, brought to life by the creative will of the artist. . . . Roerich's thought-images—it is impossible to define his paintings any other way—are breakthroughs into the cosmos" (E. Gollerbakh). "Peter the Great opened a window on the West for the world. Roerich opened a window on Russia for the world, on the East" (Ivanov).[18]

Roerich's colleague from his Mir Iskusstva days, Alexander Benois, accused Ivanov and Gollerbakh of turning their study of Roerich into a hymn. He confessed that Roerich's messianism was not to his taste, that he didn't believe anything substantive could be achieved through "conferences, pacts, leagues, speeches, jubilees, [and] apotheoses."[19] Although he was not about to take issue with the "Himalayan hermit's" belief that art has a beneficial effect on the spirit of the world, on the sowing and reaping of Good, he felt that this very credo served to limit rather than enrich Roerich's art. Benois admitted that some of Roerich's works were remarkably beautiful, infused with a genuine feeling of poetry, and successful in bringing our consciousness closer to things distant from us in space, time, and thought. But he characterized most of Roerich's paintings as superficial schemes, successful concoctions, likenesses of revelations and visions, but not

"organic forms living their own life" or "self-contained entities."[20]

Oh, if only instead of those cycles, instead of those thousands of paintings, we had a "normal" quantity of them, and if only each painting were in some way exhaustive, if we were able to "enter" it and "live" there for a while—how differently Roerich's mission itself would have turned out! Perhaps it would have been more limited in a geographic, in a planetary sense, perhaps it would have been less striking in its "universality," but it would have been more genuine and then apologists would not have had to present it as some kind of miracle about which they were obliged to speak in the language of the holy books. It would have spoken for itself.[21]

Since it is virtually impossible to separate Roerich's art from his philosophy, those who are skeptical of the artist's spiritual mission tend to dismiss his later work in particular as being repetitive and unoriginal, whereas those who embrace his philosophy experience something transcendental in those same canvases—a never-ending spiritual unfoldment. The Russian-born critic Ivan Narodny wrote, "[Roerich's] works manifest a prophetic tendency and deep religious feeling without being in the least didactic. Roerich's art speaks a language without words, a language that is sacred and universal; it is the language of intrinsic aesthetic symbols which, like the language of the magicians of the Dark Ages, was meant to perform miracles in everyday life."[22]

As World War II approached, Roerich felt the same sense of foreboding as before World War I. His 1936 painting *Armageddon* envisions the coming Holocaust as a spectacular conflagration engulfing a city in golden clouds of smoke (page 162). The city itself glows with an unworldly fuschia light. Silhouetted in the foreground, an army of warriors is seen marching across the canvas on their way to fight the final battle.

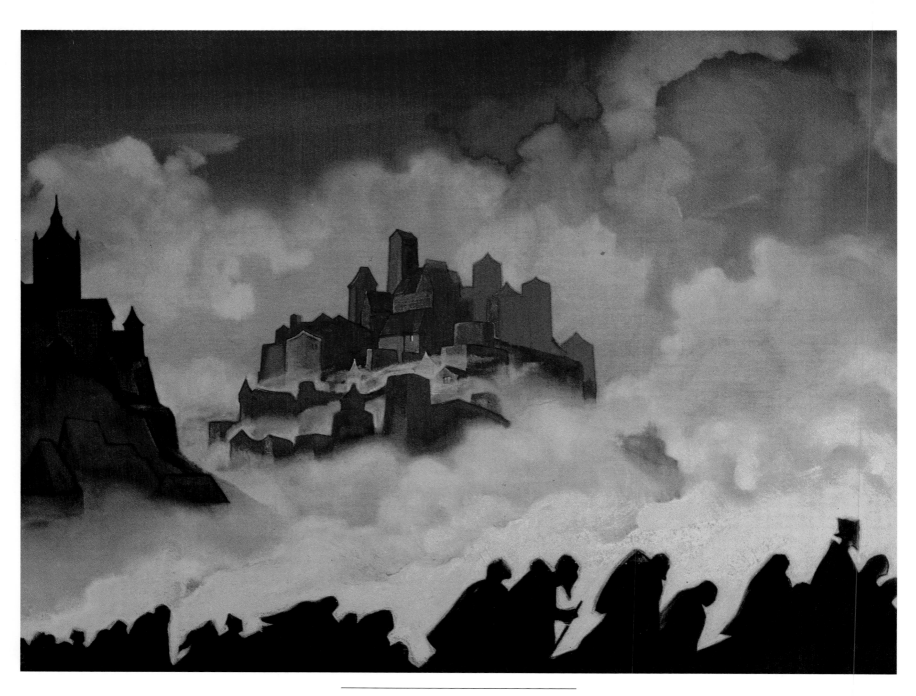

Armageddon, 1935–36.
TEMPERA ON CANVAS, 36 X 48 IN.
SVETOSLAV ROERICH COLLECTION, BANGALORE, INDIA.

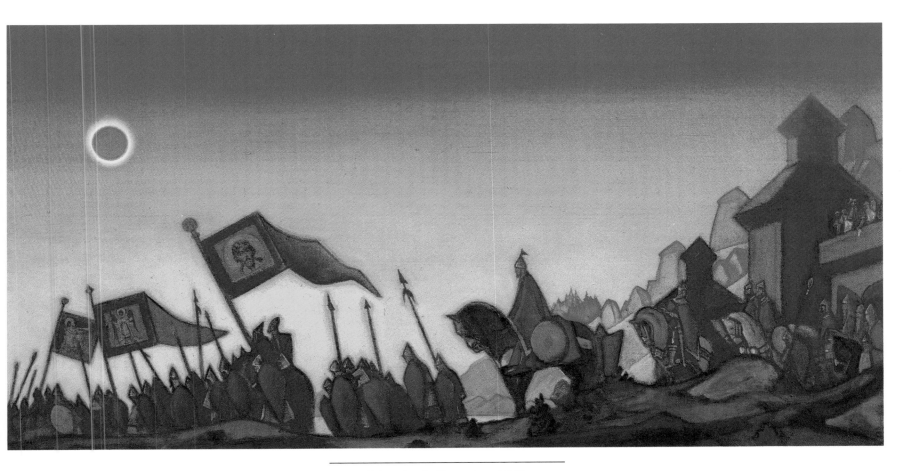

Prince Igor's Campaign, 1942.
TEMPERA ON CANVAS, 24½ X 48½ IN.
STATE RUSSIAN MUSEUM, ST. PETERSBURG.

Once the war began, communication with the rest of the world became more difficult and scientific work at Urusvati came to a halt. Roerich devoted all his energies to aiding victims of the war. Horrified by the devastation of his native land, Roerich appealed to his friends in the United States to help his Russian compatriots. In 1942 they organized the American-Russian Cultural Association (ARCA), which was supported by such prominent figures as Ernest Hemingway, Charlie Chaplin, Rockwell Kent, and Serge Koussevitsky. For his part, Roerich sent the organization patriotic articles and letters to publish. Many of his paintings during the war depicted historical moments in Russian history and legendary Russian he-

roes: *Prince Igor's Campaign,* in 1942 (above), *Alexander Nevsky* (1940), *Yaroslav the Wise* (1941), *Svyatogor: Elder of the Knights,* in 1942 (page 164), *The Partisans,* in 1943 (pages 166–167), and *Vasilisa the Beautiful,* in 1941 (page 165), in which this heroine of Russian *bylinas* is seen bending down over a windblown field of wildflowers, very much like the healer St. Panteleimon. He also painted new versions of such pre-World War I works as *The Last Angel* (page 169).

He donated the proceeds from some of his books and from the sale of his paintings at exhibitions to the Soviet Red Cross and devoted many pages of his *Diary Leaves* to the courage and heroism of the Russian people.

Svyatogor: Elder of the Knights, 1942.
Tempera on canvas, 24½ x 48½ in.
Svetoslav Roerich Collection, Bangalore, India.

Vasilisa the Beautiful, 1941.
TEMPERA ON CANVAS, 28½ X 48½ IN.
SVETOSLAV ROERICH COLLECTION, BANGALORE, INDIA.

In 1942, at the height of the war, Jawaharlal Nehru and his daughter Indira paid the Roerichs a visit in Kulu. During the week they spent there, Roerich spoke with them about establishing an Indo-Russian Cultural Association. To this day, Roerich's ties with the man who became India's leader after the country won its independence from Great Britain, and with other figures who actively opposed British rule, are recalled with pride in Russia, where friendly relations with the Indian government are a cornerstone of foreign policy.

Roerich's concern for the fate of his homeland kindled a desire to return to Russia. He began to make prepara-

tions to leave India once the war ended, but his first order of business after the Allied victories were declared was to renew the activities of the Roerich Pact. In December 1945 the Committee of the Pact and the Banner of Peace resumed its work in New York.

That same year he completed sketches for new productions of *Le Sacre du Printemps* and *Polovtsian Dances*. These works reveal how his style had gradually changed over the years. His treatment of line became more and more stylized, his use of color ever more flat and bold, his attention to minute detail less and less prominent. In a way, his later canvases are his most abstract; in a work such

The Partisans, 1943.
TEMPERA ON CANVAS, 18 X 31½ IN.
STATE RUSSIAN MUSEUM,
ST. PETERSBURG.

JAWAHARLAL NEHRU VISITING WITH ROERICH IN KULU, 1942.

as *The Hidden Treasure* (1947), for example, the play of line and color is much freer and draws greater attention to itself than in his earlier works (pages 170–171).

In 1939, at age sixty-five, Roerich had been diagnosed as having heart disease. But he was not about to let his failing health deter him from his many activities or from witnessing the "great days." He did live to celebrate not only the end of the war but India's independence from Britain in 1947. In July of that year his condition worsened considerably and he underwent surgery. He was back on his feet again by October and continued painting every day, although his doctors cautioned him against tiring himself out. He was working on a variant of *The Master's Command* (1947), in which a white eagle is seen flying toward a *chela* meditating in the lotus position on a cliff (pages 172–173), when his heart failed and he too

received a command "from beyond." Nicholas Roerich left this life on December 13, 1947.

Two days later his body was cremated in front of his home. A large stone was subsequently placed in this spot facing the mighty Himalayas; it bears the following inscription: "The body of Maharishi Nicholas Roerich, great friend of India, was cremated on this spot on 30 Mahar in the year 2004 of the Vitram era, corresponding to 15 December 1947. OM RAM."[23]

Soon after Roerich's death Helena and George Roerich moved to Kalimpong, near Calcutta, where George continued his research at the local university. Svetoslav and his wife, Devika Rani, at the time one of India's most renowned film stars, moved to Bangalore, where they still live.

Helena Roerich died in Kalimpong in 1955. Her ashes

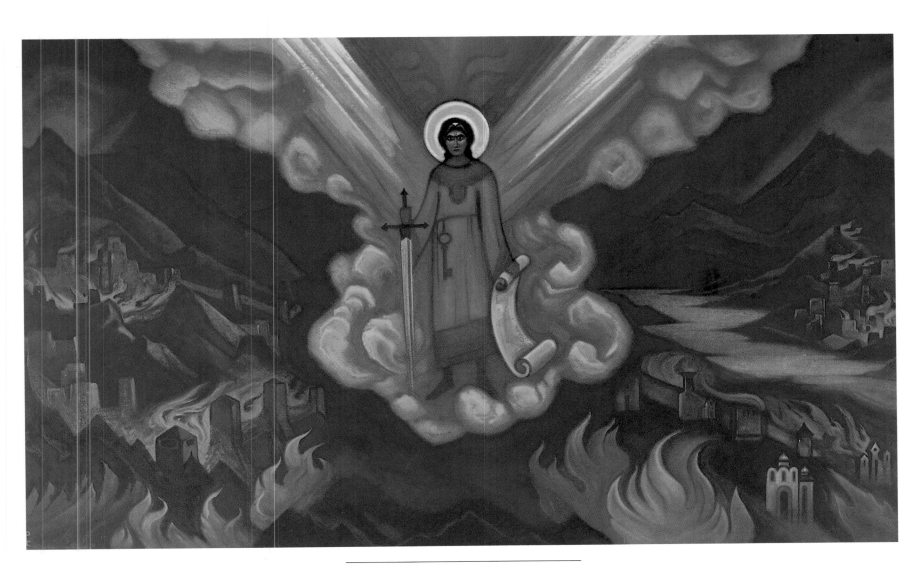

The Last Angel, 1942.
TEMPERA ON CANVAS, 36 X 60 IN.
SVETOSLAV ROERICH COLLECTION, BANGALORE, INDIA.

The Hidden Treasure, 1947.
TEMPERA ON CANVAS, 36 x 60 IN.
SVETOSLAV ROERICH COLLECTION,
BANGALORE, INDIA.

OVERLEAF:
The Master's Command, 1947.
TEMPERA ON CANVAS, 33 x 60¼ IN.
SVETOSLAV ROERICH COLLECTION,
BANGALORE, INDIA.

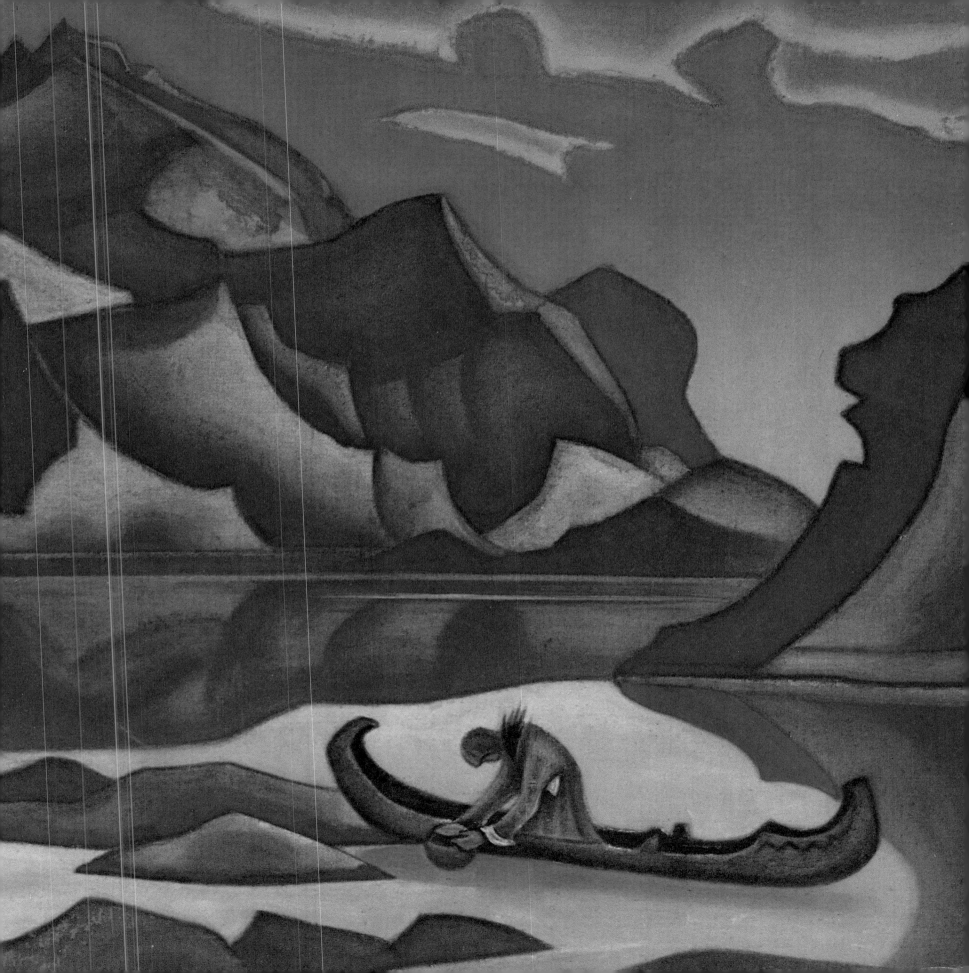

were buried on the slope of a mountain, and a stupa was erected at the site. Though she had chosen to remain out of the public eye, she had collaborated closely with Roerich on all his endeavors and had published several books of her own, usually under various pseudonyms. She also maintained a voluminous correspondence with her students and friends all over the world. She wrote on ethical and spiritual subjects, especially on the importance of the woman's role in the New Era. To many, she was a true spiritual teacher. In 1941, on their fortieth anniversary, Roerich wrote about his wife:

> Forty years is quite a long time. On such a long voyage, meeting many storms and dangers from without, together we overcame all obstacles. And obstacles turned into possibilities. I dedicated my books to "Elena, my wife, friend, fellow traveler, inspirer!" Each of these concepts was tested in the fire of life. And in Petersburg, Scandinavia, England, America, and in all Asia we worked, we studied, we broadened our consciousness. Together we created, and not without reason is it said that the work should bear two names—a masculine and a feminine.[24]

In 1957 George Roerich, along with Lyudmila and Iraida Bogdanova, the sisters who had joined the Central Asian expedition in 1927, returned to the Soviet Union, where he had been invited to rebuild the Institute of Oriental Studies. In Moscow, George continued his research, prepared works for publication, and taught in the Institute of Oriental Studies. On May 21, 1960, he died suddenly of a heart attack.

Nicholas Roerich's legacy extends to four continents; it comprises some 7,000 paintings, drawings, and set and costume designs; nearly thirty books; countless articles and lectures; museums and societies throughout the world; and the Roerich Pact. All along the path that took him from *The Messenger* to *The Master's Command,* from St. Petersburg to the Kulu Valley, he followed Tolstoy's advice and held the helm high to reach his destination.

NOTES

EARLY YEARS

1. Nicholas Roerich, *N. K. Rerikh: Iz literaturnogo naslediya* (Moscow: Izobrazitel'noe iskusstvo, 1974) p. 79.
2. *Ibid.* p. 81.
3. *Ibid.*, p. 82.
4. E. I. Polyakova, *Nikolai Rerikh* (Moscow: Iskusstvo, 1973), p. 9.
5. L. V. Korotkina, *Rerikh v Peterburge-Petrograde* (Leningrad: Lenizdat, 1985), pp.13–14.
6. *N. K. Rerikh: Iz literaturnogo naslediya*, p. 84.
7. *Ibid.*, p. 94.

UNIVERSITY YEARS

1. Polyakova, p. 25.
2. *Ibid.*
3. Korotkina, p. 21.
4. *Ibid.*, pp. 21–22.
5. *N. K. Rerikh: Iz literaturnogo naslediya*, pp. 88–89.
6. Polyakova, p. 31.
7. Korotkina, p. 33.
8. Polyakova, p.34.
9. Korotkina, p. 50.
10. *N. K. Rerikh: Iz literaturnogo naslediya*, p. 109.

THE WORLD OF ART

1. Polyakova, p. 52.
2. Korotkina, pp. 77–78.
3. *Ibid.*, p. 78.
4. *Ibid.*, p. 88.
5. *Ibid.*, p. 89.
6. *N. K. Rerikh: Iz literaturnogo naslediya*, p. 82.
7. Korotkina, pp. 81–82.
8. Polyakova, p. 61.

9. *Ibid.*, p. 62.
10. Korotkina, pp. 90–91.
11. *N. K. Rerikh: Iz literaturnogo naslediya*, p. 83.
12. Polyakova, p. 57.
13. *N. K. Rerikh: Iz literaturnogo naslediya*, p. 301.
14. Polyakova, p. 60.
15. *N. K. Rerikh: Iz literaturnogo naslediya*, p. 132.
16. Nicholas Roerich, *N. K. Rerikh: Izbrannoe* (Moscow: Sovetskaya Rossiya, 1979), pp.74–75.

THE STONE AGE

1. Polyakova, p. 124.
2. Korotkina, p. 103.
3. Sergei Ernst, *N. K. Rerikh* (Petrograd: Obshchina Sv. Evgenii, 1918), pp. 90,121.
4. A. D. Alekhin, "Tvorcheskii metod N. K. Rerikha," in *N. K. Rerikh: Zhizn' i tvorchestvo* (Moscow: Izobrazitel'noe iskusstvo, 1978), p. 52.
5. *N. K. Rerikh: Iz literaturnogo naslediya, p. 275*
6. S. Makovsky, as quoted in *N. K. Rerikh: Zhizn' i tvorchestvo*, p. 66.
7. For a detailed account of the whole sorry affair, see Robert C. Williams, *Russian Art and American Money: 1900-1940* (Cambridge, Mass.: Harvard University Press, 1980), pp. 42–82.
8. Richard Buckle, *Diaghilev* (New York: Atheneum, 1984), p. 53.
9. Marc Chagall, *My Life*, trans. from the French by Elizabeth Abbott (New York: Orion Press, 1960), p. 79.

10. *Ibid.*, p. 86.

THE THEATER

1. *The Nicholas Roerich Exhibition*, with Introduction and Catalogue of the Paintings by Christian Brinton (New York: Redfield-Kendrick-Odell, 1920), n.p.
2. *N. K. Rerikh: Iz literaturnogo naslediya*, p. 103.
3. E. More, *Forty Years of Opera in Chicago*, as quoted in John Bowlt, *Russian Stage Design: Scenic Innovation, 1900-1930, from the Collection of Mr. and Mrs. Nikita D. Lobanov-Rostovsky* (Jackson, Miss.: Mississippi Museum of Art, 1982), p. 255.
4. *N. K. Rerikh: Iz literaturnogo naslediya*, p. 353.
5. Serge Lifar, *Serge Diaghilev: His Life, His Work, His Legend. An Intimate Biography* (New York: Putnam, 1940. Reprinted New York: Da Capo, 1976), p. 127.
6. Victor Seroff, *The Real Isadora* (New York: Avon, 1972), p. 161.
7. Quoted in Bronislava Nijinska, *Early Memoirs* (New York: Holt, Rinehart and Winston, 1981), p. 274.
8. From two unidentified newspaper clippings. Quoted in Richard Buckle, *Diaghilev* (London: Weidenfeld and Nicolson, 1979), pp. 145–46.
9. F. Ya. Syrkina, "Rerikh i Teatr," in *N. K. Rerikh:*

Zhizn' i tvorchestvo, p. 92.
10. *Ibid.*, pp. 90–91.
11. *Ibid.*, p. 91.
12. *Ibid.*, p. 91.
13. Polyakova, p. 161.
14. *Ibid.*, p. 160.
15. *Ibid.*, p. 171.
16. *Ibid.*, p. 171.
17. Millicent Hodson, "Nijinsky's Choreographic Method: Visual Sources from Roerich for *Le Sacre du Printemps*," Dance Research Journal 18/2 (Winter 1986–87), p. 12.
18. *Ibid.*
19. Bronislava Nijinska, p. 449.
20. *Ibid.*, p. 450.
21. *Ibid.*, p. 461.
22. As quoted in Romola Nijinsky, *Nijinsky* (London: Sphere Books, 1970), pp. 165–6.
23. *Ibid.*, p. 166.
24. Vera Krasovskaya, *Nijinsky* (New York: Schirmer Books, 1979), p. 263.
25. *N. K. Rerikh: Iz literaturnogo naslediya*, p. 361.
26. Anna Kisselgoff, "Roerich's 'Sacre' Shines in the Joffrey's Light," *The New York Times*, November 22, 1987, p. H 10.

TRANSITION

1. Polyakova, pp. 104–05.
2. P. Belikov, V. Knyazeva, *Rerikh* (Moscow: Molodaya Gvardiya, 1972), p. 91.
3. *N. K. Rerikh: Iz literaturnogo naslediya*, p. 93.
4. V. P. Knyazeva, "Bogatyrsky Friz," in *N. K. Rerikh: Zhizn' i tvorchestvo*, p. 108.

5. Polyakova, p. 156. The previous year she had left the stage to run her own company, and her departure had spoiled the plans for a production of *The Tragedy of Judas Iscariot,* a play by the gifted writer Alexei Remizov, who had asked Roerich to design the sets and costumes. Komissarzhevskaya was to have played the part of the cruel, voluptuous Princess Unkrada. All that remains of the ill-fated production are Roerich's sketches, including the painting of a sad, large-eyed maiden standing next to a slender birch tree—his well-known *Unkrada.*
6. *N. K. Rerikh: Iz literaturnogo naslediya,* p. 106.
7. *Ibid.,* p. 319
8. Korotkina, p. 191.
9. Heinrich Zirnmer, *Myths and Symbols in Indian Art and Civilization,* ed. by Joseph Campbell (Princeton, N.J.: Princeton University Press, 1974), p. 20.
10. Irina H. Corten, *"Flowers of Morya:* The Theme of Spiritual Pilgrimage in the Poetry of Nicholas Roerich" (New York: Nicholas Roerich Museum, 1985), p. 7.
11. *Ibid.,* p. 8.
12. Translated by Irina Corten, in Corten, p. 11.
13. Belikov, Knyazeva, p. 139.
14. *N. K. Rerikh: Iz literaturnogo naslediya,* p. 111.

AMERICA

1. Quoted in "Roerich by his Contemporaries," *Archer,* March 1927, n.p.
2. Sina Fosdick, "Muzei imeni N. K. Rerikha v N'yu Yorke," *N. K. Rerikh: Zhizn' i tvorchestvo,* p. 199.
3. Robert C. Williams, *Russian Art and American Money: 1900–1940,* p. 318.
4. As quoted in Williams, p. 122.
5. As quoted in Williams, pp.122–23.
6. Williams, pp. 124—25.
7. *Ibid.,* p. 131.
8. *The Roerich Pact and The Banner of Peace* (New York: The Roerich Pact and Banner of Peace Committee, 1947; New York: Nicholas Roerich Museum, 1979), p. 28.
9. Williams, p. 135.
10. *Ibid.,* p. 143.
11. Fosdick, pp. 197-–8.
12. *Ibid.*
13. *Ibid.,* p. 197.
14. Williams, p. 118.
15. *Ibid.,* p. 140.
16. *Ibid.,* p. 143.
17. Fosdick, pp. 197–98.
18. *N. K. Rerikh: Iz literaturnogo naslediya,* p. 215.
19. Williams, p. 144.
20. Karl E. Meyer, "The Two Roerichs Are One," *The New York Times,* January 22, 1988.
21. Nanette Hucknall, "Nicholas Roerich, Artist, Author, Peace Builder," letter to the editor, *The New York Times,* February 9, 1988.

HEART OF ASIA

1. Belikov, Knyazeva, p. 160.
2. Nicholas Roerich, *Serdtse Azii (Heart of Asia),* in *Izbrannoe,* p. 155.
3. Nicholas Roerich, *Himalayas: Abode of Light* (Bombay, India: Nalanda Publications, 1947), p. 110.
4. *Ibid.,* p. 21.
5. Belikov, Knyazeva, p. 166.
6. *Himalayas,* p. 97.
7. *Ibid.,* p. 24.
8. As quoted in Jerry Rosser, "Nicholas Roerich: Messenger of Beauty" (Wheaton, Illinois: The Theosophical Society of America, n.d.), p. 8.
9. Nicholas Roerich, *Himavat: Diary Leaves* (Allahabad, India: Kitabistan, 1946), p. 286.
10. Polyakova, p. 230.
11. *Himalayas,* p. 166.
12. *Heart of Asia,* pp. 111–12.
13. *Himalayas,* p. 105.
14. *Ibid.*
15. *Heart of Asia,* p. 114.
16. *Ibid.,* p. 115.
17. *Ibid.,* p. 171.
18. Belikov, Knyazeva, pp. 174–75.
19. *Heart of Asia,* p. 122.
20. Belikov, Knyazeva, pp. 178–79.
21. *Ibid.,* p. 248.
22. *Himalayas,* p. 108.
23. Polyakova, p. 261.
24. *Ibid.*
25. Belikov, Knyazeva, p. 186.
26. *Heart of Asia,* p. 134.
27. *Ibid.,* p. 137.
28. *Ibid.,* p. 138.
29. *Ibid.,* p. 266.

KULU

1. V. A. Shibayev, as quoted in P. F. Belikov, "V Gimalayakh," in *N. K. Rerikh: Zhizn' i tvorchestvo,* p. 209.
2. Belikov, Knyazeva, p. 224.
3. Shibayev, as quoted in Belikov, "V Gimalayakh," pp. 212-13.
4. *Ibid.,* pp. 210-211.
5. Polyakova, p. 272.
6. Belikov, "V Gimalayakh," p. 202.
7. *Himavat,* p. 17.
8. *Himalayas,* p. 165.
9. Belikov, Knyazeva.
10. Helena Roerich, *Letters of Helena Roerich* (New York: Agni Yoga Society, 1967), vol. II, pp. 359-60.
11. *Heart of Asia,* p. 176.
12. *Himalayas,* p. 101.
13. *Ibid.,* p. 102.
14. *Ibid.,* p. 120.
15. *Ibid.,* p. 100.
16. *Ibid.,* p. 13.
17. *Ibid.,* p. 25.
18. Polyakova, p. 276.
19. *Ibid.*
20. *Ibid.,* p. 277.
21. *Ibid.*
22. Quoted in "Roerich by His Contemporaries," *Archer,* March 1927, n.p.
23. Belikov, Knyazeva, p. 249.
24. *N. K. Rerikh: Iz literaturnogo naslediya,* p. 239.

SELECTED BIBLIOGRAPHY

I. PRIMARY SOURCES

Books by Nicholas Roerich in English:

Adamant. New York: Corona Mundi, 1923.

Altai-Himalaya. New York: Frederick A. Stokes Co., 1929.

Fiery Stronghold. Boston: Stratford Co., 1933.

Flame in Chalice. New York: Roerich Museum Press, 1930.

Heart of Asia. New York: Roerich Museum Press, 1930.

Himalayas: Abode of Light. Bombay, India: Nalanda Publications, 1947.

Himavat: Diary Leaves. Allahabad, India: Kitabistan, 1946.

Invincible. New York: Roerich Museum Press, 1947.

Realm of Light. New York: Roerich Museum Press, 1931.

Shambhala. New York: Frederick A. Stokes Co., 1930.

Collections of works by Nicholas Roerich in Russian:

N. K. Rerikh: Izbrannoe [N. K. Roerich: Selected Works], Compiled by V. M. Sidorov. Moscow: Sovetskaya Rossiya, 1979.

N. K. Rerikh: Iz literaturnogo naslediya [N. K. Roerich: From His Literary Heritage]. Edited by M. T. Kuzmina. Moscow: Izobrazitel'noe iskusstvo, 1974.

Sobranie sochinenii: Kniga pervaya [Collected Works: First Volume]. Moscow, 1914.

II. SECONDARY SOURCES

Baltrushaitis, Yu., Benois A. N., Gidoni, A. 1., Remizov, A. M., Yaremich, S. P. *Roerich.* Petrograd, 1916.

Belikov, P., Knyazeva, V. *Rerikh* [Roerich]. Moscow: Molodaya Gvardiya, 1972.

Bowlt, John. *Russian Stage Design: Scenic Innovation, 1900-1930, from the Collection of Mr. and Mrs. Nikita D. Lobanov-Rostovsky.* Jackson, Mississippi: Mississippi Museum of Art, 1982.

Brinton, Christian. *The Nicholas Roerich Exhibition.* New York: Redfield-Kendrick-Odell, 1920.

Buckle, Richard. *Diaghilev.* London: Weidenfeld & Nicolson, 1979; New York: Atheneum, 1984.

Chagall, Marc. *My Life.* Translated from the French by Elisabeth Abbott. New York: Orion Press, 1960.

Conlan, Barnett D. *Nicholas Roerich: A Master of the Mountains.* Allahabad, India: Leader Press, 1938.

Corten, Irina H. "Flowers of Morya: The Theme of Spiritual Pilgrimage in the Poetry of Nicholas Roerich." New York: Nicholas Roerich Museum, 1985.

Ernst, Sergei. *N. K. Rerikh* [N. K. Roerich]. Petrograd: Obshchina Sv. Evgenii, 1918.

Gollerbach, E. "The Art of Roerich," *Twentieth Century* 4 (1938):450-69.

Hodson, Millicent. "Nijinsky's Choreographic Method: Visual Sources from Roerich for *Le Sacre du Printemps,*" *Dance Research Journal* 18/2 (Winter 1986-87): 7-15.

Ivanov, Vsevolod N. *Rerikh: Khudozhnik/Myslitel'* [Roerich: Artist/Thinker]. Riga, Latvia: Uguns, 1937.

Korotkina, L. V. *Rerikh v Peterburge-Petrograde* [Roerich in Petersburg-Petrograd]. Leningrad: Lenizdat, 1985.

Krasovskaya, Vera. *Nijinsky.* New York: Schirmer Books, 1979.

Lifar, Serge. *Serge Diaghilev: His Life, His Work, His Legend. An Intimate Biography.* New York: Putnam, 1940. Reprint. New York: Da Capo, 1976.

Nijinska, Bronislava. *Early Memoirs.* Translated and edited by Irina Nijinska and Jean Rawlinson. New York: Holt, Rinehart and Winston, 1981.

Nijinsky, Romola. *Nijinsky.* London: Sphere Books, 1970.

Paelian, Garabed. *Nicholas Roerich.* Sedona, Arizona: Aquarian Educational Group, 1974.

Polyakova, E. I. *Nikolai Rerikh* [Nicholas Roerich]. Moscow: Iskusstvo, 1973.

N. K. Rerikh: Zhizn' i tvorchestvo [N. K. Roerich: Life and Work]. Moscow: Izobrazitel'noe iskusstvo, 1978.

"Roerich by His Contemporaries," *Archer* (March 1927): 38-45.

The Roerich Pact and the Banner of Peace. New York: The Roerich Pact and Banner of Peace Committee, 1947.

Rostislavov, A. A. *N. K. Rerikh* [N. K. Roerich]. Petrograd: N. I. Butkovskaya, 1916(?).

Selivanova, Nina. *The World of Roerich.* New York: Corona Mundi, 1923.

Seroff, Victor. *The Real Isadora.* New York: Avon, 1972.

Williams, Robert C. *Russian Art and American Money: 1900-1940.* Cambridge, Massachusetts: Harvard University Press, 1980.

Zarnitsky, S., Trofimova, L. "Put' k rodine" (The Way to the Homeland), *Mezhdunarodnaya zhizn'* 1(1965): 96-107.

Zimmer, Heinrich. *Myths and Symbols in Indian Art and Civilization.* Edited by Joseph Campbell. Princeton, New Jersey: Princeton University Press, 1974.

INDEX

PUBLISHER'S NOTE

We would like to thank the following people for their diligent efforts and unceasing support in the making of this book:

To Josh Mailman, for the vision and the certitude he brings to this project. Our appreciation for nurturing the seed and participating in its growth;

To Ira Shapiro, for bringing this project to us and facilitating its conception;

To Barbara Somerfield, for her friendship and belief in our endeavors;

To Daniel Entin, Director of the Nicholas Roerich Museum, for assistance in all aspects of this project. How amazing to rediscover a relationship begun so many years ago;

To Edgar Lansbury, President of the Nicholas Roerich Museum, for direction and support;

To Carl Ruppert, for art consultation;

To Jerry Rosser, for inspiration;

To Ana Rogers and Gene Seidman, for laboring with and delivering not only a book layout for our original cloth edition but a healthy baby too;

And to Inner Traditions' staff members Leslie Colket, Estella Arias, Susan Davidson, and Anna Congdon for the individual efforts that conjoin to form one beautiful and integrated whole.

Ehud C. Sperling

THE NICHOLAS ROERICH MUSEUM

A permanent collection of works by Nicholas Roerich is on exhibition at the Nicholas Roerich Museum, 319 West 107th Street, New York, New York 10025-2799, 212/864-7752. Founded by the artist in 1923, the purpose of the museum is to disseminate the ideals of art and culture to which Nicholas Roerich dedicated his life.